slash

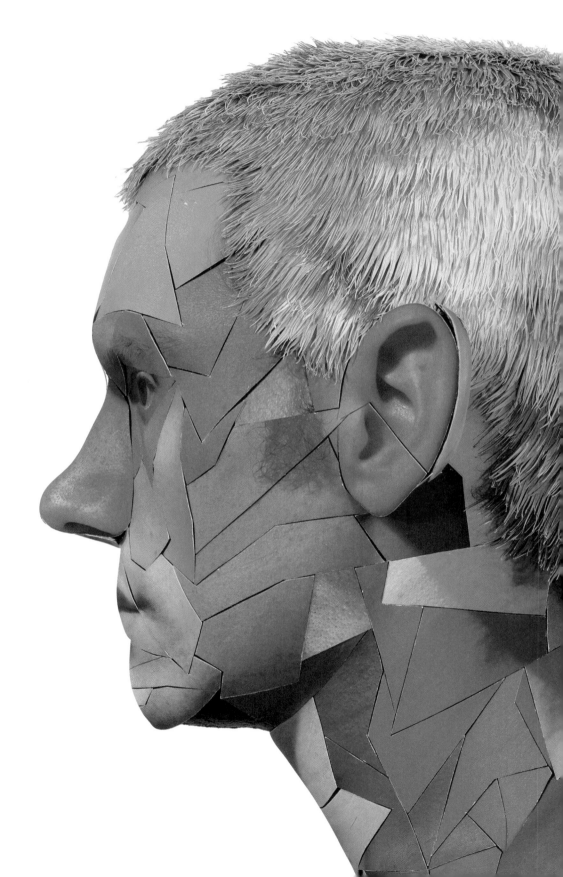

Oliver Herring
ALEX, 2009 (detail)
Digital C-prints, museum board,
foamcore, and polystyrene
Overall: 74 x 24 x 16 in.
(188 x 61 x 40.6 cm)
Courtesy of the artist and
Max Protetch Gallery, New York

slash

paper under the knife

museum of arts and design

CONTINENTS

Museum of Arts and Design
2 Columbus Circle
New York, New York 10019

Published in conjunction with the exhibition
Slash: Paper Under the Knife organized by the
Museum of Arts and Design.
October 7, 2009 – April 4, 2010

Slash: Paper Under the Knife was made possible by Kate's Paperie.
Generous additional support is provided by the Angelica Berrie
Foundation.

KATE'S PAPERIE

This exhibition is made possible, in part, through the generous support
of the Mondriaan Foundation, Amsterdam. Additional support is
provided by the Office of Cultural Affairs, Consulate General of Israel
and the Dutch Consulate General.

Mondriaan Stichting
(Mondriaan Foundation)

Edited by Martina D'Alton
Designed by Linda Florio, Florio Design

ISBN: 978-88-7439-529-3

Distributed in the United States and Canada by
Harry N. Abrams, Inc., New York.
Distributed outside the United States and Canada, excluding
France and Italy, by Abrams UK, London.

Color Separation: Pixel Studio, Milan
Printed in September 2009 by Grafiche Flaminia s.r.l., Foligno (Italy)
Printed in Italy

All measurements: height x width x depth, unless otherwise noted.
The titles of the objects featured in the exhibition are indicated
throughout the text with capital letters.
Artists' works may be found alphabetically following the essay.

Mark Fox
Untitled (We are Lost), 2007
(detail)
Ink, watercolor, acrylic, marker,
gouache, graphite pencil,
colored pencil, ballpoint pen,
and crayon on paper with linen
tape, Mylar, metal pins
Overall: 88 x 63 x 15 in.
(223.5 x 160 x 38.1 cm)
Private collection; courtesy of
Larissa Goldston Gallery

Foreword

First anniversaries are traditionally celebrated with a gift of paper. The presentation of *Slash: Paper Under the Knife* marks an important moment for the Museum of Arts and Design as we celebrate our one-year anniversary as a newly conceived cultural institution at Two Columbus Circle. The vision of MAD is to offer our public an engaging, accessible, and interactive experience of artists and designers transforming materials into objects of beauty, delight, and significance. Ways to explore materials and process are offered at all stages in our visitors' journeys. At our "open studios" they meet, observe, and converse with practitioners in a wide variety of mediums. In our galleries they experience interactive videos created in collaboration with international artists and designers. Our educational programs inspire children, adults, and families. The Museum store features one-of-a-kind, handmade works, and our newly opened restaurant presents culinary arts of material transformation.

Slash: Paper Under the Knife is the third exhibition in a series created to explore traditional, unusual, and overlooked materials and techniques through the lens of contemporary art and design. The fifty-two participating artists, hailing from sixteen countries, expand the global outreach of the Museum. Paper, one of the most ancient and humble materials, is also probably the most accessible worldwide. The works in the exhibition are diverse, ranging from intimate works to large-scale site-specific installations, from modified and altered books to animated cut-paper videos. Visually engaging, these works are also provocative in content, examining landscape, architecture, myth and memory, politics, and the human body. This most commonplace and disposable of materials is given new life and new value by these creative individuals.

Aric Obrosey
Hendrix Center Piece,
1998
Cut paper
31 x 31 in.
(78.7 x 78.7 cm)
Private collection;
courtesy of McKenzie
Fine Art, New York

As with its predecessors—*Radical Lace and Subversive Knitting* and *Pricked: Extreme Embroidery* —*Slash: Paper Under the Knife* conveys excitement, surprise, and a sense of discovery. David Revere McFadden, MAD's chief curator, has again chosen to examine a material that is now at the focal point across the fields of art, craft, and design. MAD is indeed fortunate to have his great energy, intellect, and creativity to bring to light new talent internationally. The exhibition features work by internationally renowned artists alongside emerging talent. For many artists this will be their first major museum exhibition, and many are being seen in New York City for the first time. Creating liaisons among the arts, acknowledging major artists, and providing exposure for the next generation of creators is central to the mission of MAD.

We are also fortunate to have Kate's Paperie as a partner and sponsor. Angelica Berrie's expansive vision for the company was graciously and generously extended to MAD and to these artists. We are pleased to be a part of the celebration of creativity in its many forms and to foster a new appreciation of paper, such an important and meaningful material.

Holly Hotchner
NANETTE L. LAITMAN DIRECTOR

Acknowledgments

This publication was made possible with the generous cooperation of many colleagues, collectors, galleries, foundations, and individuals, including George Adams, George Adams Gallery, New York; Gustavo Arróniz, Arróniz Arte Contemporáneo, Mexico City; Ted Bonin, Alexander and Bonin, New York; Montse Badia, Cal Cego Collection, Barcelona; Spencer Brownstone, Spencer Brownstone Gallery, New York; Laura Chiari, Galleria Lorcan O'Neill, Rome; Dennis Christie, DCKT Contemporary, Inc., New York; Rob Coffland and Mary Kahlenberg, Santa Fe; Jane England, England & Co., London; Michael Foley, Foley Gallery, New York; Louky Keijsers Koning, LMAK projects, New York; Lance Kinz, Kinz + Tillou Fine Art, New York; Molly Klais, Yvon Lambert Paris, New York; Stuart Krimko, Max Protetch Gallery, New York; Chad Longmore, Larissa Goldston Gallery, New York; Kristen Lorello, Eleven Rivington, New York; Christopher Mao and Christina Yu, Chambers Fine Art, New York; Valerie McKenzie, McKenzie Fine Art, New York; Jordi Mesalles, Galeria Llucià Homs, Barcelona; Simone Montemurno, 303 Gallery, New York; Jessica Nicewarner, Barry Friedman Ltd., New York; Claire Pauley, Tanya Bonakdar Gallery, New York; Steven G. Perelman, New York; Steven Sergiovanni, Mixed Greens Gallery, New York; Brent Sikkema, Sikkema Jenkins & Co., New York; Domenica Stagno, Gagosian Gallery, New York; Steven Stewart, Freight + Volume, New York; Lucien Terras, D'Amelio Terras, New York; Margaret Thatcher, Margaret Thatcher Projects, New York; Susannah Wesley and Joe Battat, Battat Contemporary, Montreal; James Yohe, Ameringer & Yohe Fine Art, New York.

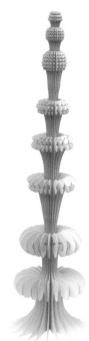

Ferry Staverman
Fountain, 2007
Cardboard, paint
31 ½ x 7 ⅞ x 7 ⅞ in.
(80 x 20 x 20 cm)
Collection of the artist

I wish to thank Laura Stern, assistant curator, for being such a vital part of both the exhibition and this publication. Laura's invaluable assistance assured that the high standards she maintains were applied to every detail of the project, while throughout retaining a wonderful sense of humor and grace under pressure. Rebecca Klassen and Sandy Kissler provided important research skills that greatly enhanced the publication. Exhibitions curator Dorothy Twining Globus once again choreographed the installation of the exhibition with her usual flare, working with installation architect Wendy Evans Joseph. Registrar Ellen Holdorf and associate registrar Elayne Rush were adept in managing complex packing, shipping, and installation arrangements. My sincere thanks to Martina D'Alton for her conscientious editing of the catalogue. Graphic designer Linda Florio, whose talent and energy never ceases to amaze, produced yet another inspired design. Eric Ghysels and Debbie Bibo of 5 Continents Editions in Milan worked closely with the Museum to produce an elegant publication. Finally, I wish to thank artists Béatrice Coron and Rob Carter for their expert advice throughout the project.

I am especially grateful to our director, Holly Hotchner, for the unflagging encouragement and thoughtful advice she provided throughout this project. It was a great pleasure to work with such a distinguished international roster of artists, and I thank each of them for sharing their talents with MAD and with our public.

David Revere McFadden
CHIEF CURATOR

KATE'S PAPERIE is delighted to collaborate with the Museum of Arts and Design to present *Slash: Paper Under the Knife*, a remarkable presentation of works that celebrate paper in all of its forms. As sponsors of this exhibition, Kate's Paperie and the Angelica Berrie Foundation are proud to support artists who have used paper as a creative medium and source of artistic inspiration.

As a company that passionately embraces creativity, Kate's Paperie has been the resource for beautiful papers and the tools to bring paper-inspired ideas to life for more than twenty years. Because we curate over four thousand papers from forty countries around the globe, Kate's Paperie intimately understands the myriad forms in which paper can be presented, manipulated, and transformed into works of art. It is this exciting and endless array of opportunities that makes us a passionate supporter of the *Slash: Paper Under the Knife* exhibition.

Artists, designers, craftspeople, and other creative people have been exploring paper and its uses for thousands of years. Kate's Paperie is happy to partner with the Museum of Arts and Design in a continuation of this exciting exploration where artistic inspiration and ideas meet paper.

KATE'S PAPERIE

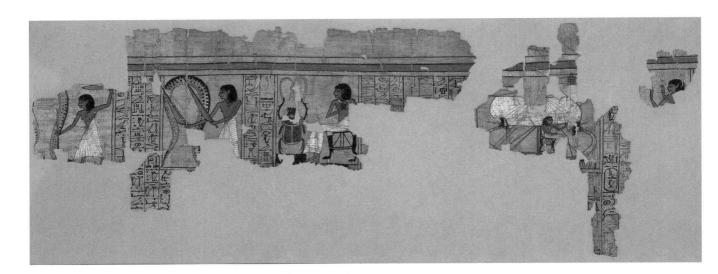

Book of the Dead, Chapter 17, (fragment),
Ptolemaic Period (?)
Princeton Pharaonic roll 2, probably found
in a Theban tomb
Papyrus, paint
8 ½ x 23 in. (21.7 x 58.5 cm)
Princeton University Collections of Papyri;
Manuscripts Division; Department of Rare
Books and Special Collections; Princeton
University Library

Slash: Paper Under the Knife

David Revere McFadden

Paper has been a ubiquitous commodity since the introduction of wood-pulp manufacturing almost two centuries ago. We record and preserve our personal and public lives on paper, in the form of documents, letters, books, magazines, and newspapers. We clean our environments and our bodies with paper. We store, carry, and consume some of our foods and beverages in paper packaging. Surgeons wear paper booties in the operating room, and babies wear paper as disposable diapers. We cover the walls of our homes with paper, and we keep and transport many documents and objects in containers made of paper.

In spite of the utopian dream of the "paperless" office, proposed almost thirty-five years ago,[2] paper has not, and probably will not, disappear. The consumption of paper worldwide, and especially in North America, has in fact increased dramatically in recent decades. The statistics of paper production are daunting: almost half the trees harvested worldwide end up as some form of paper.[3] In recent years, it has been estimated that the average office employee uses over ten thousand sheets of paper per year, in the form of computer printouts and photocopies.

Combined with other forms of paper, the per capita consumption of paper in the United States alone is around 750 pounds.[4] In 2001 it was estimated that about 1.2 trillion pages were being generated by laser printers alone.[5]

Paper as we know it today has been in existence for about eighteen centuries. Modern paper most likely originated in China in the second century, even though papyrus—beaten strips of fiber from the papyrus plant—was in use much earlier in ancient Egypt, and boiled and pounded tree bark, known

as *amatl*, was a medium used in Pre-Columbian Mesoamerica. Neither papyrus nor *amatl*, however, is true paper, which we define as a fibrous material, pulped to free individual fibers in a moist medium that is then pressed or precipitated into a flat sheet and dried. While "modern" paper began as a rare and coveted material, it soon evolved into a much more readily available commodity, spreading from China into Korea and Japan, and eventually into the Muslim world, from whence it migrated quickly to Europe. In the nineteenth century, machine production of paper replaced most handcraft production. Furthermore, in the 1830s, wood pulp was introduced as a cheap and readily available alternative to other common fibers, primarily cotton and linen, then being used in papermaking. The tidal wave of paper production and consumption was put into motion, and today paper can be made from traditional wood, rags, grasses, and other organic fibers, or more recently from synthetics and even powdered stone.[6]

Paper in its various forms has been used by artists for centuries as a surface upon which to draw or paint. Its function as a support medium for images changed dramatically when paper was "rediscovered" by such artists as Pablo Picasso and Georges Braque as a distinct medium unto itself, in a new art form known as collage—fragmented paper affixed to a surface to create a two-dimensional form. The popularity of paper collage ebbed and flowed along with the evolution of modern art. Hans Arp tore paper into fragments that were dropped onto a surface and affixed in the accidental arrangements that resulted. Henri Matisse used paper for some of his most dramatic and memorable compositions. Richard Hamilton, John McHale, Tommy Wesselman, Romare Bearden, and Michael Anderson are among the thousands of artists who contributed to the artistic lineage of the cut-paper technique.

Paper's ubiquity has assured it a special niche in the range of materials being explored by artists today—it is ordinary and commonplace to an extraordinary degree. And, while paper proliferates and accumulates—posing challenges over recycling and its overall ecological impact—it nevertheless remains readily available, inexpensive, and disposable. Because of its ordinariness, and unlike other materials such as metal, wood, glass, and ceramics, paper carries little or no cultural, social, or economic baggage. We take it for granted, and therein lies its appeal as an art medium. Its true value is discovered only in its transformation.

In recent years, there has been a virtual renaissance of interest in the use of paper as an independent medium beyond collage. Artists worldwide have focused their attention on techniques of cutting paper to create two-dimensional works as silhouettes—removing sections of paper to permit light to create a contrast between foreground and background—and as the first step in assembling separated pieces to build three-dimensional forms. Today's generation of artists using paper in these two ways are the focus of *Slash: Paper Under the Knife*.[7]

The origins of papercutting, like those of papermaking itself, are not certain, but it is reasonable to expect that papercutting as an art form began in China shortly after paper's first appearance. Chinese artists explored the medium in many applications—from paintings and calligraphy to printed texts, currency, and decorations. However, the first individual to cut (and therefore destroy) a piece of

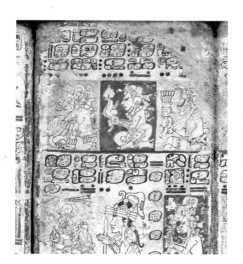

far left:
Dresden Codex of the Maya, Image 6, 13th century (detail)
Pounded tree bark
Dresden SLUB Mscr.Dresd.R.310

left:
Hawaiian Kapa cloth with sea-urchin design, 19th century
Kapa pa'u barkcloth
Courtesy of the Bishop Museum, Honolulu, Hawaii

paper was likely as courageous as the proverbial man who first ate an oyster. The practical or decorative uses of the first cut papers are unknown, but based on later developments, these cuttings probably depicted zodiacal animals or other symbols of good fortune, health, prosperity, and fertility, and were displayed at auspicious occasions such as weddings or funerals and during holidays.[8]

A remarkable group of multilayered cuttings from China dated to the ninth century are found in the collection of the British Museum, London. The cuttings depict four- or five-petal rosettes, or stylized motifs that suggest the blossoms of the peony or paulownia tree. Traces of the original red stain or dye can be seen, a color of special significance in China up to the present day. A spot of adhesive on the back of the rosettes suggests they were attached to something, perhaps a wall or other architectural feature.[9] The layering of cut paper seen in these works is also an early example of cut paper's use as a means of creating three-dimensional forms, a practice that has seen a veritable renaissance in the arts in the past decade.

Papercutting traveled from China to Korea and Japan. Japanese paper arts included origami (folded-paper sculpture), *katagiri* (folded and cut paper), and, most notably, *katagami* (cut-paper stencils used for dyeing leather or textiles). *Katagami* were extraordinary in their complexity and delicacy, with motifs so fine that they required reinforcement with strands of silk to hold them together.

As paper moved from East to West, so too did the techniques and styles of papercutting, becoming known by different names, such as *sanjhi* in India, *scherenschnitte* in Germany and Switzerland, and *wycinanki* in Poland. The styles, motifs, and techniques were preserved over the centuries as part of folk culture and are being produced today by such accomplished papercutters as the Swiss artist Ernst Oppliger. Folk-art papercutting traditions also flourished in Jewish communities, particularly in the form of beautifully cut, painted, and inscribed *mizrachs* (wall decorations indicating the East), and *ketubbahs* (illuminated marriage contracts). Equally well known are the cut tissue papers made in Mexico, known as *papel picado*, that are often strung across interiors and streets in Mexico during festivals and religious occasions. At the other end of the artistic spectrum are the elegant and sophisticated cut papers of the Italian Ugo Mochi (1889–1977), who cut fourteen 8-by-2-foot panels depicting the flora and fauna of parts of the world, a commission from the American Museum of Natural History in New York that was completed in 1967.

above:
Waves, Fishing Nets, and Pine Leaves, katagami stencil, Japan, late 19th or early 20th century (detail)
Treated and cut mulberry paper, silk threads, paste
23 ⁷⁄₁₆ x 15 ¹⁵⁄₁₆ in. (59.6 x 40.5 cm)
Cooper-Hewitt, National Design Museum, Smithsonian Institution; museum purchase through gift of Norvin Hewitt Green

left:
Paper flowers, excavated from Qian Fo Dong, Cave 17, China, 9th–10th centuries
Paper, ink, pigment
Maximum: 5 ⁵⁄₁₆ x 5 ⅛ in. (13.5 x 13 cm)
Courtesy of the British Museum

Papel picado, date and maker unknown
Cut tissue paper
13 ¾ x 17 ½ in. (34.9 x 44.5 cm)
Private collection

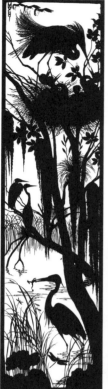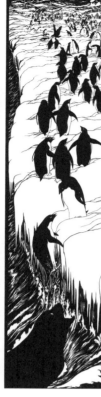

Ugo Mochi, Italy, 1889–1977
Herons (left) and *Penguins* (right), 1966–67
Cut paper
94 x 22 in. (238.8 x 55.9 cm)
Courtesy of the American Museum of Natural History

While many cut papers are used as ornaments and decorations worldwide, the medium has also been used for narrative and figural depictions. Two legendary figures in the history of cut-paper portraiture are Etienne de Silhouette (1709–1767) and Johann Kaspar Lavater (1741–1801). Each played a separate role in the history of cut-paper silhouettes. Etienne de Silhouette of Limoges, a student of economics, became the comptroller-general of France under King Louis XV. Under the protection of the king's mistress, Madame de Pompadour, de Silhouette put into effect harsh tax laws to counteract the financial drain on France brought about by the expensive Seven Years' War against England. How his name became eponymous for a monochromatic profile portrait image is conjectural at best; according to one legend, de Silhouette took up paper-cutting as a hobby and specialized in portraiture, and his name was attached to "cheap" substitutes for expensive portraits in oil, which were no longer affordable by the monetarily bereft aristocracy of France.

The silhouette at its best provides a recognizable image of an individual through outline alone. Johann Kaspar Lavater was to add another layer of meaning to the silhouette tradition when he published a volume on physiognomy—reading an individual's character solely by analyzing a sitter's profile.[11] Lavater's theory was based on a classical belief that the soul was contained in one's shadow.[12] His book contained silhouettes of specific character types.

Both de Silhouette and Lavater stand at the beginning of a list of important silhouette artists—painters and cutters—which includes the famous John Miers (1756–1821) of England, Augustin Amante Constant Fidele Edouart (1789–1861) of France, and scores of other European, British, and American silhouette makers who flourished in the nineteenth century and whose talents were rendered obsolete by the invention of photography. The idea that an outline alone can carry meaning and narrative, however, informs the work of countless contemporary artists who cut two-dimensional paper imagery today, such as Ed Pien, Dylan Graham, and Rob Ryan, whose works are included in this exhibition. The silhouette tradition of papercut-

Deborah Ugoretz, United States, born 1952
Rosenfeld Ketubbah, 1999
Cut paper, ink, gouache, acrylic paint
22 x 30 in. (55.9 x 76.2 cm)
Courtesy of Naomi Rosenfeld

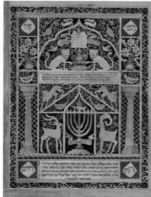

Deborah Ugoretz, United States, born 1952
Mizrach, 1999
Cut paper, gouache
14 ½ x 19 ½ in. (36.8 x 49.5 cm)
Courtesy of David and Ryna Alexander

Ernst Oppliger, Switzerland, born 1950
Noah's Ark, 1982 (detail)
Cut paper
Overall: 23 ¾ x 23 ¾ in. (60.3 x 60.3 cm)
Cooper-Hewitt, National Design Museum, Smithsonian Institution; this acquisition was made possible through the Louis Comfort Tiffany Foundation

ting resurfaced in a new format—stop-action animations captured on film—in the early years of the twentieth century and has been used effectively by such artists as Kara Walker and Carlos Amorales.

A significant number of artists included in *Slash: Paper Under the Knife* break with the silhouette tradition and take paper into the third dimension by creating constructions that range from textural wall compositions to entirely freestanding sculpture. Judy Pfaff and Andreas Kocks make dynamic and imposing "explosions" that engage both architecture and space, while Tom Friedman and Oliver Herring, among others, create memorable studies of the human figure.

Printed and bound books provide a starting point for a growing number of artists worldwide. The paper pages are cut, torn, deconstructed, and reconstructed. When the first book was cut to change both its appearance and its significance is not known. The tradition of altering books in general began quite early, however, most likely with erasures and rewritings on parchment leaves, such as the well-known Archimedes Palimpsest, which transformed a

tenth-century volume of Archimedes' *Treatises* into a Byzantine prayerbook (euchologion) in the late twelfth or early thirteenth century.[13] While this intervention had a purpose entirely different from those of later artists who modified bound books, and while erasure of text and rewriting of new texts in its place is distinctly different from cutting the paper itself, the concept of giving the book a new purpose and transforming its appearance remains consistent. An early seventeenth-century prayer book that belonged to Marie de Medici provides a rare example of virtuoso book modification by complex cutting.[14] Each page has been cut to simulate different patterns of lace, a form of costume decoration favored by the queen consort, as confirmed in her many portraits. An even earlier, albeit much less intricately cut, Book of Hours from the Champagne/Lorraine area of France is dated to around 1300–25.[15]

In more recent times, such artists as Tom Phillips expanded the repertoire of book cutting in the 1960s with his well-known *Humument*, a modified version of W. H. Mallock's *Human Document* of 1895.[16] And, while more pertinent to literature and performance art, the "cut up" technique adopted by

such writers as William S. Burroughs provide a rich context for contemporary books modified by cutting the pages and thus changing the meaning and appearance of texts. Today, book modification has become an international phenomenon: witness the creation of specialized affiliate organizations such as the International Society of Altered Book Artists.[17] Modified books by Doug Beube, Brian Dettmer, Olafur Eliasson, Chris Kenny, Carole P. Kunstadt, Georgia Russell, and Ishmael Randall Weeks, all included in *Slash: Paper Under the Knife*, highlight the diversity of approaches being taken by artists work in this format today.

Cut paper has also figured prominently in the history of animation on film. Precedents for cut-paper animation are traceable to the invention of the phenakistoscope (also known as stroboscope or fantasscope) in 1832 and the zoetrope in 1834, both of which simulated movement with a series of stop-action drawings that were viewed in rapid succession on a disk or cylinder through an aperture. The growth of the cinema industry in the nineteenth century, and Thomas Edison's more sophisticated kinetograph and kinetoscope of 1889, laid the ground

right:
Johann Caspar Lavater, Switzerland, 1741–1801
Page 187 from *Essays on Physiognomy: For the Promotion and Knowledge and the Love of Mankind* (London: G. G. J. and J. Robinson, 1789)
General Research Division, The New York Public Library, Astor Lenox and Tilden Foundations

far right:
Lucius Gahagan, England, ca. 1780–1866
Silhouette portraits of Lord Ellenborough, William Pitt, and others, 1812–17
Paper, graphite, gray wash
13 ¹⁵⁄₁₆ x 10 ⅜ in. (35.4 x 26.3 cm)
Courtesy of the British Museum

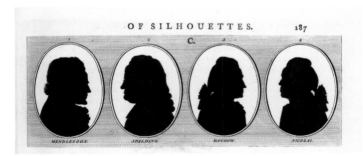

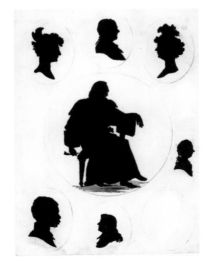

for cut-paper stop-action film as we know it today.

The use of cut-paper shapes and figures animated through stop-action photography began in 1910 in a French cartoon titled *En Route*, unfortunately now lost. It was made by cartoonist, animator, and cinematographer Émile Eugène Jean Louis Courtet (1857–1938), who later changed his name to Émile Cohl and worked for the influential Gaumont and Pathé movie studios. The fairy godmother of cut-paper animation is Lotte Reiniger, whose *Die Abenteuer des Prinzen Achmed (The Adventures of Prince Achmed)* of 1916 is the oldest surviving cut-paper animated film. This extraordinarily complex and beautiful animation, using silhouette alone to portray monsters, heroes, and animals, adumbrates the work of such brilliant contemporaries as Kara Walker and Carlos Amorales, as well as the studies of architecture and site created in cut paper by Rob Carter, who are included in *Slash: Paper Under the Knife*.

SLASH: PAPER UNDER THE KNIFE
"What kind of act is it to cut through a surface? Potentially savage, vicious and even violent, it could also be a kind of surgery or suture—a sign of healing and reparation to come. . . . But a cut is also a break, a release, a change, a sudden movement that is transformative—metamorphosizing from one state to another, . . . the cut that binds by being the cut that releases and frees."[19] The relationship between the techniques of cutting, tearing, and rending and sublimated violence is obvious, recalling Picasso's familiar injunction that "every act of creation is first of all an act of destruction." More important is the transformative nature of this destruction; through compromising the integrity of the material, paper loses its passivity, its plainness, its neutral passivity. Paper can become a dynamic spatial intervention; it can respond to an architectural environment; it can describe and even mimic other forms, such as objects and figures. Paper can be used to express profoundly personal aesthetic visions as well as to provoke debate about issues that range from global politics to personal poignancies.

Slash: Paper Under the Knife highlights work by fifty-two artists—painters, designers, sculptors, filmmakers, architects, installation and performance artists, and photographers—hailing from sixteen countries. The exhibition and accompanying publication offer a survey of two- and three-dimensional works that have been made in the past five years. Many of the artists featured in this publication work in multiple mediums, among which one is paper. And, while all works shown in the exhibition are fabricated using one or more types of paper, works in other mediums by each artist are also shown to provide a more accurate overview of their artistic output. Several themes link certain works to others in the exhibition. These themes are not intended to be hard and fast categories, offering oversimplified explanations as to the content and meaning of the works, but rather are a way to suggest aesthetic and intellectual relationships among works that may evoke and even provoke thoughtful consideration of their significance.

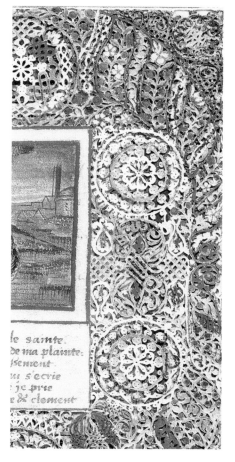

right; detail, far right:
Master of the Gold Scroll, ca. 1450
Tempera on parchment
5 ⅛ x 3 ⁹⁄₁₆ in. (13 x 9 cm)
Courtesy of The Walters Art Museum

CUTTING AS GESTURE: DRAWING WITH THE KNIFE

A significant number of artists featured in *Slash: Paper Under the Knife* studied traditional fine arts and used paper primarily as a ground for preparatory drawings and sketches or for print-making. These artists discovered the potential of paper as a medium unto itself, along with the gratifying way in which cutting, tearing, or burning captures the dynamism of a painterly gesture in real space and time. The artworks in this category range from the weaving together of subtle layers of cut lines to the expressive interventions of form, color, and line in space. These artists replace pencil, brush, or engraving tool with knives or scissors and project two-dimensional line into the third dimension.

Among those who made the transition from sculpture and painting into cut paper is the German artist **Andreas Kocks**. He began his artistic career as a sculptor working in such traditional materials as wood and bronze. The shift to cut paper permitted him to work on a scale made difficult, if not impossible, in weighty materials. For Kocks, cutting was also a logical extension of drawing dimensionally—creating a clear and continuous line that defines form and shapes space. Kocks's paper installations are dynamic and powerful, recording in monochromatic black or white the impact of an opaque liquid having been violently thrown against a vertical surface, or tracing the voluminous masses of rapidly forming and deforming clouds. Kocks achieves dramatic impact, in part, through the massive scale of his installations, which sometimes dwarf the viewer, as well as by layering the paper to bring the "splash" into the third dimension, in the manner of a stop-action film, and also by continuing smaller fragments of the splash on the ceiling or floors of the installation space. In Kocks's work, architectural and sculptural space is united in a gesture of benign violence. The viewer is swept into a maelstrom that suggests both physical and psychological chaos and a loss of control in the face of the unexpected event. The imposing and energetic forms also convey a sense of exuberance that counterbalances the emotional intensity of the black forms.

While Andreas Kocks's works literally take over the architectural spaces in which they are installed, **Aric Obrosey** focuses on complex detail to establish a more intimate relationship with the viewer. Obrosey has worked in a wide variety of mediums: etchings on Plexiglas, graphite drawings on vellum, woodcuts, and two- and three-dimensional cut paper. In one form or another, each of these modes of work reflects the artist's skill and passion, if not obsessiveness, with intricacy and finely delineated, sometimes almost imperceptible detail. The artist has produced lace-patterned workmen's gloves of extraordinary complexity—*Lace Glove Recto and Verso* (2000)—in graphite and vellum, and an outsized black lace doily of cut paper from which the face of Jimi Hendrix appears within high-Victorian scrolls, leaves, and flowers. While Obrosey's techniques demand a highly focused attention and the repetitive gestures revelatory of a meditative state, his works are also virtuoso performances that test the limits of the viewer's belief. *HAND PRODUCTION LINES*, created for this exhibition, is a tangle of black strands that interweave, knot, overlap, and coil into a writhing mass. The work's complexity frustrates easy resolution into a recognizable pattern, yet the edge of each cut line reveals silhouetted forms—almost

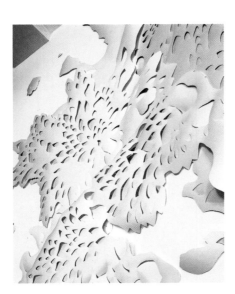

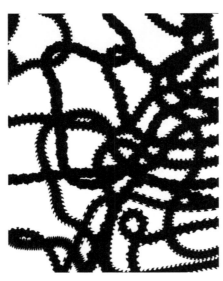

far left:
Andreas Kocks, Germany
paperwork #704 (Splatter), 2007
(detail)
Installation view at Neue Werkstätten, Munich, Germany
Watercolor paper, acrylic varnish
Overall: 13 ft., 9 ¾ in. x 45 ft., 11 in. x 6 in. (421 x 1400 x 15 cm)

left:
Aric Obrosey, United States
HAND PRODUCTION LINES, 2009
(detail)
India ink on cut paper
Overall: 40 x 60 in.
(101.6 x 152.4 cm)
Courtesy of the artist

archetypal shapes—that one recognizes immediately: phonograph records, automobile insignia, lightbulbs, architectural details, and other cultural detritus. These tangible documents of material culture are as intertwined in our lives as they are in Obrosey's Penelope-like weavings and unweavings. The artist presents a seemingly chaotic composition and then seduces the viewer into an intimate discovery of the details that distinguish each cut line. The viewer's examination becomes a parallel activity that echoes the artist's own behavior during the creative process.

The three-dimensional gestural nature of cut paper is epitomized in the work of **Mia Pearlman**, who explores the nature of ephemeral phenomena in her swirling, light-animated, site-specific studies of cloudlike forms and patterns. Pearlman's works appear to be caught in transition, in what the artist calls "the moment between creation and destruction."[20] Her installations merge the sense of the temporary—a unique moment in time captured in stop action—with the theatrical drama of Andreas Kocks's intervention and the baroque exuberance of Judy Pfaff's waterfalls of color and pattern.

Pearlman's work in other mediums is also focused on the annotation of a fleeting moment in time. For example, she has used soap and tempera to create her Bubble Painting series, polychrome mini-explosions that evoke memories of the iridescent surfaces and fragile lifespan of the soap bubbles of our childhoods. She has also used graphite on paper to record light in a variety of configurations, such as knots, streams, connectors, tunnels, and wells. Her painted studies called *Cloudscapes* are related investigations into swirling insubstantiality and the ways in which light interacts with form. In her cut-paper works, however, her ethereal forms take on an especially dramatic spatial reality. Pearlman draws the viewer's eye into the depth of her work, and yet, because of the ways in which the paper shapes reflect, hide, and transmit the ever-changing light of their settings, they refuse to become entirely static structures. She creates a maelstrom that evokes the heaven-directed clouds of Baroque paintings. If the process of change in nature is inevitable, these works acknowledge this truism, while at the same time they lure one into pondering the apparently eternal and infinite quality of space and light.

The French author Antoine de Saint-Exupéry wrote that "perfection is finally attained not when there is no longer anything to add but when there is no longer anything to take away."[21] This principle informs the work of **Adam Fowler**, who explores the textural presence of the drawn line in his cut-paper assemblies, which consist of sheets of paper filled with graphite arcs drawn with a surgeon's precision on their surfaces. Upon completion of a number of these gestural drawings, Fowler subjects the paper to a delicate surgery, liberating each drawn line from its paper support. The paper ground that supported the drawing is reduced to a thin sliver no larger than the drawn line itself; for all intents and purposes, the paper disappears, leaving only the graceful arcs drawn by the artist. Sheets of these painstakingly sliced drawings are stacked one upon the other to create a dense three-dimensional drawing in real space. The intensity of Fowler's work depends on precision of intent and control of the cutting technique. The works evolve organically from two into three dimensions; cutting is used to define territories and to

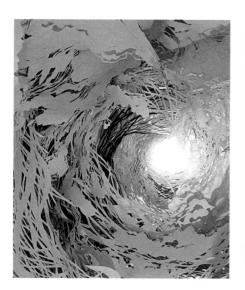

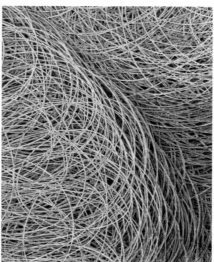

far left:
Mia Pearlman, United States
Eye, 2008 (detail)
Site-specific installation at the Centre for Recent Drawing, London
Paper, India ink, tacks, paper clips
Overall: 10 x 10 ft., 4 in. (3 x 3.1 m)

left:
Adam Fowler, United States
Untitled (55 layers), 2008
Graphite on paper, hand-cut and layered
7 x 6 in. (17.8 x 15.2 cm)
Collection of Mr. and Mrs. Michael Millette

establish boundaries between spaces. The initial appearance of the works implies a gestural chaos comprised of writhing, intersecting, and overlapping lines. However, careful study of the works reveals the meditative nature of his lines. A roadmap of the artist's repeated gesture is established in these understated and often modestly scaled compositions. Through line alone we are brought into the body and soul of the artist, whose hand is an omnipresent feature of these drawn and cut narratives.

Fran Siegel is known for her ability to engage the viewer in a space that is at once specific and enticingly vague, making best use of what has been described as "inconspicuous, overlooked space,"[22] in which the artist draws in the air to create an "ephemeral topographical image that defies specific identification."[23] Siegel's mode of working is to create magical installations that inhabit a space that is ultimately animated by the viewer's moving past the installation. These are drawings in space that have form and texture, but elude a facile reading and interpretation. Siegel's *Overland*, for example, is an installation of

fragmented drawings on paper that hover above the ground, responding to ambient movement and air currents. The installation was based on a series of photographs taken from the windows of airplanes as they descended into Los Angeles. The shattered forms of landscape features and cloud patterns as they move rapidly across the artist's vision describe a vision in flux, changing rapidly and seamlessly with the movement of the airplane. Siegel calls into question any preconceived ideas of landscape as constant, proposing instead that landscape is as fleeting as our momentary glimpse of it. Siegel's strategy of revealing and concealing views at the same time has been recurrent in her works from the past decade, most notably in *Interference* (2001), which "suggested a complex interaction between what the artist allows to be seen and what is actually there." With its highly specific geographical location, the current work also derives its energy by including both knowledge and a vision of a specific landmark, and thus adding memory to the ephemeral vista.

For *Slash: Paper Under the Knife*, Siegel has chosen the landscape of Columbus

Circle directly in front of the Museum— with its familiar column and statue, its fountains, and surrounding buildings— as subject and as provocateur. The work is installed within the window that frames the urban monument, and thus merges seamlessly with the walls that surround the aperture. The strategy of engagement developed by Siegel in this work establishes the planes of paper as both a barrier and invitation for the viewer. As Columbus Circle is perceived through a series of apertures, the translucent panels also reveal the complex topographical annotations overlaid on them, evoking the appearance of a palimpsest map.

Painting, sculpture, line, form, color, pattern, and texture are brought together in the sensuous and ebullient compositions of **Judy Pfaff**. To achieve her effects, she uses a panoply of papercutting techniques: knife cutting, tearing, shredding, burning, punching, and gluing. Pfaff holds a distinguished place in the history of installation art. Throughout her career, she has also employed a lush and unexpected repertoire of materials, ranging from wire and aluminum foil to artificial flowers and real trees. Pfaff's composi-

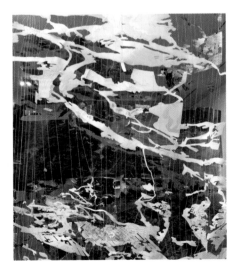

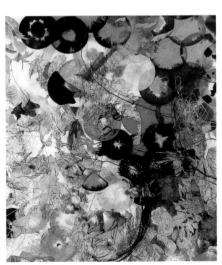

far left:
Fran Siegel, United States
Overland 5, 2008 (detail)
Installation at Ben Maltz Gallery,
Otis College of Art and Design
for *Looky See* exhibition
Graphite, paint, and colored
pencil on cut papers, Dura-lar,
string
Overall: 14 x 25 x 6 ft.
(4.3 x 7.6 x 1.8 m)
Collection of the artist

left:
Judy Pfaff, England/United States
Nature does not knock, 2008
(detail)
Folded and perforated Crown
Kozo paper, ink, dyed coffee filters,
wire, branch, plastic
Overall: 91 x 91 in. (231.1 x 231.1 cm)
Collection of the artist

tions are memorable not only for their dynamism and brilliantly modulated colors, but also for their impressive scale and complexity. Of late, she has focused on paper; true to her independent and idiosyncratic vision, she uses a wide range of paper, not only in sheets or rolls, but also in the form of coffee filters, repurposed origami objects, and filing folders. Pfaff is able to transform virtually anything, from precious to commonplace, into her raw material, a method that has been described as "Woolworth's meets Bauhaus."[25] While Pfaff's work is sometimes paired with that of installation artist Sarah Sze, Pfaff's approach is distinctive and recognizable in the density of surface she creates by layering her materials into three-dimensional appliqué or collage. Pfaff's recent explorations of paper continue her interest in merging the physical sensations of color, texture, and form with the subjective perception of space. The works are generally larger-than-life, immersing the viewer in an environment that, at first glance, appears chaotic, but which, with deliberate attention, begins to suggest its inner structure. The works reveal themselves as dance notation, each one depending on the choreography of

shape, color, and texture to achieve its purpose. Throughout, there is a sense of landscape and nature, induced by the brilliant colors of blossoms, as well as connotations of emergence, growth, and decay. One critic suggested that one "think of these intricate paper improvisations as cosmic landscapes."[26] Pfaff's work elicits strong emotional reactions that move it far beyond the standard definition of decoration, yet her creations are often whimsical and always jubilant. The ordinariness of paper feeds into the sense of engaged and attentive pleasure that defines *homo ludens* (man the player).

Michael Velliquette embraces the exuberance and innocence of the folk-art cut-paper tradition while creating works of theatricality. In recent years, Velliquette has also made large-scale installations and videos. He has found paper to be an especially responsive medium for his ideas. His cut-paper works are dense with color and texture, and his black and white studies made with graphite on paper are intricately detailed. Ceremonies and rituals are evoked through his shamanlike masks, depicted singly as full frontal portraits, or arranged in complex stacks to

create totems that Velliquette refers to as "towers." The titles given to the work underscore the anthropological and mythological aura they convey: *The Great Protector, Healer,* or *Happy Minotaur*. As a child, Velliquette assembled various found materials and used them to create highly personal "shrines" that expressed his own aesthetic and spiritual aspirations.[27] This practice led him to study the installations and interactive works of American artist Paul Thek (1933–1988), whom he credits as an influence and whose works have been called "psychedelic, irreverent, and mythological."[28] Velliquette's fanciful creatures, grimacing masks, and playful demons strike a careful balance between the playfulness of a naive artist and the elegant refinement of an accomplished virtuoso.

Shaul Tzemach of Israel, a painter, sculptor, and animator, uses cut paper to produce works that are as filled with detailed visual information as those of Aric Obrosey. The work of both artists demands the same careful examination to decode the intricate structures and complex iconographies. While Tzemach's works have a density of line and shape that recalls M. C. Escher's

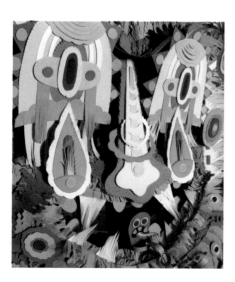

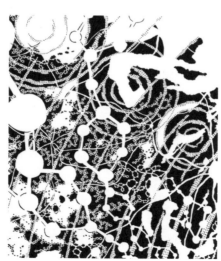

far left:
Michael Velliquette, United States
Tower 2, 2009 (detail)
Cut paper, glue
Overall: 72 x 24 x 3 in.
(182.9 x 61 x 7.6 cm)
Courtesy of the artist and DCKT Contemporary, New York

left:
Shaul Tzemach, Israel
CONCRETION/CONGLOMERATE,
2005–7 (detail)
Cut paper
Overall: 27 ⁹⁄₁₆ x 39 ⁵⁄₁₆ in.
(70 x 100 cm)
Collection of the artist

woodcuts from the 1920s, they also evoke the intricacy of the drawings of Andrea Sulzer. The hundreds of individual motifs and patterns that comprise these works resemble pen-and-ink drawings made with a micro-nib. Embedded in a skein of thin concentric circles are spirals that evoke whirling galaxies and disks reminiscent of crop circles. Organic and geometric forms are intermingled with strange hybrid creatures, with shapes that might be insects, birds, bats, roots, branches, or veins, all held in suspension in a celestial spider web. The designs seem to map the spaces of overlapping universes. Tzemach's *Legend of Species* offers a Rorschach-like recounting of the lineage of creatures from water to land to air. Other works, such as *CONCRETION/ CONGLOMERATE* shown in *Slash: Paper Under the Knife*, present a vertiginous complexity, a ponderous depth and density reminiscent of photographs taken through the Hubbell space telescope. This visual effect has more recently been translated in actual physical movement in Tzemach's experimental spinning cut-paper works. Recalling the kinetic spinning works created by Marcel Duchamp and Man Ray, these

works further the artist's vision of linking the external and the internal worlds we inhabit. They propose an alternative universe that unites body and spirit, inside and outside, time and space, in a seamless and ever-unfolding continuum. Tzemach's works fuse ancient, traditional, and mythical elements, such as trees, whirlpools, and animals, with contemporary secular and scientific elements, juxtapositions that describe the territory of the contemporary psyche.

CUTTING AS TOPOGRAPHY: EXPLORING LANDSCAPE

Paper is a highly flexible and versatile material in which to explore landscapes, both real and imagined. These artists approach it from diverse points of view, which include alterations to existing documents, such as maps—eradicating or deconstructing the "truth" they record—or creations of otherworldly and fictional three-dimensional geographies.

Doug Beube discovered paper as his medium of choice after having worked as a carpenter, learning to use of a wide range of carpentry tools, such as

saws, grinders, sanders, and drills. He applied this skill to his art, using bound books—atlases, novels, telephone directories—and transforming cultural artifacts concerned with knowledge into sculpture and installations that investigate perception, intention, and suppositions. Telephone directories were cut and then twisted into eccentric shapes as part of a wall installation for his Twister series (2002). In *Border Crossing* (2006), the pages of an atlas have been cut in half and stitched with zippers that permit endless variations of topography. For Beube, this process is the manual equivalent of cutting and pasting in a computer software program. Together they render the book illegible, disorienting, and fundamentally useless. Beube's altered atlases and maps, generically referred to as the Erosion series, are further modified with a belt sander that abrades small areas of a map, causing them to appear to have been chewed by insects or larvae. Each map is thus stripped of its practical function, challenging its validity as a useful document describing the world. These maps, including those in *Slash: Paper Under the Knife*, are made even more incomprehensible by layering one eroded page over another. The

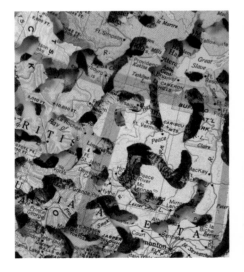

Doug Beube, Canada/United States
Eroding Continents, 2009 (detail)
Altered atlas
Overall: 12 ½ x 19 x 1 ½ in.
(31.8 x 48.3 x 3.8 cm)
Courtesy of the artist

eroded upper page permits glimpses of multiple layers beneath; a land mass appears to have a body of water in its center, while a territorial boundary mysteriously disappears into another landscape element. The individually altered pages are layered one on top of another to create a nonrational fictional world in which topographical elements, such as lakes, roads, and cities, can be glimpsed only as fragments. What had once been a rational and comprehensible depiction of reality is now illegible, disorienting, and fundamentally useless. In the artist's words, "each piece explores the reciprocity between meaning and structure as comprehended subliminally through the senses." These maps come to represent the frangible nature of political and territorial boundaries in the wake of political events and power shifts.

Chris Kenny cuts reality into fragments and reassembles and patches these fragments together to create new forms, new realities, and new meanings. While Kenny has worked with deconstructed/reconstructed maps for some time, he has also used fragments of texts. *Love Story* (2004) is a constructed collage comprised of found texts.

He extracted full and partial sentences from diverse sources and patched them together to create an atmospheric and poetic retelling of a relationship between two people. Kenny's map-based work also relies on cutting recognizable pieces of the topography from one or more sources. By bringing them together, he establishes the terrain of a heretofore unknown and unseen place. These works explore and interrogate the rational and irrational aspects of place and space. There is almost a quality of free association between the fragmented elements; large topographical features may share a border with diminutive architectural elements. Surprisingly, even though the eccentric juxtapositions that Kenny proposes may suggest the final triumph of chaos, there is an atmosphere of meditative calm that pervades the works, brought about in part by the archetypal mandala format the artist has chosen. The viewer is enticed into visiting a foreign, yet strangely familiar, land in the telescoped vistas that Kenny has created.

In her mysterious simulacra of weathered and eroded landscapes, **Noriko Ambe** maps a territory of both memory

and fantasy. Ambe's work is labor-intensive in the extreme; each sheet of paper (there may be thousands in a single work) is painstakingly cut by hand with a precision that imitates "some computer modeling apparatus that meticulously carved out the forms of climbing hillsides and plunging valleys." Embedded in Ambe's work is the unrelenting presence of time and the evolution of physical reality that takes place over time. Some of Ambe's pristine white landscapes are displayed as negative reliefs on the wall, or they may appear as three-dimensional organic forms displayed horizontally. Ambe's signature works are the multi-layered paper landscapes she has fitted into the drawers of commercial filing cabinets. Each drawer can be pulled out to provide a glimpse into the depths of the valleys, canyons, and arroyos that the artist has so meticulously created.

Ferry Staverman works in a variety of mediums including gouache drawings made sequentially as a journal or diary. The imagery Staverman creates is most frequently based on the human figure, which often appears as a highly stylized bilaterally symmetrical study of the body, body parts, and internal organs.

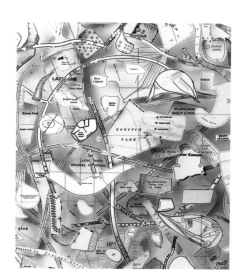

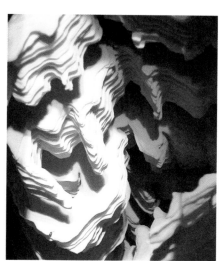

far left:
Chris Kenny, England
Nonsuch (White Map Circle), 2007 (detail)
Construction with map pieces
Overall: 24 x 24 x 3 in.
(61 x 61 x 7.6 cm)
Courtesy of England & Co.

left:
Noriko Ambe, Japan/United States
FLAT FILE GLOBE 3A RED VERSION, 2007 (detail)
Cut Yupo, metal cabinet, Plexiglas
Overall: 37 x 13 ¾ x 18 ⅛ in.
(94 x 34.9 x 46 cm)
Courtesy of the artist

Staverman's work in paper expands the idea of symmetry into a three-dimensional mode; he creates landscapes of stylized plants and figures made of precisely cut sheets of cardboard, arranged in radially symmetrical order. The works at first glance evoke the mundane expandable honeycomb paper decorations sold in stationery and party supply shops. Closer examination, however, reveals them to be elegant, evocative, stylish. Their profiles, made up of subtle convex and concave curves, evoke the complex curves of extraordinary seventeenth-century ivory turnings, which were produced and collected as examples of virtuosity. Like Rorschach blots, Staverman's forms take on the image projected onto them by the viewer—they may be figures in regalia, exotic trees, fountains, or cacti—in the same way that landscapes are given emotional and spiritual meanings and serve as referential metaphors for the human condition.

Daniel Alcalá draws inspiration from the urban landscape of Mexico City and environs. It has provided a rich repository of industrial imagery—the water towers, bridges, antennae that inhabit the city—as has the complex and often chaotic grid of streets that make up industrialized cities. Like many artists that have turned to cut paper as one of their primary mediums, Alcalá is also a painter. His precise and graphic style of cutting, following the traditional silhouette format, presents industrial and urban structures that are rendered in a rich velvety black graphic against a stark white background. He creates a "dazzle" effect that is seen in reality only when the brilliant skies of dawn or dusk completely erase details and flatten three-dimensional forms. It is the cutting technique, which produces a razor-sharp edge, that accommodates the artist's quest for perfect lines. Alcalá's urban world is familiar, yet unsettlingly strange, as if these artifacts of industry, commerce, and communication have shed their original purpose and remain as haunting specters of the passing of time. The hybridization of the manmade and nature is probably most dramatically expressed in his intricately cut depictions of cellular telephone antenna towers disguised as living trees, his distinctive "conciliation between nature and the artificially created panoramas."

Béatrice Coron's work is at once epic and intimate. The scale ranges from tiny books to cut Tyvek panels up to 50 feet long. Her work frequently takes the form of a series of vertical or horizontal panels informed by a work of literature from which she extracts ideas that are materialized as cross-sections through environments. The series titles often provide clues to the motifs and the iconographical program: *Habitats & Vagabonds*, *Personal Cities*, or *Inner City*. In *Personal Cities*, the artist created a series of visual essays on what would be the essential elements of a single person's life that would be found in their "personal" city. The structures in her environments, whether domestic residences, butcher shops, schools, or graveyards, are populated with hundreds of figures engaged in their daily lives. These anonymous inhabitants read, eat, and die; they also float in the air, swim underwater, and hang from clouds. The cut figures evoke the long tradition of folk-art papercutting. Coron's command of gesture, topographical details, and nuanced narrative are both alluring and compelling. Her work for this exhibition is a site-specific installation within the floor-to-ceiling windows of two floors of the museum.

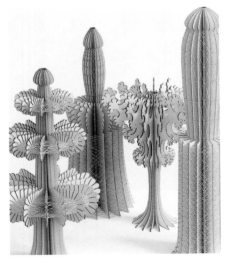

far left:
Ferry Staverman, The Netherlands
Trees and Penises on Stumps,
2006–8
Cardboard, thread, paint
Dimensions variable
Collection of the artist and
T. Renes

left:
Daniel Alcalá, Mexico
Técnica No. 31, 2007 (detail)
Graphite on paper cutout
Overall: 33 ½ x 43 ½ in.
(85.1 x 110.5 cm)
Courtesy of Arróniz Arte
Contemporáneo, Mexico City

Coron's imaginary landscapes take the visitor on a tour of *HEAVENS* on the upper floor, and of *HELLS* on the lower. The figures in each are involved in nearly identical circumstances and actions; whether or not these actions direct one to either heaven or hell is determined by the final results they induce, beyond the individual control of the participants.

Nina Katchadourian has explored landscape through the medium of maps for over twenty years, beginning in 1989 when she cut apart a map of the world and rearranged the isolated continents into a new configuration in which and masses separated by great distances—Alaska and Australia, for example—fitted neatly into each other. The eccentric logic of this reconstruction of the world is typical of Katchadourian's artistic vision that upends expected relationships, hierarchies, functions, and meanings. One writer has described the artist as "a connoisseur of ingenious but doomed arrangements, senseless hierarchies, crackpot taxonomies."[32] The surprising and perplexing visual and intellectual exercises she puts her viewers through are like reality stress

tests: she has mended broken spider webs with red thread and glue— *Mended Spiderweb #19 (Laundry Line)* (1998)—only to have them rejected and reconstituted by the spider and subsequently recovered by the artist, to be presented as *Rejected Patches, Mended Spiderweb #19 (Laundry Line)* (1998). Her pas de deux with the spider pits human rationality and intention with the equally determined logic of nature. She has programmed a popcorn popper to translate the sound of popping kernels into unintelligible Morse code (*Popcorn Journal,* 2001) and has rearranged the contents of a library so that book titles on the spines create running sentences with their own internal logic: "Primitive Art/Just Imagine/Picasso/ Raised By Wolves" (*Sorting Shark* [from the Sorted Books project], 2001), revealing the books to be "in secret narrative collusion."[33] In Katchadourian's reconstructed worlds, order is recognized, manipulated, and reconfigured, not for purposes of distortion alone, but to focus attention on the ways in which knowledge is gathered and interpreted. These "deliberate attempts to observe, scrutinize, order, and disorder her surroundings"[34] are effective in engaging the viewer with wit and chutzpah.

They thus challenge complacency and unquestioned beliefs. Travel routes on maps, whether of road systems or subways, are bundled into new evocative forms, such as those extracted from a road map of Austria and reformed into the shape of a heart (*Austria,* 2006) or the New York subway system (*Hand-held Subway,* 1996). These works, as well as *HEAD OF SPAIN,* shown in this exhibition and suggestive of a bull's head, are configured as tangible artifacts—a bundle of now meaningless disembodied paths—as well as cibachrome prints of the artifact. Shown together, artifacts and images establish a visual and intellectual repartee that underscores the collapse of reason, and its replacement by emotional and new insight.

Studio Libertiny was founded by Tomáš Gabzdil Libertiny in 2006 in Rotterdam, the Netherlands. Nature in general and the relationships between nature, culture, and design have been foremost in Libertiny's innovative and experimental work. He has explored aspects of nature in a direct and unexpected manner, as in his landmark *Honeycomb Vase* (2007). To create this work, Libertiny molded a large-scale

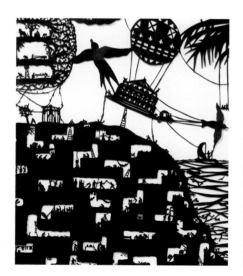

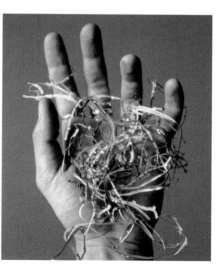

far left:
Béatrice Coron, France/
United States
Habitats & Vagabonds, 2007
(detail)
Cut Tyvek
Overall: 45 ½ in. x 27 ft.
(115.6 cm x 8.2 m)
Collection of the artist

left:
Nina Katchadourian,
United States
Hand-held Subway, 1996
Cibachrome
19 x 13 in. (48.3 x 33 cm)
Courtesy of the artist; Sara
Meltzer Gallery, New York;
and Catharine Clark Gallery,
San Francisco

classically inspired vase armature of beeswax, upon which a swarm of tens of thousands of living bees built their honeycomb. He referred to the process as "slow prototyping."[35] Libertiny's dialectical exploration of nature and culture continued in *THE PAPER VASES* (2007), shown in this exhibition. Originally created as part of a performance piece at Design Miami in Florida, the work was informed by the designer's belief that wood is the material most often associated with nature in modern and contemporary design, and that the physical and cultural extension of wood is seen in the material of paper.[36] For the vases, Libertiny printed reams of paper with the identical image of a tree, laminated the images together into a solid block, and then turned the block on a woodturning lathe to create the vases. The turning technique exposed a small section of the printed image of each tree, creating the surprising effect of revealing the image of the complete tree on the exterior surface of each vase. In effect, this represents the circular transformation of wood into paper, paper laminated to create a simulacrum of wood, which was then turned to reveal the image of the original source. Libertiny continued

this kind of exploration in *Writing Table No. 3*, which was composed of 22,000 strips of paper stacked horizontally and sanded to create a velvety writing surface. Libertiny's designs explore landscape in its broadest definition as a locus for the intersection of culture and nature, a reunification of the subjective meaning of landscape and the objective reality of place.

FORM AND SPACE: SLICING ARCHITECTURE

Architect Frank Gehry is quoted as saying, "Paper is structure. If I can make it out of paper I know I can build it."[37] Several of the artists in *Slash: Paper Under the Knife* establish a visual and intellectual dialogue with architecture —as form, as space, and as social and cultural environment.

Jane South's *Working Drawing* (2002), installed at MASS MoCA, North Adams, MA, comprised a 90-foot-wide wall composition painted a garish industrial orange. Schematic drawings of wheels, gears, grids, and push buttons emerged from the wall in three dimensions. These mutant mechanisms, paper simulacra of metal machines, began

to take over South's painted surfaces; the fine drawn lines and bold painted colors on the walls were transferred to the machines themselves, creating the effect of illusionistic shading that further defined her forms while making the surfaces appear like engraved images of machines. South has continued to respond to the industrial landscape she observes and analyzes: "her work speaks to the interconnected, sprawling nature of our modern environment."[38] Her landscapes of mysterious and sometimes threatening machinery are silent and abandoned. They confound rational understanding of their purpose, while engaging us with their lacelike structures and often surprising colors, ranging from rusty browns and sooty grays and blacks to depressing dusty pinks and sallow greens that recall public schools and hospitals. By 2004, South's fully formed contraptions began to function as extrusions from and intrusions into architecture, as seen in her *Untitled (Double Cut Wall)* at Spencer Brownstone Gallery, New York. The work intersected the gallery wall to create a visual dialogue between structure and space. This concept has been fully realized in her current installation; an imposing wall of machines

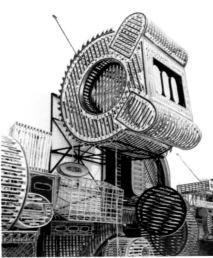

appears to have entered the museum gallery by way of a vertical window slot, providing a barrier wall while also permitting fragmented views of the space through the gridwork of struts and structures the artist has created.

Danish-Icelandic artist **Olafur Eliasson**, internationally recognized for the dramatic experiential installations he has created, engages the viewer on both spatial and temporal levels. The visual impact of his work derives from scale—he often works in such vast spaces as the Turbine Hall of the Tate Museum in London (*The Weather Project,* 2003) or in extended urban settings, such as New York's East River (*The New York City Waterfalls,* 2008), but also from the intensely visceral experiences that he creates through light and atmosphere. Seeing and perceiving are tandem behaviors, each susceptible to the influence of both subjective and cultural memories. Negotiating a territory between the subjective and the objective requires an immediate, and in some instances innocent, experience of space, light, time, and atmosphere made possible in the settings and environments the artist creates. Viewing as a passive behavior is transformed in

these works into an active experience, ranging from the visual and tactile quality of water mist that creates iridescent, ever-shifting rainbows (*Beauty,* 1993) to projected simulations of rippling water induced by the footsteps of viewers as they walk across the gallery floor (*Notion Motion,* 2005). The responsibility for both seeing and experiencing is given over to the participant; Eliasson's ongoing explorations of the relationship between his art and those who experience it was succinctly summed up in a series of exhibitions that began with the possessive pronominal adjective "your." *Your Foresight Endured* (Milan, Italy) was followed by many others, such as *Your Windy Corner* (Stockholm, Sweden, 1997), and most recently, *Your Mobile Expectations* (Munich, Germany, 2008). In 2007 Eliasson created *YOUR HOUSE*, a 454-page book with a laser-cut interior of the artist's house.[39] The negative space defining both the exterior and interior of the house permits the reader to "walk" through the house as each page is turned. The interior includes such details as fenestration and ceiling decoration. As with Eliasson's other works and installations, space is modified into experience; the tour through the house is both visual,

and mental. The process of entering the book is made possible only when the reader is physically engaged. The work multifunctions as an art book, a work of sculpture, and an experience that becomes a memory marker of space and time.

Peruvian artist **Ishmael Randall Weeks** interweaves architecture and landscape, themes of migration and transportation, and the persistence of memory in his work. He explores a range of found, repurposed, and recycled material, from lumber, rubber tires and boats, and metal machinery parts to stones, bricks, and live plants. Cutting is a primary technique, whether as shredded, cut photographs, or carved books. Migration imagery abounds in Randall Weeks's sculptures and installations. *Saddle* (2009) consists of a rubber saddle without a horse, held together with zip ties and suspended above a blanket of splayed automobile tires. The juxtaposition of the outmoded means of travel by horse and the useless automobile tires is both ironic and poignant. The reassurances of the physical world are called into question with particular focus in his works based on the material culture of the built environment.

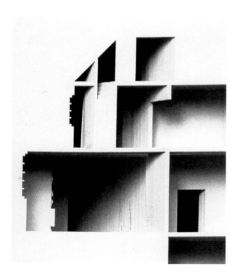

Randall Weeks has produced a series of works as tributes to the visionary architect, artist, and thinker Lebbeus Woods. Photo-transfer drawings of Woods's interiors, structures, and spaces are cut with angular lines and backed with white paper to create resonant forms in negative that intersect and reorder the original images. In *Macchi* (Plans) Randall Weeks uses a set of architectural plans, from which he has cut virtually all of the paper away leaving only the printed lines that once described the building, in a manner similar to the work of Adam Fowler. Rather than displaying the plans flat, however, Randall Weeks simply hangs them from a nail on the wall. Flaccid and limp, these shredded plans are like a worn item of clothing. Space that was once inhabitable and functional is impotent and meaningless.[40] In *LANDSCAPE* a steel table supports a deep stack of architectural plans. The layers of paper have been carved away to create a ghostly landscape that recalls the mysterious terrains of Noriko Ambe, but with the added element of the architectural language embedded in it. Legends can be read here and there on the carved plans. The structures that the plans once described in precise

detail have eroded into sedimentary layers that describe both nature and memory. There is an aura of loneliness and wistfulness that pervades the work and suggests the fleeting and purposeless activities that people undertake to give form to the environment.

London-based **Saraben Studio** (**Sara Shafiei** and **Ben Cowd**) use the laser cutter to construct complex baroque structures in three-dimensions. *THEATRE FOR MAGICIANS* is a fantastical structure planned for the National Botanical Gardens in Rome. The intricate organic and geometric forms that merge in this design evoke a sense of wonder and fantasy, while creating spaces that deal with the practical needs of a theater for projections, performances, and illusions. The design is convoluted and dynamic, a supple and muscular skeletal structure. *SOLAR TOPOGRAPHIES* is a bound book containing a laser-cut architectural plan of multiple layers. The design was for an observatory that overlooks the ruins of the Palatine in Rome. The plan for the observatory is informed by the architectural ruins of its setting; multiple laser-cut layers are presented in the manner of an architectural excavation.

The technique of laser cutting permits Shafiei and Cowd to create precise contours and surfaces. The building is also planned to function as an eternal clock and calendar, tracing the passage of time in light and shadows that change throughout the year. Steps represent the days and the months, stones represent minutes, and lines stand for the seconds.

Tomás Rivas works directly on panels of commercial drywall, cutting into the paper surface and selectively peeling it back to create three-dimensional shapes informed by architecture and architectural ornament. The curled papers released from the gypsum core create shadows that suggest an even greater depth to the surface. Rivas quotes liberally from the vocabulary of historical architectural ornament. It is, however, architecture captured in the humble medium of paper-covered plaster board, a contrast of intention and application that "conveys a sense of the conditional, relative, and ephemeral. It cloaks those postmodern ideas in the classical vocabulary of the monumental, the unchanging, and the timeless."[41] Rivas is able to achieve a tension between two- and

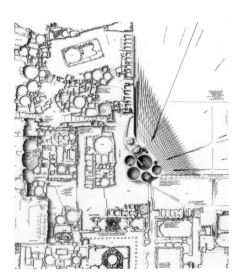

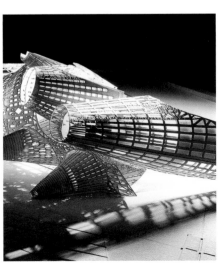

far left:
Ben Cowd, England
SOLAR TOPOGRAPHIES: PLAN, 2007 (detail)
Laser-cut watercolor paper
Overall: 23 ¼ x 33 ⅛ in.
(58.9 x 84 cm)
Collection of the artist

left:
Sara Shafiei, England
Sectional Model, *THEATRE FOR MAGICIANS*, 2007 (detail)
Watercolor paper
Overall: 27 ⅝ x 39 ⅜ in.
(70.1 x 100 cm)
Collection of the artist

three-dimensional representations of architecture, playing with our perception of space, depth, and light. His new work for *Slash: Paper Under the Knife*, is an on-site installation based on the extraordinary *Apotheosis of St. Ignatius* painted by Andrea Pozzo on the ceiling of the Church of Sant'Ignazio in Rome. The impressive trompe l'oeil effect achieved by Pozzo is recast by Rivas as a ghostlike shadow theater. Typical of Rivas's approach is his use of a specific building, interior, or architectural fragment. The monumental character of his source and the ephemeral nature of the cut paper become relative terms in a dialogue between past and present, memory and vision, and between the real and the imagined.

The poet Samuel Taylor Coleridge wrote about the willing suspension of disbelief that permitted a reader to fully participate in a piece of literature, regardless of how fantastic the subject might be. Willing suspension of disbelief changes the nature of how one experiences theater or film, allowing the viewer to silence the rational parts of the mind, the parts that recognize that it is not reality unfolding on the stage or screen. Paper is used

by **Thomas Demand** to create environments, spaces, and furnishings he constructs in real scale, then photographs, and destroys, leaving behind only the photographic image of what once was. We want to believe that these environments are real, but the artist is not content with effect alone. Demand's environments seduce us into a state of disbelief and then slowly question our perceptions—the more intently one studies Demand's photographs, the less "real" the images become. The effect over time has been referred to by one critic is of "clinical detachment."[42] For Demand, "photography is less about representing than about constructing its objects. I think that is one of the central points of my work: to reconsider the status of the image by producing one particular moment of perfection."[43] The vacant and silent interior spaces Demand feed the intense dis-ease felt when looking at them.[44] His scenes are often based on mundane journalistic photographs culled from the popular press. The spaces or interiors of themselves are in general unremarkable, made meaningful only through their association with a newsworthy individual or narrative. Demand has created and photographed the kitchen used by

Saddam Hussein while in hiding, the room used to plot the assassination of Adolf Hitler, a Munich hotel bathroom in which a German politician was found dead. Demand's *SHED* is featured in this exhibition. The eerily empty space is based on a newspaper photograph of the country building in Sicily in which the notorious Bernardo Provenzano of Corleone, head of the Sicilian Cosa Nostra, was finally apprehended in 2006 after more than four decades in hiding. The banality of this vacant interior is matched only by the banality of the method of his capture; the police tracked the delivery of his laundry from his family home to the shed in which he was living.

CORPOREAL CONCERNS: REVEALING THE BODY

The human figure has functioned in the work of many artists using cut paper. The physical properties of paper—its flexibility, thinness, and fragility—are metaphors for the skin that covers our bodies.

Having begun his career with the intention of being a painter, **Oliver Herring** today is most accurately described as

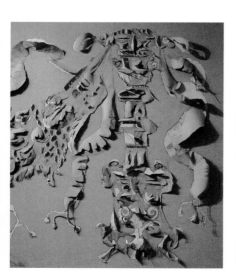

a multimedia artist who has created an impressive body of work in video, sculpture, photography, and performance. The conceptual foundation of his art is buttressed by the artist's long-standing interest in both materials and process. In the 1990s, Herring taught himself to knit, which allowed him to combine practice, performance, and production. Herring's best-known works in this decade were a series of blankets and coats knitted of transparent tape and Mylar in memory and honor of the New York drag legend, performance artist and playwright Ethyl Eichelberger, whom Herring credits as a profound source of inspiration. Herring favors labor intensive, hands-on practices to make his art; he chose the traditional handcraft of knitting because of its repetitive, time-consuming, and contemplative nature, which he described as "slow, incremental and most importantly, mindless," giving him the "time to think and figure things out."[45] In 2004 Herring moved into a completely different arena that made use of his talents as a photographer but nevertheless demanded exceptional dedication to the standards of handcraft. This brought papercutting into the foreground of his work. He

created *Patrick* (2004), the first of several three-dimensional photographic portraits comprised of hundreds of individual closeup photographs of every square inch of his subject's body. The individual photographs were printed at life size, cut into even smaller fragments, and painstakingly applied over a styrofoam underbody that echoed the sitter's form. The process demanded the time and intense concentration most frequently associated with putting together a jigsaw puzzle or intricate patchwork quilt. The result was a dimensional photograph that documented the actual flesh of the subject with uncanny realism and unsettling accuracy. The entire process placed the artist into a much different relationship with his subject than is generally the case in traditional portraiture. He commented that "at the end of the day I know their exterior bodies better than they do. Think about it, you never actually see your back. Our notions of ourselves is so dictated by two-dimensional mediums—film, photographs, the mirror—that we never actually see ourselves as a whole in three dimensions."[46] While the photorealistic portraits may superficially be compared to works by such artists as

Duane Hanson or Ron Mueck, who also create works that are at once realistic and entirely artificial, Herring's work exists in a strange psychological limbo of the credible and the incredible. The effect is what one writer associates with Freud's concept of bewilderment—a dis-ease "generated by our encounter with objects that manifest qualities of the animate and inanimate simultaneously. . . . And it is this friction between the organic and the inorganic that is responsible for the work's palpable uncanniness."[47] For *Slash: Paper Under the Knife*, Herring has created a figure that has had an additional element added to the photographic assemblage: the closeups of skin and hair of the model are printed in vivid colors—blue, aqua, rose, yellow, green—and the pieces cut into strict geometric forms. The resulting figure still has an uncanny presence and realism, but one that is further removed, even from the realm of the incredible, with the addition of color and the crystalline geometry of the individual cuttings.

Anne-Karin Furunes's work, at first glance, appears to be a photograph; most frequently the image is an extreme closeup of a male or female

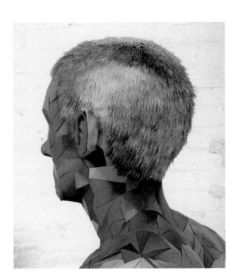

face. As one approaches the image, however, it begins to fade and ultimately disappears as the viewer becomes visually aware of the plain black surface of the paper. What had been an easily recognizable visage is seen to be a sheet of black paper (or canvas) punctured by hundreds of small holes. The effect is dependent upon light transmitted through the holes from behind the sheet; without light the image is nearly invisible. The punched holes vary in diameter; together they are able to create the illusion of highlights and shadows and thus define the form with astonishing accuracy. While based on actual photographs, the works are entirely hand punched. The artist has used photographs of named contemporary figures in Norway and China, but also photographs of anonymous individuals, including a group of faces collected as part of a racial genetic study from the 1920s to 1940s. Furunes touches upon issues of memory on many levels in these works; the ghost-like faces are simultaneously engaging and inviting, detached and distant.

If, as Aristotle claimed, wit is educated insolence, **Tom Friedman** deftly and intelligently brings high seriousness and ironic humor together in sculptures made from materials that range from aspirin tablets, soap, and styrofoam to toothpaste, yarn, apples, and Play Doh, materials that are so insolent, eccentric, and astonishing that they suggest the accidental more than the intentional. However, the works demand that the viewer confront both the means and the methods of the artist simultaneously. In Friedman's works, the medium is the message, but so too are the artist's methods, which critic Arthur Danto has referred to as "a kind of artisanal perfection . . . as if their maker had spent an entire career mastering these ordinarily intractable substances."[48] In certain instances, Friedman's subject matter is the material, such as his *Pencil Shaving* (1992), a single pencil pared into an unbroken spiral pendant, or *Memory of a Piece of Paper* (1994), shreds from a single sheet of paper arranged on the floor around a negative image of the original sheet. The artist returns to paper time and time again, each time discovering and exploiting new aspects of the material. Paper has been crumpled, pulped, rolled into a cylinder, stuck with pins, cut into hundreds of tiny pieces to be reassembled as a new object, and used in a number of figural works. *Untitled* (2000) is a cut and assembled self-portrait with body parts violently separated, lying in a splattered pool of red paper blood. *QUAKER OATS* is an upwardly mobile box of the iconic breakfast cereal, identified with American virtues of thriftiness, simplicity, and wholesomeness. The box, however, is distorted into a tumescent column; the dynamism of the gesture is captured in the blurred fragments of text, color, and imagery that create a sensation not unlike that of a migraine headache.

In 2005 **Tom Gallant** created the first in a series of works under the general title of The Collector, referencing Arts and Crafts luminary William Morris's wallpaper patterns and the collecting of pornography. Gallant's cut-paper works are made from the pages of pornographic magazines; they have been cut with the same precision as Japanese *kirigami* cutting to fragment and obscure the colored images. Gallant has created works inspired by Morris's *Golden Lily* wallpaper, as well as by carpets designed by the influential thinker who wrote a new chapter

in the history of the decorative arts. Wallpaper also serves as a provocative metaphor for skin—the human flesh depicted in the pornography is both revealed and disguised. For this exhibition, Gallant has created a work that merges the *Golden Lily* pattern with the image of a rose window from a Gothic church. The effect is to contrast the stylized organic plant forms with the geometricized nature of the rose window in a way that breaks up the recognizable patterns of each. The rich colors of the pornography provide a palette similar to that of medieval painters and illuminators, but also one of flesh and earthly delights. Sex, sin, memory, and redemption amalgamate in this work.

Throughout the career and work of **Lesley Dill**, the human body and language have been inextricably linked in a sensual and spiritual mode. It is a unity that the artist has explored in many different modes: video, performance, photography, installations, prints, drawings, and sculpture. Dill's unrelenting aspiration to achieve a synthetic unity between language and the body in her art and in performance have logically led her to conceive and produce her

2008 opera, *Divide Light*, a multilayered performance based on the poetry of Emily Dickinson, to whom Dill frequently returns for inspiration. It was language that opened up the most fertile and productive avenue for the artist: "It was such a relief when I found my way to using language in my work because my whole life it felt as if language was tangible, not some vaporous, whimsical thing that evaporates the moment it is out."[49] As language is most often encountered as printed text on paper, Dill's choice of paper as her major medium is not surprising. Dill's relationship to the paper is constant and ever evolving. Art historian and curator Nandini Makrandi Jestice explained that "for Dill, paper is metaphor for the human condition, seemingly fragile, yet malleable and strong."[50] While Dill has worked in a wide variety of materials, ranging from steel and bronze to organza and horsehair, it is in her works made of paper that a unique synthesis of language and vision triumphs. In *Small Poem Dress (The Soul Selects . . .)* (1993), Dill inscribed a diminutive bodiless dress with the lines of poetry taken from the pages of Indian newspapers. This was followed by variations on the concept of clothing, specifically

dresses as "psychic skins" that protect and reveal the wearer at the same time.[51] For this exhibition, Dill made a new work titled *BLIND HORSEMAN*, inscribed with Emily Dickinson's line "there is a word that bears a sword." Dill tends to use fragments of text, as in this work, to "remove the words from their original linguistic context, . . . embedding them in an imagistic one."[52] For her, language is that sightless bearer of intentions, whether benign or malevolent, nurturing or ruthless. A horse and rider serve as metaphors for paper as the bearer of language; the creative and destructive nature of cutting is symbolized by the large pair of scissors the rider carries.

Kako Ueda uses cut paper as an investigative and illustrative tool for examining the relationships between nature and culture, their conflicts and their interdependencies. For Ueda, paper is in itself a metaphor for the relationship between the two—nature in the form of trees or plants is destroyed to make paper pulp, but it is also resurrected in the final product. Contrasts and conjunctions permeate her work at many levels, ranging from grand themes such as life and death, science and art,

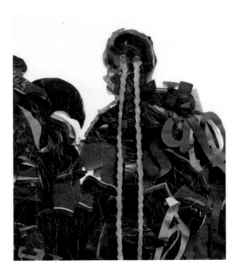

to more intimate and psychological concerns of body and soul, internal and external states of being. Growing from these investigations is Ueda's engagement with hybrid forms that often result from these pairings. She recalls the Japanese *katagami* tradition of cutting stencil patterns in her finely cut two-dimensional works, not only in her technique but also in her imagery which, like many *katagami* stencils, is inspired by nature in the forms of flora, fauna, and landscape. Ueda's *Eros and Thanatos* depicts a death's head literally and figuratively crawling with life in the form of spiders, moths, and other insects, many of which derive their life through the death of their prey. Writhing snakes, bird feathers, and psychedelic-patterned eggs create a theatrical headdress for the skull. The large-scale two-dimensional cuttings eventually found their way into site-specific installations that covered entire walls and floors, such as *Totem*, an assemblage in scarlet which filled a gallery corner with an horrific mixture of imagery—detached eyeballs leaking blood, figures cavorting with animals, blood-vomiting heads, and skulls, moths, and bats arranged as a vertical totem. There are moral lessons and

warnings embedded in Ueda's work, compelling us to consider the consequences of our inability to unite nature and culture fully. For *Slash: Paper Under the Knife*, Ueda has cut *RECIPROCAL PAIN*, an oversized figure that appears to have been flayed and eviscerated, its intestines transforming into a serpent, with arms and legs becoming exposed veins and nerves that evoke patterns of rivers and root systems. The androgynous figure functions as a metaphor for nature in peril, threatened by human beings. The delicacy and decorative nature of her cut forms belie the unsettling psychological trauma of the imagery. It is a macrocosm of conflicts between nations, cultures, and religions, and the reciprocal pain inflicted as a result of conflict, but also as a microcosm, a "scenario for personal relationships—between lovers, parent and child, or siblings. It requires tremendous determination and compassion to get out of the vicious cycle of pain. The figure was also inspired by imagery of people in pain, such as saints and martyrs, as well as by the dissected bodies in medical books."[53]

DISSECTING THE PAST: MYTHS AND MEMORIES

Paper is used with language to record our histories, thoughts, concerns, and aspirations. Paper is also used as a raw material for artists who address topics that revolve around our pasts—our beliefs, cultural mythologies, and personal memories.

Chris Gilmour's sculptures made from cardboard often reproduce in full scale the monuments and trophies with which we define our lives and our relationships to time, space, and history. Gilmour has created cardboard simulacra of such prized possessions as an Aston-Martin automobile, complete in every detail inside and out, a Harley-Davidson motorcycle, or a grand piano. The monetary and emotional value of these objects is evoked, and yet denied, by the ordinary packing box cardboard from which they are constructed. They are commonplace, yet richly endowed with unspoken narratives of the individuals for whom they were significant; they are objects that are "carefully chosen for their evocative and conceptual power, for the potential for mnemonic narration they contain. They offer a blank canvas upon which the

Chris Gilmour, England/Italy
Aston-Martin DB5, 2004 (detail)
Cardboard, glue
Life-size
Courtesy of Perugi
Artecontemporanea, Padua, Italy

viewer can project their own memories or experiences."[54] Gilmour has also dealt with shared cultural myths and histories in the form of re-creations of monuments and commemorative sculpture that address issues of power and dominance, such as equestrian monuments that honor military leaders. Another large-scale cardboard sculpture reproduces the well-known monument to Queen Victoria in front of Buckingham Palace. For *Slash: Paper Under the Knife*, Gilmour responded to the Museum's setting on Columbus Circle, in the center of which is the monument to Christopher Columbus (1892) by Italian sculptor Gaetano Russo (b. ca. 1852). Also on the circle is a 1913 monument by Attilio Picarelli (1866–1945) that honors the memory of 260 sailors killed in the explosion of the battleship *Maine* in Havana, Cuba. A figure of Columbia Triumphant symbolizes the dominant position of the United States at the beginning of the twentieth century. For the exhibition, Gilmour has created a cardboard version of *ST. GEORGE AND THE DRAGON*, an image of the struggle between good and evil.

Andrew Scott Ross imagines scenes from prehistory, ghostlike images cut from ordinary office paper. Dozens, in some cases hundreds, of figures and animals populate his landscapes made of crumpled sheets of paper. For this exhibition, Ross has created a new work, *STONES AND ROCKS AND STONES AND BONES*. The title derives from Ross's continuing interest in the intersection of nature and culture and the evolutionary changes brought about in each as a result of this intersection. In this monochromatic tableau, hundreds of one-inch-tall figures, each a representation of the artist's own body, are depicted in a variety of rituals—celebratory festivals, games, work, warfare, and sexuality. Each of the figures in a cutout reappears as a negative in the crumpled paper from which it was cut, and as both shadow and light projection, a metaphorical strategy for the physical presence of the body, memory, and self-projection through art. Ross takes the viewer on a tour of an archaeological site that bears the traces of both culture and nature by way of this poetic metaphor.

Lu Shengzhong's works in cut paper are inhabited by thousands of small red archetypal human figures standing spread-legged and with arms raised heavenward. The figures float in space or cascade into deep clusters; they are universal, timeless, and a metaphor for Everyman.[56] Lu's intensive study of Chinese cut paper—undoubtedly the oldest of the cut-paper traditions worldwide—and Chinese folk-art traditions informs both his aesthetic and his method of working. Each of the diminutive, stylized figures is cut by hand with scissors or scalpel. The figures are based on the popular Chinese folk culture's *zhuaji* doll, a venerable symbol of fertility and increase.[57] At their core, the artist's assemblages of little red figures connote an ancient lineage of culture and spirituality. The figures are identical in size, shape, and color, suggestive of the vast number of individuals who have peopled the earth over millennia. They are fragile and ephemeral, much like the thin tissue paper from which they are cut. Lu's *HUMAN BRICK II*, shown in this exhibition, consists of a triangular assembly of red tissue-paper figures, some of which have floated upwards, freed from the mass that has formed below. The densely layered figures are evocative of the pedestrian traffic on the streets of

far left:
Andrew Scott Ross, United States
Rocks and Rocks and Caves and Dreams, 2007–8 (detail)
Gray paper
Dimensions variable
Collection of the artist

left:
Lu Shengzhong, China
HUMAN BRICK II, 2004 (detail)
Cut paper, Plexiglas, silk thread
Panel: 39 ½ x 60 x 3 ⅛ in.
(100.3 x 152.4 x 7.9 cm)
Brick: 4 ¾ x 9 ½ x 3 ⅛ in.
(12.1 x 24.1 x 7.9 cm)
Private collection; courtesy of Chambers Fine Art

global cities such as Beijing. The anonymous thousands of individuals they represent were cut from a single block of tissue the size of a standard building brick. The negative spaces left by the cutouts in the brick suggest the shadow memories of the past. Lu's works offer a delicate balance between the sacred and the spiritual.

The Romanian artist **Andrea Dezsö** works in a broad range of mediums that include graphic design, video, book making, embroidery, and cut paper. She draws upon personal childhood memories from Transylvania, family lore and legend, cultural mythologies, and the subconscious to create her compelling, frequently unsettling works. Her videos often explore the dark side of dreaming—themes of fear, loss, and loneliness—with titles such as *Nightmare with Insect* or *Nightmare of Chase*. Dark themes, however, are not the sole substance of her personal narratives. She has also created a poetic video titled *Heart*, a kaleidoscopic meditative essay in blue and white based on her experience in Japan, learning to dye fabric with indigo. Dezsö has made a specialty of Tunnel Books, five-layered accordion-pleated constructions. Each

layer in the tunnel is cut and painted to create three-dimensional compositions that recede in space, much like the sets of a traditional proscenium-arch theater. *For Slash: Paper Under the Knife*, Dezsö has made thirty Tunnel Books, each presenting a scene composed of "archetypal characters engaged in mysterious and symbolic activities that are seen but not explained."[58] The imagery is simultaneously engaging and disturbing; the refined details and vivid colors of her painted images evoke the intimacy and precision of the scenes in an illuminated manuscript. The narratives revolve around childhood fears that linger into adulthood. In one book, an intense young woman, presumably a self-portrait, sits primly behind a drawn curtain, her innards exposed to reveal her heart and veins, and her other organs transformed into strange mutant plants. In another, an arm holding a severed hand above a tree-stump-cum-chopping-block emerges from a cluster of dead trees; another arm, brandishing a rusty knife, has just lopped off a finger from the disembodied hand. Another book in the series records a young woman falling from a construction site. A child lost in an abandoned amusement park is the

subject of another. A green, outer space alien haunts a leafless vineyard in a fourth book. The atmosphere of surreal angst created in the books is intensely personal to the artist, informed by her personal narratives, obsessions, and fears. They are also, however, shared archetypal images that elicit equally personal memories and reflections from the viewer.

Memory, the wistfulness of time's passage, and an embrace of people's foibles and frailties have marked the work of **Nava Lubelski** over the past decade. She has worked in diverse materials and techniques ranging from embroidery to papercutting in the creation of works embedded with personal historical narratives. Lubelski's best-known series of embroidered works consists of found linens, tablecloths or fabric swatches that have been compromised by stains or rips, records of unfortunate and, one assumes, unavoidable accidents. Lubelski delineates the flaws by carefully embroidering their outlines, embellishing their damaged eccentricities. Three years ago, she began working with memories recorded on paper. *Tax Files* were assemblages of cut

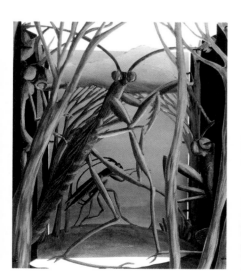

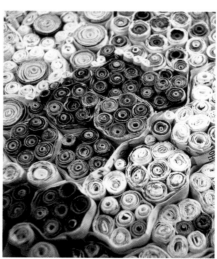

far left:
Andrea Dezsö, Romania/United States
MANTIS DIORAMA, 2008 (detail)
Hand-cut paper, thread, acrylic paint, mixed media
Overall: 7 x 5 x 6 in.
(17.8 x 12.7 x 15.2 cm)
Collection of the artist

left:
Nava Lubelski, United States
CRUSH, 2008 (detail)
Cut and shredded love letters, glue
Overall: 1 x 38 x 38 in.
(2.5 x 96.5 x 96.5 cm)
Courtesy of the artist and LMAK projects, New York, NY

and rolled paper made from one year of the artist's financial records—pay stubs, bank statements, and income tax forms. For this exhibition, Lubelski has made *CRUSH* from the personal papers, documents, and ephemera assembled over five years by an individual as he confronted his own sexuality, identity, and relationships, coming out to friends and family as a gay man. In a manner that recalls Dario Robleto's use of original documents and artifacts as the raw material for his art, Lubelski transforms a trail of events, behaviors, and emotions into a tangible presence.

Andrea Mastrovito works in a range of scale, from the intimate to the monumental, and in mediums that include film and video, performance, music, photography, and, of course, paper. Whether cut, folded, torn, painted, or photocopied, paper is central to a majority of his installations. He has said that "paper allows me to be more direct, more fundamental, and even simple. I use paper like a writer, for art is a kind of language, and where could you better write what you want to say than on paper?"[59] In his "writings" on paper, he entices the viewer into narratives in the form of tableaus.

He mines the history of art for imagery that is iconic and thus susceptible to being recast. In his work, players from historical subjects become contemporary protagonists. In *Le déjeuner sur l'herbe* (2006), Mastrovito reconstructs Manet's woodland scene and players in sheets of black, white and gray paper, adding jewellike touches of red to pinpoint a cravat or a cluster of cherries. Exuberant color suffuses installations such as *In & Out of Life* (2006), in which forests of cut-paper polychrome trees serve as a setting for equally colorful wall collages. His recent *Enciclopedia dei Fiori da Giardino* (*Encyclopedia of Garden Flowers,* 2009) is an imposing floor installation of masses of colorful foliage and blossoms, cut from the pages of dozens of seed and plant catalogues, and folded to create a verdant field of flowers. Darker subjects are also addressed by Mastrovito in such works as *The Disasters of War* (2006), a panorama of black paper, cut with images derived from Goya's compelling engravings. In *The Isle of the Dead* (2005) the lacy tendrils of jungle plants are as menacing as the insects, spiderwebs, and ghostlike hanging figures of the piece. Mastrovito is a canny and intrepid commentator on the world

around us, but he does not consider himself a political artist. Politics, according to the artist, is "silly people talking about useless things while they try to steal as much money as they can."[60] Mastrovito's concerns are more ethical than directly political, as they reflect on "the human condition, human suffering, and its causes and consequences."[61] For *Slash: Paper Under the Knife*, Mastrovito responded to the Museum's location on Columbus Circle and created an installation based on an Italian comedy film from 1984, *NON CI RESTA CHE PIANGERE* (There's Nothing Left To Do But Cry), in which two protagonists—Roberto Begnini and Massimo Troisi—suddenly find themselves transported back to 1492. They attempt to reach Spain to stop Christopher Columbus from sailing to the New World, and thus to alter the course of world history. "I am creating a scene from this history upside down on the museum lobby ceiling, depicting a sudden storm that overtakes the *Santa Maria* and prevents Columbus from reaching San Salvador." Mastrovito choreographs this epic with grace and irony.

Célio Braga began cutting paper as an extension of his drawing practice in

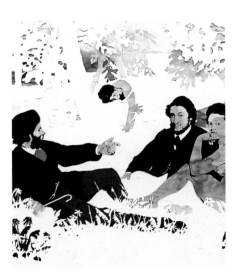

far left:
Andrea Mastrovito, Italy
Le déjeuner sur l'herbe, 2006 (detail)
Collage, acrylic paint on paper
Overall: 98 ⅜ x 70 ⅞ in.
(250 x 180 cm)
Private collection

left:
Célio Braga, Brazil/The Netherlands
PLACEBOS, 2008–9 (detail)
Medicine instructions, clear tape, paper, C-print cutouts
Dimensions variable
Collection of the artist

2004. He acknowledges the inspiration of the late Felix Gonzalez-Torres, who was known for his poignant and restrained installations using ordinary materials such as lightbulbs, reams of plain paper, or even edibles such as candy. Gonzalez-Torres's *Untitled* (1991), a billboard photograph of an empty bed, commemorating his lover who died from AIDS, adumbrates Braga's 2004–5 installation of thousands of wax flowers entitled *Full Blown*, a term referring to fully developed AIDS. The wax flowers, metaphor for the thousands of anonymous AIDS victims, were displayed over a 13-by-13-foot gallery floor, a translucent carpet of memories. Skin and the body as manifestation of inner states of being and consciousness also function in *Untitled* (Skin) from 2007–8, a series of layered color photographs of skin closeups, with thousands of cuts that echo the pattern of blood platelets and veins. Memory, loss, and vulnerability come together in *PLACEBOS*, an installation the artist has created for *Slash: Paper Under the Knife*. This work, like *Full Blown*, is comprised of thousands of small flowers, these fabricated from the printed documentation that accompanies containers of prescription drugs.

The flowers are arranged as a series of memorial wreaths, seen behind a wall of cut and folded paper hung in a dense series of linked chains. The drug papers are displayed against a background of white paper that has been cut with thousand of small incisions suggesting the texture of pale flesh. The printed papers were assembled by the artist over an extended period of time from family members, friends, and friends of friends, by way of what the artist has called his "personal chain of collecting and giving."[62] Braga's work strikes a delicate and precarious balance between acceptance of fate and anxiety in the face of the inevitable, between despair and hope, and between memories of the past and dreams for the future.

Lane Twitchell, a Brooklyn-based artist, takes a highly distinctive approach to the issues of nature and culture, of architecture and space. His work explores nature using an idiosyncratic vocabulary of images and forms within historical and contemporary architectural spaces and elements found in the urban environment. Architectural ornaments, pediments, and cornices, often citing specific locations, are combined with motifs as disparate

as flying birds, leering monkey faces, and cartoon-book plants and flowers, as in *PEACEABLE KINGDOM (MYSTIC LIGHT)*, shown in this exhibition. The work uses architectural forms as the structural frame for dozens of interlocking and juxtaposed motifs that fill the visual space and give it a nervous energy. Twitchell's Mormon upbringing (born in Salt Lake City, Utah, to a practicing Church of Latter Day Saints family) may have contributed to the mystical appearance of such works—here a circular mandala, folded and then cut to produce a strict bilaterally symmetrical shape. The intricate cut patterns and motifs reveal themselves only after careful examination, the symmetry drawing the viewer's eye toward the center. The works are painted with gradations of color, ranging from brilliant scarlets and yellow to intense blues and dark greens, painted in concentric bands that reiterate the central theme of the work. *Peaceable Kingdom* features the classical pediment of the Bronx Zoo, flanked by stylized elephant heads, evoking the faint image of a cross. In the center is a nimbus of light surrounding the outline of a white flying bird, suggesting the familiar iconographic motif of the Dove

Lane Twitchell, United States
*PEACEABLE KINGDOM
(MYSTIC LIGHT)*, 2009
60 x 60 in. (152.4 x 152.4 cm)
Acrylic on laser-cut paper
mounted on Plexiglas over acrylic
on panel
Collection of the artist

of the Holy Spirit from Western religious art. The suggestion of an interior source of (divine?) light gives these works their haunting quality, a "pervasive luminosity . . . a sense of light coming through the painting, almost as if it were backlit."[63] In these compositions the works of man and of nature are synthesized in a way that has been described as a combination of "folk art, science fiction, and psychedelia."[63]

Dario Robleto has stated "Not everything is what it seems in my work." [65] Robleto constantly tweaks and tests the limits of belief in works that often combine original documents and other materials within an engaging but frequently unsettling programmatic structure designed to elicit both visceral and mental responses. Art critic Frances Richard, writing in *ArtForum*, referred to Robleto's sculptures as "reliquaries, totems whose power derives from the authenticity of the stuff of which they are made."[66] In Robleto's installation and assemblages, objects that held important places in the lives of individuals are permeated by what, in anthropological terms, is often described as mana, a force that is resident in objects. These objects

include deeply personal mementoes and souvenirs, such as antique letters or photographs,[67] other paper of many varieties, and buttons, needles, ribbons, vinyl records, and powdered or carved bone. Robleto includes detailed and carefully itemized lists of all materials used in each work. While the lists are informative on a banal level, they are meant to bring the viewer into the spirit of the work, in the way the reading of names at memorial services both acknowledges and evokes the spirit of those who have departed. The work fabricated from these ingredients serves as a vessel that preserves and intensifies the cultural, emotional, and even spiritual essence of the objects. Robleto's works often evoke contemplation on death and loss. In *Nurses Needed Now*, he assembles a diverse and provocative larder of found personal objects: paper made from pulped letters written by soldiers to their families at home during various wars, ink retrieved from other letters, fabric from soldiers' uniforms and gauze bandages from World War I, along with hair, ribbons, and crepe. These are assembled to suggest the accumulations of personal items deposited at holy shrines. Crude blossoms, cut with a ragged

edge, encircle various documents and a homemade doll-like figure of a nurse. Two lists are enframed by the paper flowers. One, headed "Skilled Hands Needed For," is followed by poignant reflections on for aid and succour, such as "When Your Heartstrings Break, I Can Mend Them Back" and "Each Days Memories Wrapped in Heliotrope." The second list cites "Benevolent Efforts Toward" spiritual repairs, "A Homeopathic Treatment for Human Longing," and "Fear and Tenderness In Men," among other thoughts and fragments of sentences. The words seem to have been lifted from a diary or journal; they are intensely personal, and at the same time comment on shared human aspirations and fears. Embued with the spirit of the original documents and objects from which they are fashioned, the past is effectively recast and transformed into a gentle commentary on the present.

Dario Robleto, United States
The Southern Diarists Society, 2006 (detail)
Homemade paper (pulp made from brides' letters to soldiers from various wars, ink retrieved from letters, cotton), colored paper, fabric and thread from soldiers' uniforms from various wars, hair flowers braided by war widows, mourning-dress fabric, silk, ribbon, lace, cartes de visite, antique buttons, excavated shrapnel, melted bullet lead from various battlefields
Overall: 45 x 37 x 6 in. (114.3 x 94 x 15.2 cm)
Courtesy of the artist and D'Amelio Terras, New York

CULTURE CLASHES: POLITICS ON THE EDGE

Politics, violence, warfare, racism, and power are issues that have engaged artists for centuries. Today, paper is being used by artists to create provocative and powerful statements of their personal concerns and aspirations.

Sangeeta Sandrasegar's work touches upon timeless issues and universal themes as viewed through the lens of contemporary culture, politics, and identity concerns. Her Australian and Indian-Malaysian background has also led her to explore and comment on colonialism and cultural hybridism. To illuminate her inquiries, she turns to recent and contemporary events. Themes of revenge, retribution, and violence were addressed in the Goddess of the Flowers series (2003–4), which was based on the life of Phoolan Devi, a low-caste Indian who was repeatedly raped by rich landowners. Revenge was achieved by organizing a bandit group that murdered landowners living near New Delhi. Phoolan Devi was later elected to Parliament and was assassinated in 2001. Southeast Asian cut shadow puppets and Chinese cut-paper folk art inspired other works by Sandrasegar. Her cut-paper works based on the archetypal image of feet and hands often blatantly depict political and sexual scenes within decorative frames that evoke the complex patterns of henna body decorations. The Shadow of Murder Lay Upon My Sleep series takes its title from a line in Bertolt Brecht's poem "To Posterity." The piece she created for *Slash: Paper Under the Knife* uses the forms of three iconic modern chairs—the Zig Zag chair by Gerrit Rietveld, the Wassily armchair by Marcel Breuer, and the Charles Eames RAR rocking chair. The two-dimensional cutouts, when installed, create shadows that give the illusion of the third dimension. With this device, Sandrasegar raises questions about how reality is defined by both plans and accidents. The chairs express the twentieth century's optimistic belief that art and design could alter and improve the world at large. The forms are further cut with scenes of violence, strife, and anguish that argue the opposite point of view.

Mona Hatoum's body of work ranges from performance pieces starting in the 1980s to work in a wide variety of materials, from broken glass, hair, and sand, to silk organza, rubber, and paper. Hatoum addresses universal themes that expose the relationship of the individual to contextual and societal customs, rituals, and beliefs, along with the issues of power, control, and surveillance that arise from them. She also investigates the ways in which the human body parallels and provokes the social, cultural, and political environment in which it functions. Hatoum has focused on issues of violence—between individuals, between cultures, and between nations. In the works featured in this exhibition, *UNTITLED (CUT OUT)*, Hatoum evokes the simplicity of children's papercutting of snowflakes or paperdolls. The imagery of armed warfare and exploding bombs is a counterfoil to the intentional naïveté of the simple white sheets. The unmodulated white fields, punctured by the images, also evoke white handkerchiefs of surrender, as well as the thin paper cutouts that accompany *Dias de los Muertos/Day of the Dead* celebrations in Mexico.

In line with the silhouette tradition of two-dimensional papercutting, **Dylan Graham**'s works are generally large in scale but delicate and complex in their

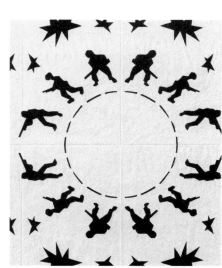

far left:
Sangeeta Sandrasegar,
Australia/England
UNTITLED #25 (from The Shadow of Murder Lay Upon My Sleep series), 2009 (detail)
Cut paper
Overall: 25 9/16 x 17 11/16 in.
(65 x 45 cm)
Courtesy of the artist

left:
Mona Hatoum, Lebanon/England
UNTITLED (CUT OUT 1), 2005
Tissue paper
Overall: 15 x 17 1/2 x 1 1/8 in.
(38.1 x 44.5 x 2.8 cm)
Courtesy of White Cube

cut details. Narrative scenes and figures are often cut against a grid of thin cut-paper lines that hold the composition together literally and figuratively, recalling the use of silk threads in Japanese *katagami*. Graham's monochromatic narratives are based on historical and contemporary issues of colonialism and global events. He has used papercutting to recount the Spanish conquest of the Americas in *Armada*, in which Spanish galleons sail toward the New World above a submerged skeletal mariachi band. In *Rain Follows the Plow*, a title borrowed from a now debunked theory of climatology in the American West, a procession of figures, presumably farmers, stand beside a skeletal windmill and empty house beneath a massive stylized cloud. Based on the popular myth that cultivating the land necessarily brings prosperity—thereby justifying westward expansion in America—the work is an ironic reminder of the ravaged land of the American South that culminated in the Dust Bowl of the Depression. The silhouettes in Graham's work evoke mystery shadows and "create an eerie, almost mythic haze over each history-book genre scene."[68]

Pietro Ruffo's work is informed by contemporary politics and current events. Ruffo's involvement includes not only works of art but also direct interventions and community-based projects that are intended to ameliorate the effects of psychological trauma. He uses art as therapy. His vision and approach to his art link him to the historical avant-garde artists who sought to reunite art and life as a means of examining the basic purpose of art and art making. After developing art therapy programs for psychiatric patients in Alsace, Ruffo implemented an intensive art program for children from Beslan who survived the death of their peers at the hands of Chechen and Ingush terrorists. Ruffo's political stance has endeared him to many and enraged others. He has consistently tackled thorny issues with compelling directness. His work often makes use of flags and maps that trace the evolution of globalization. He focuses on the often devastating gap that exists between physical territories and their shifting edges and the political and economic constructs that are used to defend or erode these territories. Inequities among nations have been core to Ruffo's Six Nations series (2006–7). In

part of the series a pyramid of packing boxes from China housed a video on the subject of migration for the viewer to watch. In another part, paintings of British and American flags were composed of morphed skulls. Another series was devoted to the philosopher Isaiah Berlin (1909–1997) and his exploration of the issues of liberty, values, and the abuse of power on the part of individual and nations.[69] Insects and beetles figure prominently in Ruffo's work, such as *YOUTH OF THE HILLS*, shown in this exhibition. For Ruffo, beetles are a metaphor for political power and domination since they lay their eggs on a host and eventually kill it. The motif has been used in works that deal with territorial conflict in the Middle East and that address relationships between the United States and South America.

Kara Walker's cut-paper silhouettes are her authorial signature. They have been used for large-scale wall installations, as freestanding small-scale sculptures, and as actors in shadow-puppet light projections and cut-paper animations that bring her compelling and provocative narratives to life. Her cut-paper animals, props, and sets, and

far left:
Dylan Graham, New Zealand/
The Netherlands
Armada, 2006 (detail)
Hand-cut paper
Overall: 36 x 96 in. (91 x 245 cm)
Courtesy of the artist and RARE
Gallery, New York

left:
Pietro Ruffo, Italy
YOUTH OF THE HILLS, 2008
(detail)
Wood, paper, Hebrew prayer
script, nails
Overall: 31 7/8 x 23 5/8 x 74 13/16 in.
(81 x 60 x 190 cm)
Courtesy of Galleria Lorcan
O'Neill, Rome

her figures in particular, are contemporary confirmations of the physiognomic theories of Lavater, who believed that one's true character was revealed in the profile outline of one's face. Walker's flat shadows suggest narratives without being literal. Her shadows are Platonic outlines of a world filled with sexual, racial, social, political, and emotional anxiety, conflict, and satire. The critic Holland Cotter stated, "all of her work is, in a sense, a form of thinking out loud,"[70] and it is this intensely personal, complex, and skeptical voice that emanates from her cut-paper installations, videos, projections, and sculptures. Her characters are intentionally cartoonish and stereotypical, deceptively humorous or naïve, and bitingly insightful. The anthology of folk tales, popular legends, and romantic stories, from which she draws, conflate history and the present. These narratives explore the cultural complexities that bind us as members of the same race, culture, religion, or political party. The titles of Walker's works alone suggest the nature of their content. Her earliest large-scale cut-paper installation was *Gone, An Historical Romance of a Civil War as It Occurred Between the Dusky Thighs of One Young Negress and*

Her Heart (1994). Drawings from 1997 were called *Do you Like Crème in Your Coffee and Chocolate in Your Milk*. Her light projection from 2001 was titled *Darkytown Rebellion*. Walker's video, *8 Possible Beginnings or: The Creation of African-America, A Moving Picture,* made in 2005, is comprised of an octet of stories that propose versions of history with grim and striking directness. Walker's cut-paper figures pull no punches. Shown in *Slash: Paper Under the Knife* are three of Walker's three-dimensional sculptures. Each consists of two or more flat silhouetted figures arranged so that their outlines overlap and interlock, compositions in which the relationships between the figures shift according to the point of view. Shadowy acts of dominance and submission are performed by characters with stereotypical racial features or accessories. The simplicity of their shapes and arrangement belie the powerful and provocative realities they define—racial conventions and conflicts, gender and power, violence and conflict.

The subjects in **Ed Pien**'s work range from the personal imagery of the myths and stories of his native Taiwan to the

political commentaries informed by the visual arts of the West. In addition to cut paper, Pien also creates installations and video incorporating sound. Ghosts and witches are referred to in his works, as are shadows, the concept of floating in space, and an eerie night light. The works merge recognizable motifs, such as human figures and trees, in atmospheres suffused with strangely colored light. Pien relies on the silhouette format to reveal contour, giving his images a generic, timeless quality. He often cites familiar and iconic imagery from the history of art, such as Hieronymus Bosch's *Garden of Earthly Delights*, peopled with bizarre, yet familiar, figures. *Slash: Paper Under the Knife* includes Pien's *NIGHT GATHERING* (2005), a 16-foot-wide silhouette of a tree with spreading branches. Although the tree appears to be bilaterally symmetrical, there are seven human figures among the branches, each in a distinctive position, negating the Rorschach-like effect. Six of the figures climb through the branches, while one hangs suspended from the highest branch. The work is freely based on Jacques Callot's famous etching in *Miseries and Misfortunes of War*, published in 1633, when Lorraine was

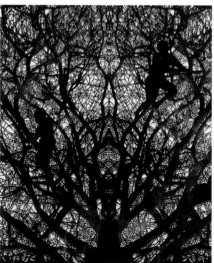

far left:
Kara Walker, United States
*DESCRIPTION/ATROCITY/ WITNESS/*YAWN*/WARNING WARNING/REPEAT: INTIMATIONS*, 2008 (detail)
Cut paper
Overall: 5 x 10 x 6 ⅛ in.
(12.7 x 25.4 x 15.6 cm)
Courtesy of the artist and
Sikkema Jenkins & Co., New York

left:
Ed Pien, Taiwan/Canada
NIGHT GATHERING, 2005 (detail)
Ink on Shoji paper
Overall: 8 ft., 1 in. x 16 ft., 1 in.
(2.5 x 4.9 m)
Collection of Joe Battat; courtesy
of Joe Battat and Pierre-François
Ouellette Art Contemporain,
Montreal

invaded and the Thirty Years' War with France commenced. Pien has adapted Callot's powerful antiwar image of a mass lynching, using the silhouette format to achieve a dark and threatening atmosphere.

Ariana Boussard-Reifel has worked in many mediums in addition to altered books. *BETWEEN THE LINES*, shown in this exhibition, was one of three works she created for *Speaking Volumes: Transforming Hate*, an exhibition at the Holter Museum, Helena, Montana, in 2008. The artists involved used volumes acquired by the Montana Human Rights Network from a defector from the World Church of the Creator (WCOTC),[71] a white-supremacist hate organization. Working with Stan Reifel and Dana Boussard, Boussard-Reifel created an installation piece, *Hate Begins at Home*—a house with walls made from WTOTC books—and a performance piece in which she painted texts from the books on Dana Boussard's skin until it was entirely black and illegible. The third piece, included in *Slash: Paper Under the Knife*, is a veritable textbook of white supremacy from which every word has been individually cut to eliminate the text. The excised words are displayed beside the book as a meaningless pile.

SHREDDING THE WORD: BOOKS AND LANGUAGE

The artists in this section respond to paper as a carrier of the written word, using their knives and scissors to transform one form of an artifact into another that carries new information and meaning.

Early in his career **Brian Dettmer** worked as a signmaker. Today, he still works with words, language, and images through the medium of altered books.[72] The evolution of Dettmer's work with paper began with making collages with newspaper and continued with using pages torn from books. Ultimately the book has been retained mostly intact, with cutting used to reveal the visual elements without destroying the basic structure. Because Dettmer cuts the books to create a series of visual layers, the viewer can look into and through the volume. His work has been compared to biological dissection or archaeological excavation, both being activities that reveal content. What remain in Dettmer's creations are receding galleries of images and fragments of images. Most often they are divorced from the text that explicated the imagery, allowing them to be read like compressed graphic novels. Although static, the overlapping and partial revelation of images has the same visual effect as flickering images in a video. Books demand that one's interaction with them be of a linear nature to preserve meaning.

Rob Ryan is a poet who writes with a knife rather than a pen. He began as a painter, but found that words kept returning to his works. Papercutting was a way of avoiding language, but he found this technique to be ideally suited for his needs. Ryan's cut-paper poems, musings, and commentaries on life and the world are disarmingly simple. At first glance his choice of decorative motifs—flowers, trees, stars, birds, hearts, and clouds—appear conventional and obvious. However, when combined with his words, these motifs exude a visual poignancy and intimate charm. The sentiments expressed are at once naïve and highly sophisticated, and while often positive, such affirmations can also take on a much darker and melancholic air. "No Minute Gone

Comes Ever Back Again," cut with an image of a woman and man opening the gate to a flower-strewn garden is juxtaposed with "We Had Nothing, We Had Not Much, We Had Enough, We Had Everything," showing a man lying on the branch of a tree lifting a little girl into the air. Love, despair, regret, memories, and dreams—the personal, intimate, and universal—are all woven with consummate skill in Ryan's work.

Su Blackwell began altering books in 2003 and has made a specialty of the art form. She is most widely known for her alterations of children's books, such as Lewis Carroll's classic, *Alice in Wonderland*, from which emerge three-dimensional figures and tableaus like the familiar Mad Hatter's Tea Party. In such works, Blackwell often cuts and constructs the figures from the same pages of text in which the narrative takes place. Although children's books reappear frequently in her oeuvre, they are not the only type of book she alters, nor are all of the scenes that she cuts lighthearted and charming. In a recent work, cut from *Arthur Rackham's Book of Pictures* (1913), Blackwell pursues the darker side of the story in which the characters Margorie and Margaret

face an eerie and sinister forest. Similar juxtapositions of innocence and peril appear in such works as *Wild Swans*. A dim light casts a glow and shadows on the scene. The ongoing series began after Blackwell visited Thailand, where she saw the corpse of a Buddhist monk at one temple. She then cut a copy of *The Quiet American* by Graham Greene. The book had been annotated by a Thai reader. Blackwell created a swarm of moths emerging from the pages, the moths containing both the printed text and handwritten annotations. For this exhibition, Blackwell is cutting *RAPUNZEL* from *A Book of Fairy Tales* by the Brothers Grimm.

Music scores, maps, newspapers, currency, photographs, and books have been cut, shredded, or manipulated by Scottish artist **Georgia Russell**. Time and memory are explored in her work, and so too is the futility of logic. Maps and books, in particular, are invested with layers of cultural meanings that revolve around ideas of knowledge and permanence, tangible records of who we are and where we are in the world. Challenging the security of that knowledge and the reassurance of permanence opens up two paths of

perception. One path leads to an abandonment of what is believed to be rational, and an acceptance of the chaos that stalks human culture. The other is the path to transcendence—recognizing the beauty inherent in the ephemeral, the nonsensical, and the random. Russell's altered books, such as *Memoire* (2001–2), are displayed like dried specimens inside transparent bell jars, some underwater creatures whose elastic and slippery tentacles have become desiccated tendrils. *Memoire* is an ironic comment on the ways in which our memories are subject to the vagaries of time, becoming fragments of what had once been life. *De Baudelaire au Surréalisme* (2007), an 1897 book by Marcel Raymond, also floats in a bell jar. Shredded into long strips, except for the title, the object takes on the eerie quality of a shaggily bearded human head, in keeping with the subject matter. Ernst Gombrich's classic *THE STORY OF ART* will be familiar to art history students. Displayed under a Plexiglas dome and hung on the wall like a trophy, this sweeping history of the visual arts, beginning with the ancient world, contained images of paintings and sculptures that have become icons of Western culture. The shredded pages

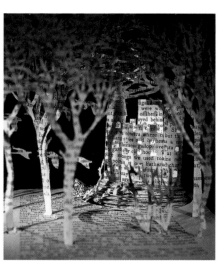

far left:
Rob Ryan, England
We Had Everything, 2007
Paper
16 ½ x 18 ½ in. (42 x 47 cm)
Courtesy of Robert Ryan papercuts

left:
Su Blackwell, England
Wild Swans, 2008 (detail)
Reclaimed book in box
Overall: 13 ¾ x 9 ⅞ x 10 ¼ in. (35 x 25 x 26 cm)
Courtesy of the artist

show only fragments of recognizable words or images. This book and others, in the artist's own words, invite the viewer to "'read' them again and to 'listen' to them—to almost hear the past; but all that can be grasped are fragments which give clues."[73]

Carole P. Kunstadt's sliced and reconstructed psalm book has been interleaved with tissue and gold leaf and then stitched in horizontal lines. The raw material—pages from an antique book of psalms—has been destroyed by cutting into shreds, and then resurrected as an object in which the language of prayer and supplication is released from its role in a sequential narrative and returned to a cluster of fragmentary statements. The tissue and gold leaf underscore the age of the yellowing documents. The repetitive stitching, for the artist, is a reminder of song and prayer. A sense of intimacy and loss pervades the work; fragments of memory and belief are brought together to create a hybrid form that negates the sequential nature of reading, replacing it with suggestive echoes of inner states of praise, worship, and prayer.

Mark Fox paints, draws, and writes on paper with bold abandon. His trail of marks, whether fragments of text, rough sketches of familiar and banal objects, cartoonlike figures, and miscellaneous graffitilike doodles, are subsequently cut away from their ground and reassembled piece by piece in exuberant layers, explosive clusters, and pendant trails. There is a nervous energy to the cacophony of motifs brought together in these works; cartoon characters, tree branches, kitchen utensils, and vegetables collide with random words devoid of a context that would give them meaning or with humorous phrases: "Principle," "Nut Brown," or "I Bumped My Head on a Stalactite in Plato's Cave." Fox intentionally seeks out images and phrases that are random, fragmented, echoing his "stream of consciousness" method of drawing and painting, in which accidental and spontaneous mark making is privileged. He engages the viewer with a directness and intimacy that may have been informed by his earlier work as a puppeteer and performance artist; from the jumble of colors and shapes a narrative, albeit obscure, begins to reveal itself. The spontaneity and improvisational quality of performance

is retained in these floating compositions. Fox's painstakingly pieced constructions—each small cutting attached to its neighbor with a glued paper tab—are sometimes given added complexity by being hung with the white verso of the piece facing the viewer and the recto facing a wall that is sometimes covered with mirrored Mylar. In this way only particle reflections of the painted marks can be glimpsed. While many of the works echo the barrage of visual stimuli that confront us in the form of advertising, film, video, the internet, and commercial signage, there are other works that focus on single issues, themes, or ideas, many of which derive from the artist's staunch Catholic upbringing. Fox specifically cites doctrines and dogmas, ranging from the political to the religious. The often lengthy texts are calligraphically inscribed on paper with a paintbrush, cut free, and suspended above the viewer like a hovering (or menacing) cloud, or supported on commonplace devices, such as sawhorses. Fox's work interrogates both language and vision by "unraveling" what we believe to be the logic of daily life. He then reassembles these random fragments of images and texts to make tangible the

far left:
Georgia Russell, Scotland
De Baudelaire au Surréalisme,
2007 (detail)
Cut book in bell jar
Overall: 25 ¾ x 10 ½ in.
(65.4 x 26.7 cm)
Courtesy of England & Co.

left:
Carole P. Kunstadt, United States
SACRED POEM XXVII, 2006
(detail)
Pages from 1844 Parish
Psalmody, gampi tissue; cut,
altered, sewn
Overall: 4 ¼ x 9 ¾ x 1 ¾ in.
(10.8 x 24.8 x 4.4 cm)
Collection of the artist

fragile nature of our beliefs, intentions, and aspirations.

THE MOVING IMAGE: PAPER AND ACTION

With the invention of the movie camera, cut paper moved into a new role—that of actor in animated stop-action films. The low-tech, yet time-consuming nature of the technique of stop-action animation gives these videos a directness and immediacy not found in other moving pictures.

Carlos Amorales's work over the years has included performance pieces danced by Galia Eibenschutz to music by Amorales's collaborator Julián Léde. Amorales has created work with the rock group Nuevos Ricos and has staged wrestling matches. He has worked in aluminum (*Transformable Spider Webs,* 2008), vinyl (*Rorschach Room,* 2006), and acrylic and wood (*Exotic Ravens [10 Puzzles],* 2006), but he consistently returns to paper as a primary medium. Amorales is the curator of Liquid Archive, a database repository of images he has collected since 1999. This cabinet of visual curiosities includes familiar, often quotidian images—birds, airplanes, masks, animals, trees—that Amorales then transforms into haunting, anxiety-ridden, and seductive constellations. The images function as pictographs in which the viewer seeks the narrative, only to realize that it is being written during the process. The motifs are often used in ways that transform the commonplace into the sensational; a butterfly connotes delicacy, lightness of being, and fragility, but 25,000 black butterflies (*Black Cloud,* 2007) confined to a room becomes a specter of oppression, destruction, and violence. It is a phenomenon that one writer has described as "a territory that fluctuates between the obscure and the optimistic, the macabre, and the alluring."[75] The clouds of black butterflies reappeared in Amorales's *BLACK CLOUD* video, which is featured in *Slash: Paper Under the Knife*. In it, a camera moves slowly through gloomy interiors devoid of signs of life other than the thousands of still and silent black butterflies that cover the walls and ceilings, fill the window sills, and congregate in corners. A haunting soundtrack compounds the claustrophobic and menacing effect, "as if the moths [sic] had won a decisive and final doomsday battle and conquered every realm of human existence."[76] *FACES* (2007), also shown in this exhibition, is frenetic, rapid fire, and nervous in comparison. Flocks of black birds fly across the screen with strobe-light quickness, meshing and merging with irregular black splatters and, at various times, attacking fragmented of Mexican wrestlers' masks. Nature and culture once again collide with dramatic effect.

Cut paper and stop-action animation are used by British artist **Rob Carter** to explore the mythology and the reality of the built environment. Unlike many artists working with cut-paper animation, Carter does not rely on the silhouette, but rather cuts and animates images—maps, photographs, engravings—to bring structures and settings to life. Carter focuses on places and buildings that have powerful cultural associations, such as churches, sports stadia, and public monuments. He also incorporates time-lapse video in some of his works; the natural world, in the form of growing plants, sometimes intersects with man-made structures in construction or decline. *Metropolis* is an imaginative history of the city of Charlotte, North Carolina, from its

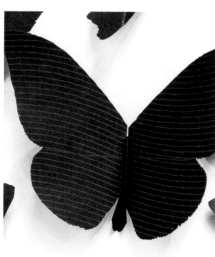

origins on a Native American trading route through its burgeoning economy of the late twentieth and early twenty-first century and its ultimate destruction and burial by the landscape on which it was founded. *Circulus* documents the action at the finish line of the Bank of America 500 NASCAR race of 2007, while *Reseed* follows the growth of real seedlings into, through, and around images of the Wimbledon tennis courts. Nature ultimately triumphs over culture in this short but powerful video. For this exhibition, the artist has created a work based on Gothic church architecture, outlining the process of destruction and rebuilding that has taken place at the Cathedral Church of St. John the Divine in New York City. The video examines the irony of building a twentieth- and twentieth-first-century building using medieval techniques which, in their own time, were considered revolutionary and innovative. Carter states that "the result now, especially from the outside, is a very sad site."[77]

The artists chosen for *Slash: Paper Under the Knife* reveal the intelligent and passionate exploration of one of the most available and ordinary of materials. Importantly, they underscore the truth that any material, regardless of inherent value, is limitless in its potential when transformed by a creative individual. The exhibition documents an extraordinary moment, when paper has re-emerged as a valuable ally for artists whose intentions and practices vary dramatically. Cut paper today is a global phenomenon that adds another layer of material meaning to the worlds of contemporary art, craft, and design.

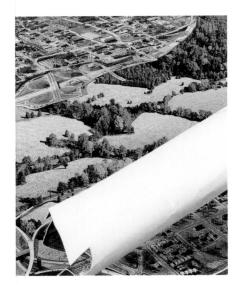

Rob Carter, England/United States
Metropolis, 2008 (still)
Cut-paper animation
Black & white/color/sound; total
running time: 9 min., 30 sec.
HD DVD video

Notes

1. Quoted in Brett Littman, "The Education of Thomas Demand," *Art on Paper* (March/April 2005), 51–53 (quote on p. 52).

2. See Abigail J. Sellen and Richard H.R. Harper, *The Myth of the Paperless Office* (Cambridge, MA: MIT Press, 2001). The phrase appeared in print in 1975; see "The Office of the Future," *Business Week* (June 30, 1975), 48–70.

3. "Paper Related Statistics," Environmental Paper Network, www.environmentalpaper.org/PAPER-statistics.html (accessed May 2009).

4. "Things to Know About Paper Consumption," www.mdfsystems.com/artman/publish/article_42.shtml.

5. "No End to Paperwork," World Resources 1998-99 (updated June 2001). http://earthtrends.wri.org/features/view_feature.php?theme=6&fid=19.

6. A recent innovation is TerraSkin©, a paper made from stone that has been ground to a powder and combined with a resin. This new paper requires no trees, water, or bleach in its fabrication; it uses waste products from the building industry and degrades back to its source in less than a year.

7. Due to the enormous amount of work being created today, definitions and parameters needed to be established to focus the exhibition and make it manageable. Paper was generously defined as any nonwoven material, generally made of wood or fiber pulp, but also including new materials. Therefore, materials such as Tyvek (nonwoven, flashspun high-density polyethylene fibers) and TerraSkin (a combination of calcium carbonate and a nontoxic binding resin made from postindustrial recycled marble and limestone, which degrades in under year when exposed to moisture and sunlight) were included. The definition of cutting was likewise broadened to include cutting with knives or scissors, tearing, burning, punching, and laser cutting. Film and video using cut-paper animations are also featured in the exhibition. Collage, however, has been excluded as a vast subject requiring a separate survey. From the collages of early modernist artists, both cubists and Dadaists, to the scrap-booking craze of recent years, there are literally thousands of artists and hobbyists using collage techniques, ranging from traditional gluing of cut or torn pieces of paper or other materials to high-tech digital collage. The number of artists who use various cutting and folding techniques to create three-dimensional works such as origami and "pop-up" books provided a similar challenge and were likewise eliminated from *Slash: Paper Under the Knife*.

8. Wu Hung, "Lu Shengzhong's First Encounter," in *The New Emerging from the Old, Lu Shengzhong: Works 1980–2005*, (Albany: University Art Museum, SUNY/Albany, 2005), 36.

9. For full description, see http://www.britishmuseum.org/research/search_the_collection_database/search_object_details.aspx?objectid=1336530&partid=1&searchText=mas.913.d&fromADBC=ad&toADBC=ad&numpages=10&orig=%2fresearch%2fsearch_the_collection_database.aspx¤tPage=1.

10. De Silhouette was also responsible for melting down vast quantities of domestic silver and gold confiscated from the Crown and the aristocracy to pay off France's war debts. As a result, French gold and silver plate of the eighteenth century is extremely rare today.

11. *Lavater, Physiognomische Fragmente zur Beförderung der Menschenskenntnis und Manschenliebe* (1775–78; facsimile reprint, Zurich: Orell Fussli, 1968).

12. See Victor I. Stoichita, *A Short History of the Shadow* (London: Reaktion Books, 1997).

13. Sold at Christies, New York, October 29, 1998, sale 9058, lot 1. Now on deposit at the Walters Art Museum, Baltimore, MD; see also the Palimpsest Project, http://www.archimedespalimpsest.org (accessed May 2009).

14. Walters Art Gallery, Baltimore, MD, W.494. I am grateful to Ben C. Tilghman, Department of Manuscripts and Rare Books, Walters Art Gallery, for information on the Marie de Medici prayer book, the fourteenth-century French Book of Hours, and the Archimedes Palimpsest.

15. Walters Art Gallery, Baltimore, MD, W.93.

16. See Daniel Traister, "W. H. Mallock and a Human Document," http://humument.com/essays/traister02.html (accessed May 2009).

17. The society maintains a website at www.alteredbookartists.com (accessed May 2009).

18. Richard Llewellyn, "Chronology of Animation, 1910," www.animated-divots.com/chrn1910.html (accessed May 2009).

19. Bruce Ferguson, "Outside of Sculpture, Outside of Drawing and Outside of Time," in *Andreas Kocks: Unframed/Paperworks*, exh. cat. (New York: Jeannie Freilich Fine Art, 2007), 43.

20. Quoted from the artist's statement, www.miapearlman.com/statement.htm (accessed May 2009).

21. Antoine de Saint-Exupéry, *Wind, Sand and Stars* (New York: Reynal and Hitchcock, 1939), 66.

22. Lily Wei, "Cuenca, Ecuador: Cuenca Bienal," *Sculpture 26*, no. 9 (November 2007), 74.

23. Rex Weil, "Fran Siegel," *ARTnews* (January 2005), 128.

24. Jonathan Goodman, "New York/Fran Siegel/Margaret Thatcher," *Sculpture 20*, no. 9 (November 2001), 70.

25. Roberta Smith, "Review/Art; For Judy Pfaff, Moderation at Last," *New York Times*, September 28, 1990.

26. Kim Levin, "Judy Pfaff: Ameringer and Yohe Fine Art," *ARTnews* (April 2009), 108.

27. Larry Rinder, "Michael Velliquette," in *International Artist-In Residence New Works* (San Antonio, TX: ArtPace, 2008), 31.

28. Ibid., 35.

29. Doug Beube to David McFadden, personal communication, June 3, 2009.

30. Eric Bryant, "On the Cutting Edge," *ARTnews* (April 2008), 109.

31. Axel Velázques "Paperscapes," exh. brochure (Mexico City: Arróniz Arte Contemporaneo, 2007), n.p.

32. Brian Dillon, "Nina Katchadourian: Found in Translation," *Art Review* (April 2008), 68.

33. Frances Richard, "Para/Sympathetic," in *Nina Kathchadourian: All Forms of Attraction*, exh. cat., Frances Young Tang Teaching Museum and Art Gallery, Skidmore College, 2006. (Saratoga Springs, NY: the Museum, 2006), 47.

34. Ian Berry, "How To Fix Things: Nina Kathchadourian's Instructional Art," *2wice 9*, no.2 (2006), 1.

35. Fiona Ratray, "Studio Libertiny," *I.D.* (March/April 2008), 76.

36. Laura Houseley, "Tomáš Gabdzil Libertiny," *ICON* (May 2008), 69.

37. Quoted from "Architect is an Artist," May 7, 2007, http://architectook.net/architect-is-an-artist/#more-384 (accessed May 2009).

38. Apsara DiQuinizio, "Fluid Coordinates: The Work of Jane South," in *Jane South*, exh. cat. (New York: Spencer Brownstone Gallery, 2006), 3.

39. The book was originally created for the Library Council of the Museum of Modern Art, New York, in a limited edition of 225, and produced by Kremo Laser-Papierfeinstanzungen in Mosbach, Germany.

40. Randall Weeks's art was described as being about "fragility and security, the need for shelter and the randomness of fate"; see Thomas Micchelli, "Ishmael Randall Weeks," *The Brooklyn Rail: Critical Perspective on Arts, Politics and Culture* (May 2009), at www.brooklynrail.org/2009/05/artseen/ishmael-randall-weeks (accessed May 2009).

41. David Gariff, *Tomás Rivas: Left To My Own Devices*, exh. cat. (Washington, DC: Douze and Mille Gallery, 2007), 11.

42. Pepe Karmel, "The Real Simulations of Thomas Demand," *Art in America* (June/July 2005), 147.

43. Neville Wakefield, "Sites Unseen," *Art Review* (February 2005), 69.

44. "We are routinely shown sheets of paper without writing on them; books without titles on their bindings; boxes, bottles, and tubes without logos; telephones without buttons or numbers; ballots without names or markings; light switches without on-off mechanisms. . . . Demand's photographs depict places and things absolutely devoid, indeed systematically purged, of all traces other than those pertaining to the physical making of the models"; Michael Fried, "Without A Trace," *Artforum* (March 2005), 201.

45. Quoted in Buck Ellison, "The Knitting Factory: Buck Ellison Interviews Oliver Herring," *Columbia Spectator*, February 2008.

46. Ibid.

47. Kelly Baum, "Oliver Herring," *American Art Since 1900*, ed. Baum and Annette DiMeo Carlozzi (Austin: Blanton Museum of Art at the University of Texas, 2006), 132.

48. Arthur C. Danto, "Geometricity and Finesse: The Spirit of Tom Friedman's Art," *Tom Friedman*, exh. cat. (London: Gagosian Gallery; New Haven and London: Yale University Press, 2008), 14.

49. "The Gesture of an Open Hand: Dede Young and Lesley Dill in Conversation September 2006," in *Lesley Dill: Tremendous World*, exh. cat. (Purchase, NY: Neuberger Museum of Art, Purchase College, State University of New York, 2007), 22.

50. Nandini Makrandi Jestice, "Vision, Touch, Voice," *I Heard A Voice: The Art of Lesley Dill*, exh. cat. (Chattanooga, TN: Hunter Museum of American Art, 2008), 11.

51. Ibid.

52. Lesley Dill to David McFadden, email correspondence, May 28, 2009.

53. Kako Ueda to David McFadden, email correspondence, May 29, 2009.

54. Guido Bartorelli, "Chris Gilmour," translated by Simonetta Caporale at http://www.chrisgilmour.com/en.antologiacritica.html (accessed May 15, 2009).

55. Lu stated, "I did not invent the shape of the Little Red Figure. The Little Red Figure stretches out its four limbs symmetrically—feet touch the earth and hands support the sky. Similar forms can be found in early civilizations from many parts of the world. As the earliest self-portrait and the first evidence of self-awareness, the shape illustrates the congruities among early civilizations"; *First Encounter: Lu Shengzhong*, exh. cat. (New York: Chambers Fine Art, 2000), 6.

56. Edward M. Gomez, "Lu Shengzhong's Timeless Art of Transformation," in *The New Emerging from the Old Lu Shengzhong: Works 1980–2005*, exh. cat. (New York: Chambers Fine Art; Albany: University Art Museum, 2005). 6.

57. Li Xianting, "The Greatest Meaning is the Transformation of Language," in ibid., 32.

58. Andrea Dezsö to David McFadden, email correspondence, May 19, 2009.

59. Andrea Mastrovito to David McFadden, email correspondence, May 28, 2009.

60. Ibid.

61. Ibid.

62. Célio Braga to David McFadden, email correspondence, September 30, 2008.

63. Thomas Piché Jr., "Makings' Meaning in the Paintings of Lane Twitchell," *Revelation: Lane Twitchell, Drawing and Painting*, exh. cat. (Auburn, NY: Schweinfurth Memorial Art Center, 2007), 5.

64. Holland Cotter, "Art in Review: Lane Twitchell, Leap With Me, Roebling Hall," *New York Times*, April 4, 2008.

65. Ian Berry, "Dario Robleto—Alloy of Love," interview, museum newsletter/announcement of shows, brochure (Saratoga Springs, NY: Frances Young Tang Teaching Museum at Skidmore College, 2008), n.p.

66. Frances Richard, "Dario Robleto/D'Amelio Terras," *Artforum* (November 2006), 296.

67. Robleto's transformation of personal and antique documents and objects into the raw material from which his works are built is viewed by some as transgressive and questionable, as has been noted by Michael Duncan, "Remixing the Past," *Art in America* (November 2007), 203.

68. Leigh Anne Miller, "Dylan Graham at RARE," *Art in America* (September 2006), 167.

69. Isaiah Berlin, *Two Concepts of Liberty* (Oxford: Clarendon Press, 1958).

70. Holland Cotter, "Black and White, But Never Simple," *New York Times*, October 12, 2007.

71. The World Church of the Creator was founded by Ben Klassen in 1973. Klassen committed suicide in 1993.

72. The artist has stated that "working with signs made me think about language in a more philosophical way"; Ellen Firsching Brown, "The Cut-Up Artist," *Fine Books & Collections* (May/June 2008), 48-50; 52-53 (quote on p. 50).

73. *Georgia Russell: Paper Constructions & Bookworks*, exh. cat. (London: England & Co., 2002), n.p.

74. First installed at the Yvon Lambert gallery in New York and subsequently reconfigured at the Philadelphia Museum of Art in 2008.

75. Blanca de la Torre Garcia, "Carlos Amorales, Yvon Lambert New York," *Arte al Dia* 122 (2008), 122.

76. Isabelle Dupuis, "Carlos Amorales/Yvon Lambert," *Flash Art Review* 41 (January–February 2008), 148.

77. Rob Carter to David McFadden, email correspondence, March 9, 2009.

Jane South
Untitled (Tracing Parameters), 2006 (detail)
Hand-cut and folded paper, ink, acrylic, graphite, balsa wood
Overall: 108 x 144 x 20 in. (274.3 x 365.8 x 50.8 cm)
Courtesy of the artist and Susanne Vielmetter Los Angeles Projects, CA

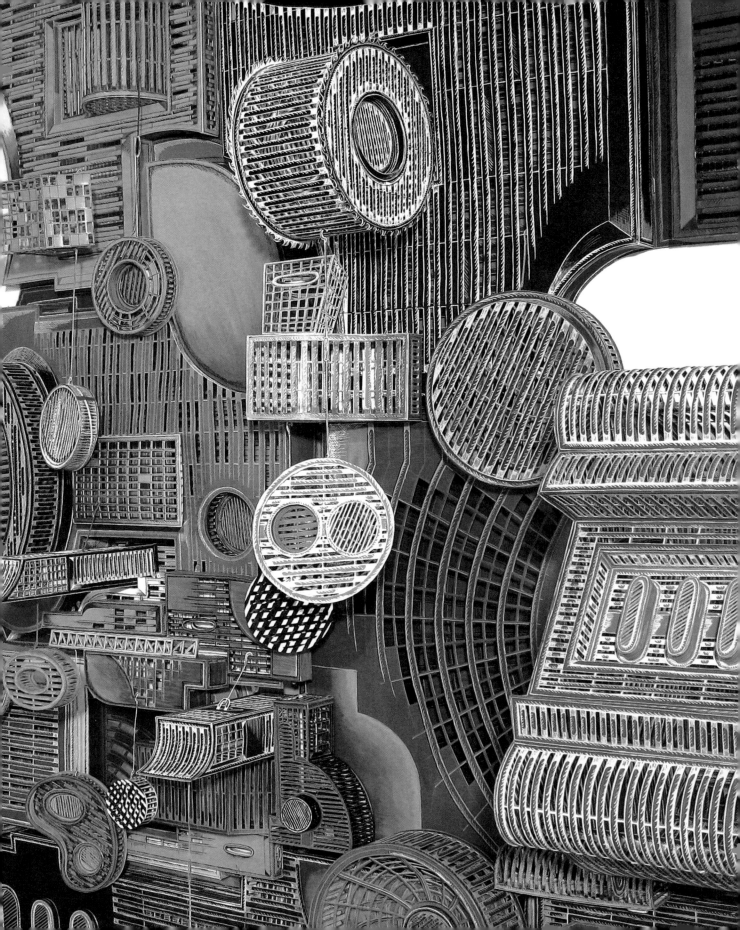

Daniel Alcalá

Born in Saltillo, the capitol of the state of Coahuila, Mexico, sometimes referred to as the "Athens of Mexico," Daniel Alcalá studied from 1996 to 2000 at the Escuela de Artes Plásticas "Ruben Herrera," Universidad Autónomica Coahuila, in Saltillo. He received his diploma in visual arts in 2001 from Universidad Autónomica Metropolitana in Mexico City. This was followed by studies at Escuela Nacional de Pintura, Escultura y Grabado "La Esmeralda," in Mexico City. Alcalá's work has been shown in Colombia, Russia, Switzerland, Austria, Cuba, and the United Kingdom. His work has been displayed at the Scope Art Fairs in Miami and New York, as well as in numerous galleries, but this is his first showing in an American art museum.

Moving between small drawings and graphic interventions directly on the wall, my work is an investigation of the accelerated and uncontrolled growth of cities and their consequential alteration of the natural landscape in the form of billboards and other outdoor signs, telecommunication antennas, construction cranes for buildings, and water towers. The title of this work, New Typologies, *alludes to the work of Bern and Hilla Becher, who photographically documented the industrial landscape, and to the eighteenth-century cataloguers of newly discovered flora and fauna; my flora and fauna take the form of cellular telephone antennas disguised as trees. I use cut paper—a demanding and obsessive technique—to underscore the craft of making and the direct involvement of the artist in the work.*

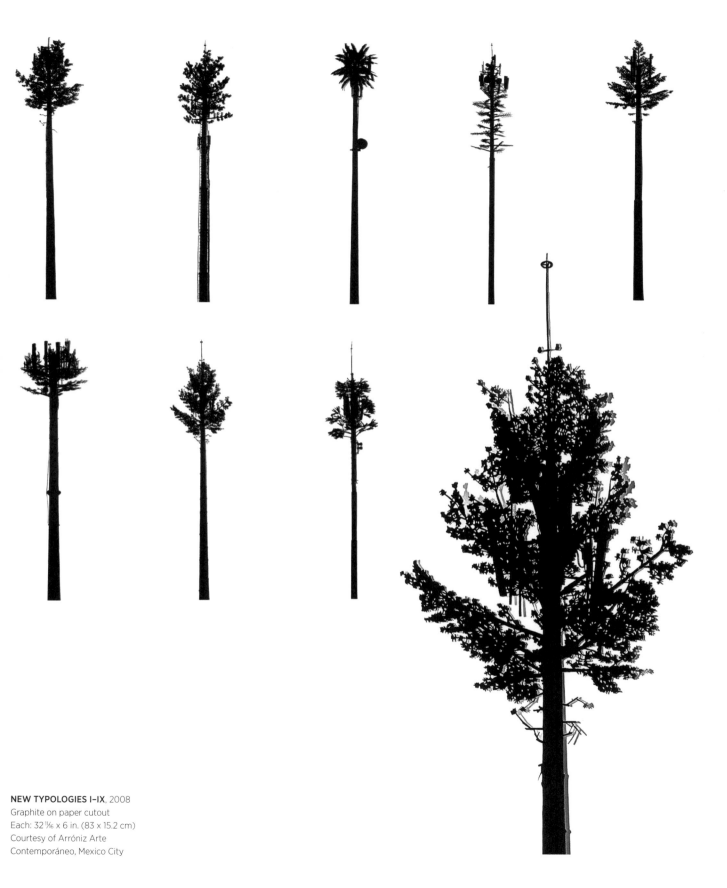

NEW TYPOLOGIES I–IX, 2008
Graphite on paper cutout
Each: 32 ¹³⁄₁₆ x 6 in. (83 x 15.2 cm)
Courtesy of Arróniz Arte
Contemporáneo, Mexico City

Técnica No. 31, 2007
Graphite on paper cutout
33 ½ x 43 ½ in. (85.1 x 110.5 cm)
Courtesy of Arróniz Arte
Contemporáneo, Mexico City

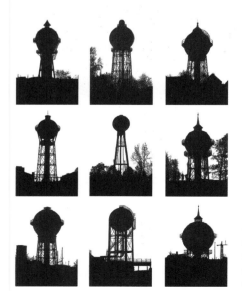

Becher's Typology II, 2007
Graphite on paper cutout
Each: 14 ⅝ x 10 ⅝ in. (37.1 x 26.9 cm)
Courtesy of Arróniz Arte
Contemporáneo, Mexico City

Puente, 2007 (detail)
Paper cutout
Overall: 47 ¼ in. x 39 ft., 4 ⅜ in.
(119.9 x 1199.9 cm)
Courtesy of Arróniz Arte
Contemporáneo, Mexico City

FLAT FILE GLOBE 3A RED VERSION, 2007
Cut Yupo, metal cabinet, Plexiglas
37 x 13 ¾ x 18 ⅛ in. (94 x 34.9 x 46 cm)
Courtesy of the artist

Noriko Ambe

Noriko Ambe was born in Saitama, Japan. She received her BFA in oil painting from Musashino Art University in Tokyo. In 1992 she had her first solo exhibition in Tokyo. In 1999 she came to New York, where she began exhibiting in 2002. Since then she has had four solo exhibitions and has been shown in group exhibitions in the United States, Italy, Canada, Austria, and China, as well as Japan. She has been awarded residencies at the Vermont Studio Center by The Freeman Foundation, and at the Art Omi Residency in Columbia County, New York. Ambe has also received a Pollock-Krasner Foundation fellowship. Her work is found in the collection of the Whitney Museum of American Art, New York, and the K.K.R. Collection, Tokyo, as well as numerous private collections. Ambe's work will be featured at a show at the Flag Art Foundation, New York in 2010.

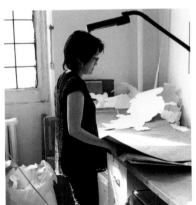

I have been mapping the mysterious land between physical and emotional geography. I want to attain something sublime. The entrance to this area is through attention to details. Details are the key to nature, and we are part of nature. I do not try to draw or cut mechanical or perfect lines in my work, for subtle natural distortions convey the nuances of human emotions, habits, or biorhythms. When I am drawing or cutting lines, I am interested in observing the power of the changing, growing shape. This dynamic shape becomes an entity in itself—another geography. In a sense, the empty space is myself, and the materials represent the present world.

The new sculpture project, made with Yupo synthetic paper, using metal cabinets with drawers and called the Flat File Globe series, began after my solo exhibition of 2006. The work is a metaphor of the human body and also the cross section of the passage of time into the present.

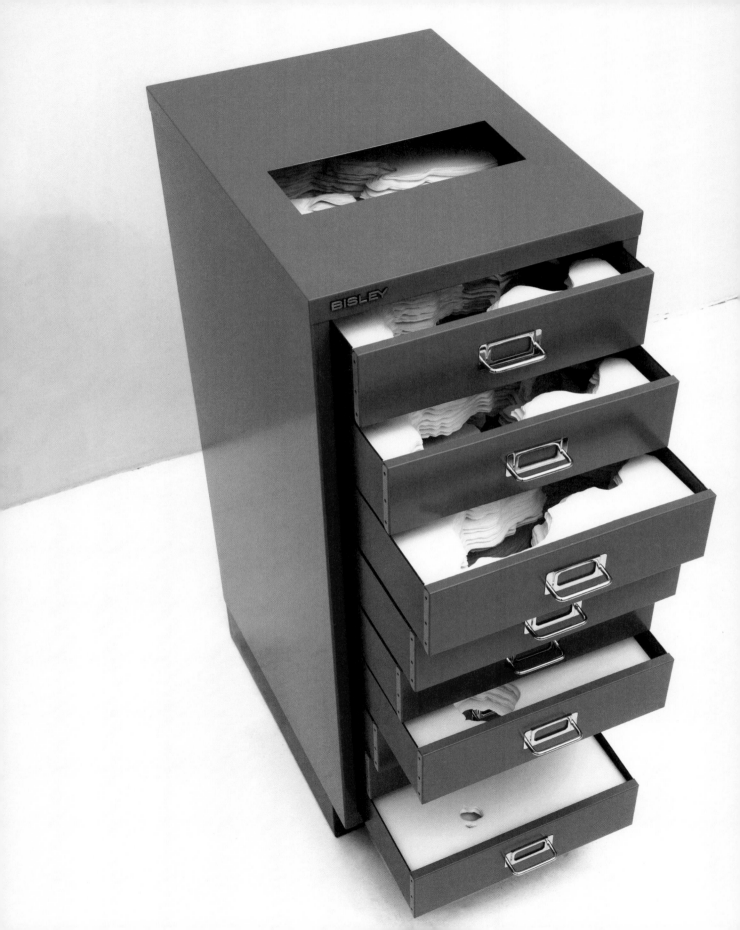

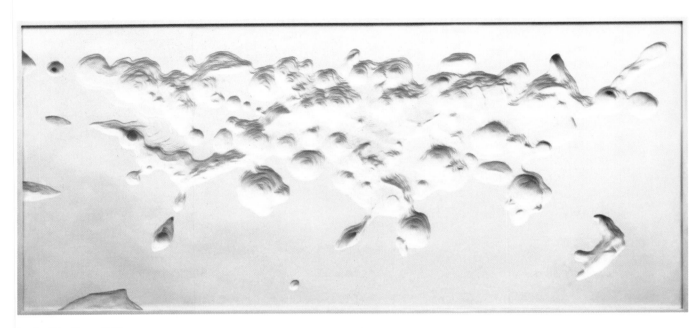

Lands of Emptiness, 2008
Cut on paper
25 ⅜ x 56 x 1 ⁷⁄₁₆ in.
(64.5 x 142.3 x 3.75 cm)
Private collection

FLAT FILE GLOBE 3A RED VERSION,
2007 (detail)
Cut Yupo, metal cabinet, Plexiglas
Overall: 37 x 13 ¾ x 18 ⅛ in.
(94 x 34.9 x 46 cm)
Courtesy of the artist

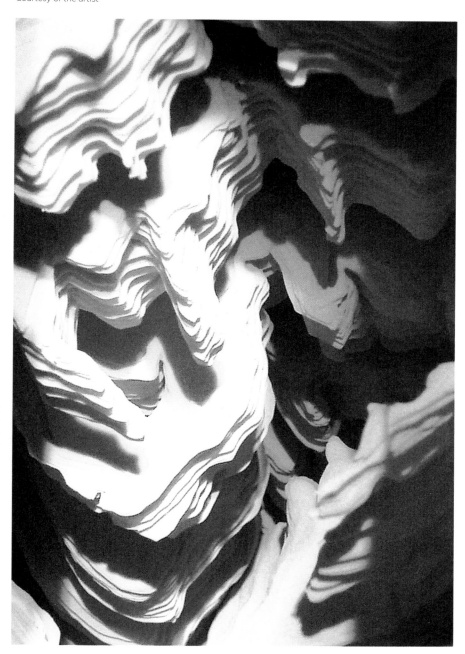

below; and detail:
Sculpaper 1, 2006
Cut on Housho-shi paper, pedestal
16 x 48 x 72 in. (40.6 x 121.9 x 182.9 cm)
Courtesy of the artist

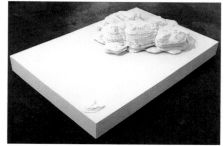

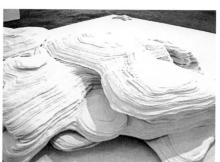

Carlos Amorales

Carlos Amorales was born in Mexico City, where he resides and works today. He studied at the Gerrit Rietveld Academie, Amsterdam, from 1992 to 1995, and at the Rijksakademie, Amsterdam, in 1996. Since 1997, Amorales has had numerous solo exhibitions, most notably at Bard College, Annandale-on-Hudson, New York (2000); the Tate Modern, London (2003); the Contemporary Arts Center, Cincinnati (2008); and the Philadelphia Museum of Art (2008). His work has also been shown at galleries throughout Europe, Canada, South America, and Scandinavia, as well as extensively in Mexico. It is found in many public and private collections, including the Museum of Modern Art, New York; the Cisneros Foundation Collection, New York; the Margulies Collection, Miami; and the Irish Museum of Modern Art, Dublin.

In August 2005 I started an animation studio in Mexico City, Broken Animals, to explore the possibilities of the archive [Liquid Archive, begun 1999] and to make animated films and artworks through a collective of draftsmen, motion-graphic designers, media researchers, and a musician. This working project—an animation collective—is a conscious pauperization of the Walt Disney Studios model: it is a contemporary effort to redirect the understanding of fantasy toward obscurity, where the fantastic can stimulate questions (as well as emotion), without giving answers.

My life is not a performance, my profession is only one part of my life. Actually, I am very interested in removing my personal history from the results of my work. Since personal history is a great source of meaning, however, I enter into a contradiction that I try to solve by masking. I guess my work is very much about masking, that is, about hiding and showing.[1]

1. Quoted in part from Julie Rodriguez Widholm, ed., *Escultura Social: A New Generation of Art from Mexico City*, exh. cat. (Chicago: Museum of Contemporary Art; New Haven: Yale University Press, 2007), 61; and Norma Mangione, "A Pirate Paradise: An Interview with Carlos Amorales," *Uovo*, no. 12 (2006), 134–55 (quote on p. 144).

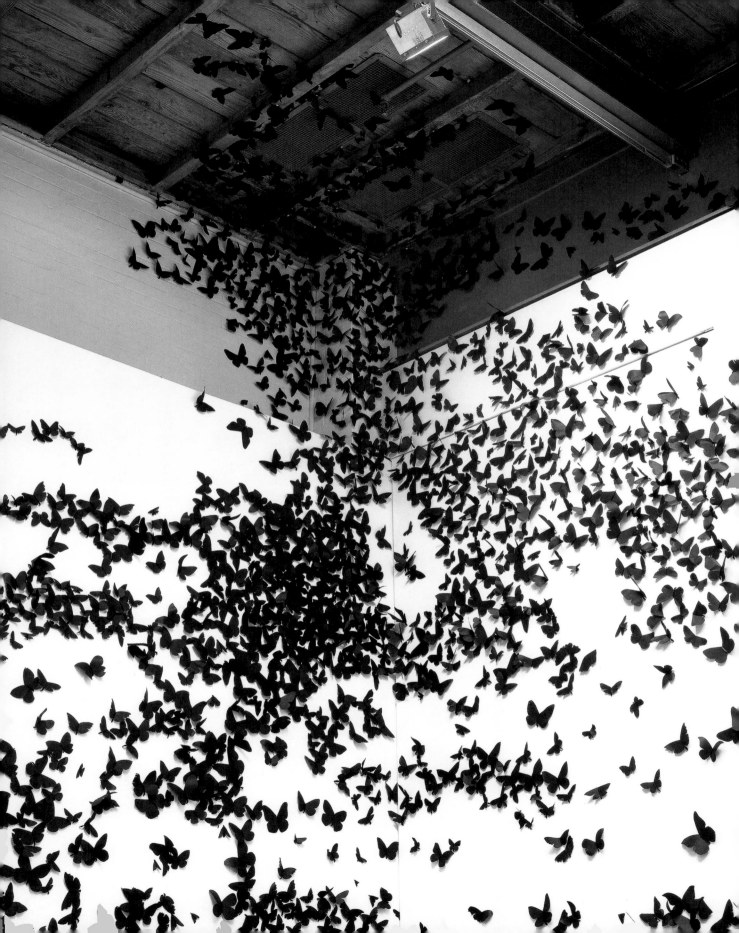

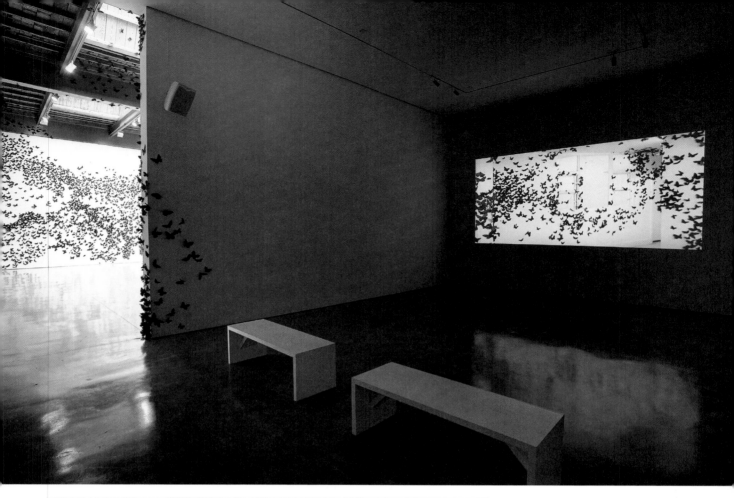

BLACK CLOUD, 2007 (still)
Cut-paper animation
16mm transferred to high-definition
video
© Carlos Amorales; courtesy of
the artist and Yvon Lambert Paris,
New York

BLACK CLOUD, 2007
Cut-paper animation
Installation view at Yvon Lambert
Paris, New York
16mm transferred to high-definition
video
Dimensions variable
© Carlos Amorales; courtesy of
the artist and Yvon Lambert Paris,
New York

FACES, 2007 (still)
Cut-paper animation on video
support with sound
© Carlos Amorales; courtesy of
the artist and Yvon Lambert Paris,
New York

Doug Beube

Doug Beube received his BFA in film from York University in Toronto in 1974 and his MFA in photography from the Visual Studies Workshop in Rochester, New York, in 1983. Beube has been artist in residence at such schools as Penland School of Crafts, North Carolina; Haystack Mountain School of Crafts, Deer Isle, Maine; the MacDowell Colony, Peterborough, New Hampshire; and the Maine College of Art, Portland. He has served as curator for numerous exhibitions of artists' books, photography, works on paper, and artist-modified existing books. He is curator of The Book Under Pressure, an international collection of bookworks for Allan Chasanoff in New York City. He has had over twenty solo exhibitions in Canada and the United States and has participated in countless group shows since 1973. He frequently lectures and has written on books and artists' books. Beube's work can be found in the Brooklyn Museum, New York; the Art Gallery of Ontario in Toronto, Canada; the Walker Art Center, Minneapolis, Minnesota; and the Museum of Modern Art, New York.

My work explores "the book itself," a seemingly antiquated technology that is still purposeful in a digital age. The codex, which literally means a "block of wood" in Latin, is undeviating in its essential form. Its fixity is antithetical to the capabilities of the computer to function on a synergetic/simultaneous plane. I began changing the book's structure in 1979 by pushing its physical properties—piercing, gouging, and excavating it as if it were a thrilling, previously undiscovered site in an archaeological dig. As an artist, I seek to transform a recalcitrant technology—the book—to function outside a linear read.

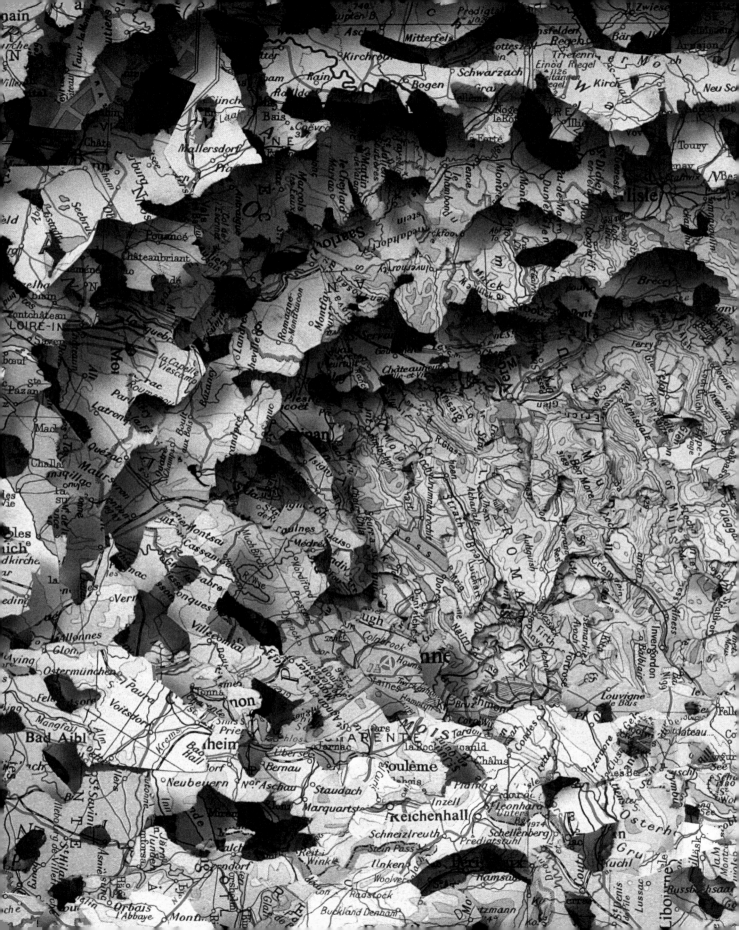

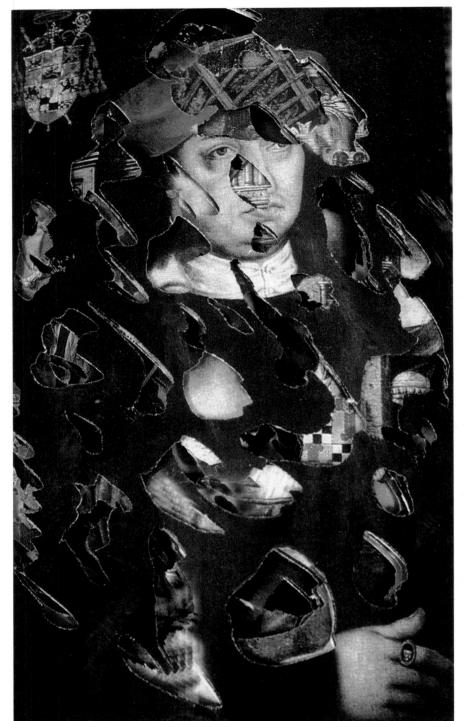

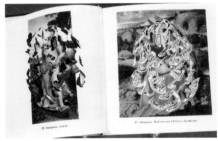

right; detail above:
**Portrait of a Virus in
the Hermitage**, 1995
Altered book
Closed: 7 ⅛ x 7 x ⅝ in.
(18.1 x 17.8 x 1.6 cm)
Collection of the artist

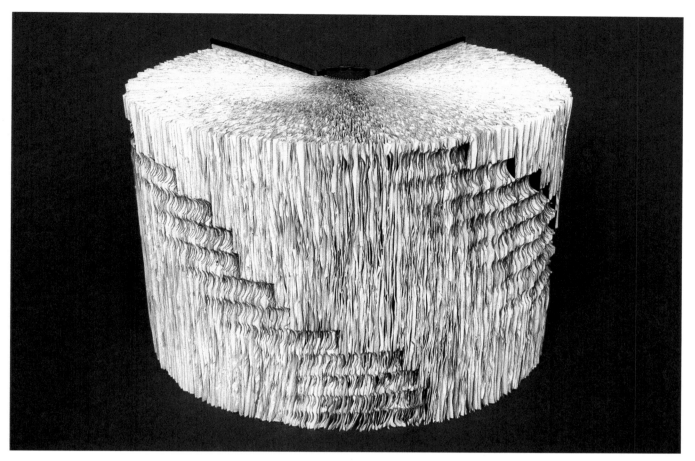

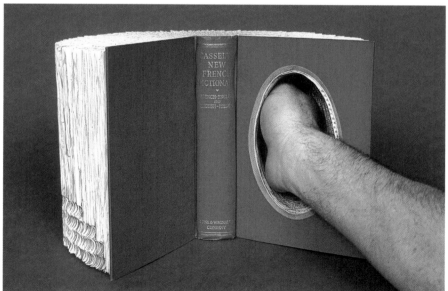

two views:
Ruffled Collar, 2004
Altered French/English dictionary
8 x 11 x 11 in. (20.3 x 27.9 x 27.9 cm)
Collection of the artist

Su Blackwell

Su Blackwell received her BA in arts and design from Bradford College of Arts and Design, West Yorkshire, England, followed by an MA in textiles at the Royal College of Art, London. She has had solo exhibitions in Australia and the United Kingdom, and has participated in group exhibitions in the United States as well as the UK. She has carried out commissions for many clients, including Harvey Nichols in the UK, and Beringer Vineyards, Publicis & Hal Riney, and Kate's Paperie in the US.

My work is a lot about transformation. I take an object of value, such as a book, and de-value it by cutting it up. I then transform it into a "work of art," turning it back into an "object of value." It's as if I take the familiar and turn it into the fantastical. I like to use non-art materials, such as books and clothes, to create works that evoke a sense of dreamy melancholy or magical enchantment. I'm interested in the realm of fairy tales and folk legends. I externalize the stories from the pages of the book, allowing the book to read in a "new way."

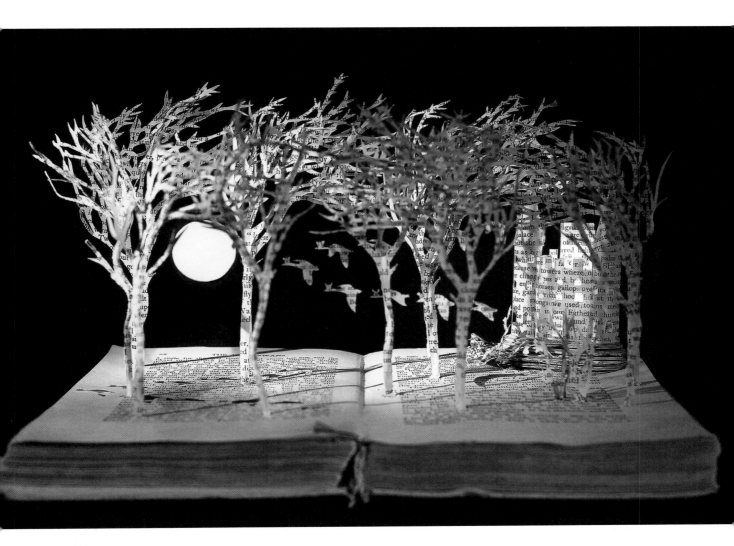

Wild Swans, 2008
Reclaimed book in box
13 ¾ x 9 ⅞ x 10 ¼ in. (35 x 25 x 26 cm)
Courtesy of the artist

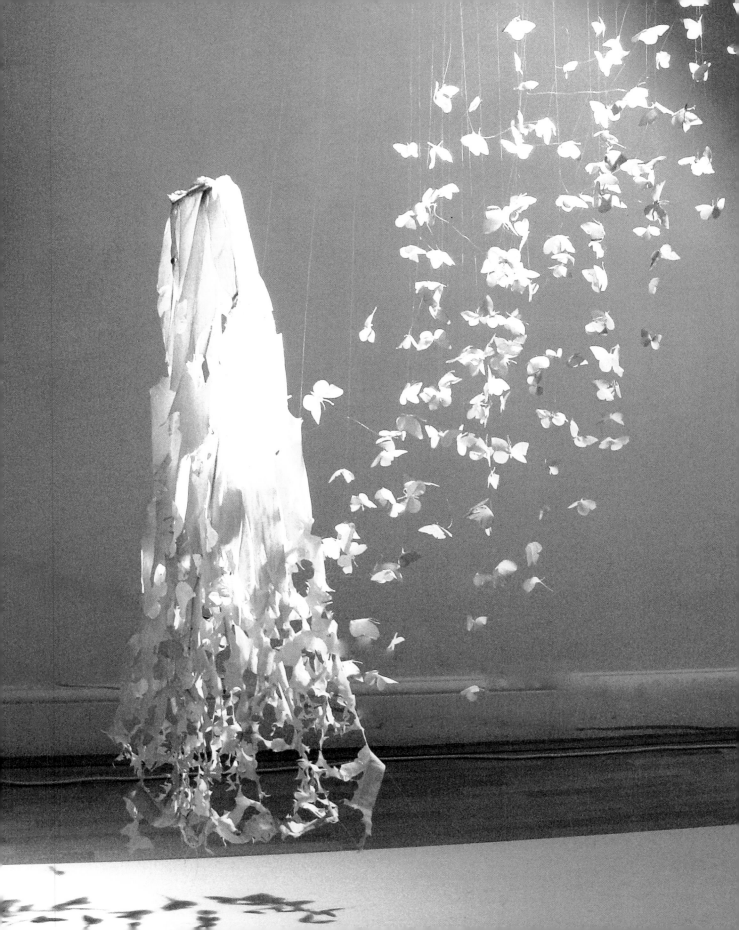

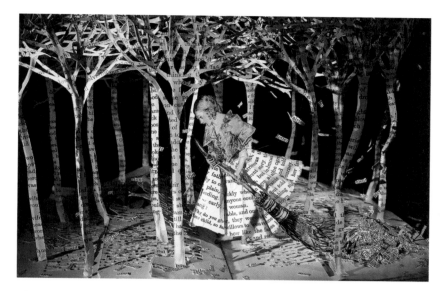

opposite:

While You Were Sleeping II, 2008
Cotton dress, monofilament thread
78 ¾ x 39 ⅜ x 55 ⅛ in.
(200 x 100 x 140 cm)
Collection of Katie Melua

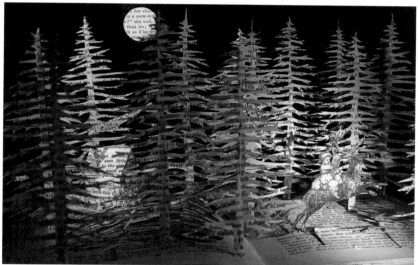

top to bottom:

The Girl in the Wood, 2008 (detail)
Reclaimed book in box
Overall: 13 ¾ x 9 ⅞ x 10 ¼ in.
(35 x 25 x 26 cm)
Courtesy of the artist

The Snow Queen, 2008 (detail)
Book, wood, glass, lights
Overall: 13 ⅜ x 9 ½ x 9 ½ in.
(34 x 24 x 24 cm)
Private collection

The Woodcutter's Hut, 2008 (detail)
Reclaimed book in box
Overall: 13 ¾ x 9 ⅞ x 10 ¼ in.
(35 x 25 x 26 cm)
Courtesy of the artist

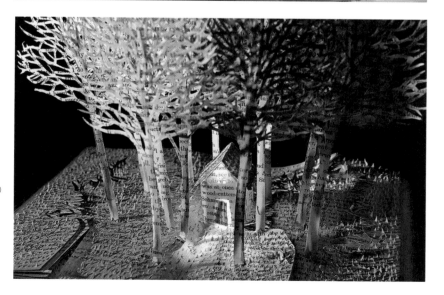

opposite; detail top:
BETWEEN THE LINES, 2007
Cut and altered book
Dimensions variable
Collection of the artist

Ariana Boussard-Reifel

Ariana Boussard-Reifel received her BA in 2003 from Carleton College, Northfield, Minnesota. Today she lives and works in New York City. Her exhibition history began in 2003, and since that time she has participated in exhibitions at the Boulder Museum of Contemporary Art in Colorado; the Holter Museum of Art, Helena, Montana; the Minnetonka Art Center, Wayzata, Minnesota; and the Virginia Commonwealth Sculpture Gallery in Richmond, among others. She has received a postgraduate fellowship and the Ursula Hemingway Jepson Memorial Award from Carleton College, as well as a post-Baccalaureate Residency at Virginia Commonwealth University. She participated in a documentary performance with Lesley Dill, another artist represented in this exhibition.

Superficially, this work is a cheaply printed paperback with the words removed. But with the additional knowledge that this book is a white supremacist bible and the words viciously and exactly describe the necessity of racial segregation, it becomes a quiet plea for unification. I am originally from Montana where, in recent years, there has been a growth in a particular white supremacist group called the World Church of the Creator. This group gained support by disseminating such books as The White Man's Bible, Against the Evil Tide, *and the one that I transformed,* RAHOWA (Racial Holy War): This Planet is All Ours. *I cut out all of the black ink, left the white pages pristinely intact, and consequently rendered the book meaningless. I saved the words and present them alongside the book to act as traces of the making as well as to note the contrast in color and purpose.*

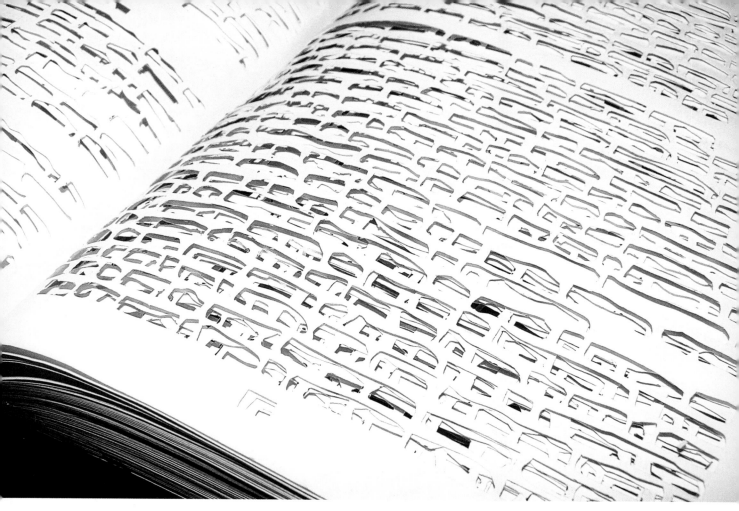

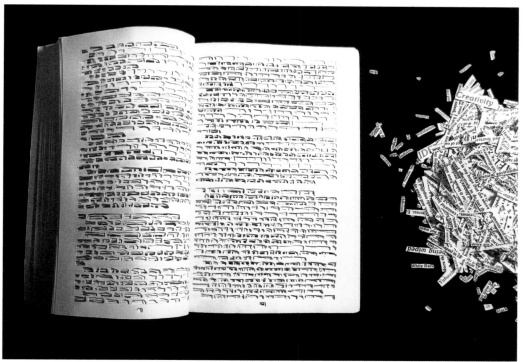

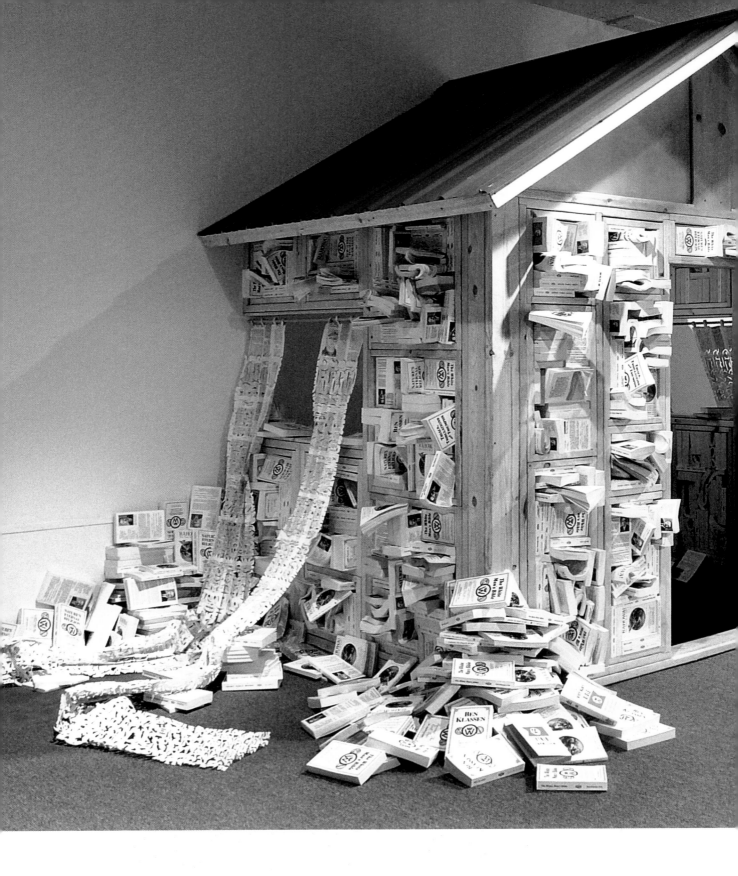

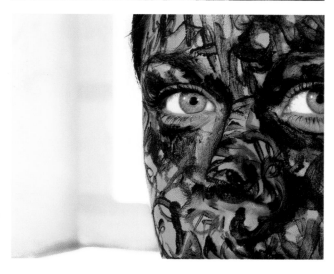

opposite:
Ariana Boussard-Reifel and
Dana Boussard
Hate Begins at Home, 2007
Construction materials, white
supremacist books, digital
projection
Dimensions variable
Collection of the artist

three views:
Ariana Boussard-Reifel and
Dana Boussard
Like Mother, Like Daughter, 2007
Digital projection
Dimensions variable
Collection of the artist

Célio Braga

Born in Brazil, Célio Braga studied at the Boston Museum School of Fine Arts, and subsequently at the Gerrit Rietveld Academie in Amsterdam, the Netherlands, where he lives today. Braga has been nominated for the Gerrit Rietveld Prize and has received an award and stipend from the Fonds BKVA in Amsterdam. His work has been collected by such noted institutions as the Stedelijk Museum, Amsterdam; the European Ceramic Work Centre Den Bosch (where Braga was also artist in residence in 2006); the Museu de Arte Contemporânea, Goiás, Goiânia, Brazil; and the Textielmuseum, Tilburg, the Netherlands. Braga's solo and group exhibitions have been at international venues in Spain, Finland, Sweden, the United Kingdom, the United States, the Netherlands, and his native Brazil.

My work deals with the fragility of the human body. I am particularly interested in the relation between the rational value of life, its inevitable transience, and our ritualized attempts to embellish, protect, save, and cure our bodies.

Placebos is a natural blossoming. I think a lot about the big water-lily paintings of Monet. However, since the colors of my flowers are mostly white, black, blue with random accents of red and sometimes yellow, it is almost like a color study, minimal, almost invisible. It first attracts you by beauty and then confronts you with the material the flowers are made of—the printed description and contra-indications attached to containers of prescription medicines. The thousands of small flowers, arranged as wreaths and garlands, reflect the hard reality of our relations with medicines, and with our own impermanence and fragility. The medicine notices that I use to make the flowers and the chains for the curtains are collected and given to me by family members, acquaintances, friends, and friends of friends. They range from simple painkillers (aspirin, for example) to powerful drugs to combat AIDS, cancer, and heart disease.[1]

1. From the artist's website, www.celiobraga.com (accessed May 2009); and Célio Braga to David McFadden, email correspondence, September 23, 2008.

PLACEBOS, 2008–9 (detail)
Medicine instructions, clear tape,
paper, C-print cutouts
Dimensions variable
Collection of the artist

Rob Carter

Rob Carter received his BFA from the Ruskin School of Drawing and Fine Art at Oxford University in 1998. In 2000 he relocated to New York City to attend Hunter College, receiving his MFA in 2003. Since then he has exhibited in numerous places in Europe and the United States. In 2008 he attended the Art Omi International Artists Residency in upstate New York, was a West Prize finalist, and was awarded studio space for 2008–9 at the Marie Walsh Sharpe Foundation in Brooklyn. Carter has had solo exhibitions in Italy, Spain, and the United Kingdom. He currently lives and works in Brooklyn.

My videos and photographs examine paper as both a physical object and a malleable document of the real. The work employs stop-motion animation, time-lapse video, and photographic "re-constructions" to spotlight the iconic and political structures in our urban environment, especially sports stadia, skyscrapers, churches, and other historical landmarks. The most recent work draws parallels between the inspiration of the natural world and the human manipulation and control of it in the past, present, and future.

three stills:
Metropolis, 2008
Cut-paper animation
Black & white/color/sound; total
running time: 9 min., 30 sec.
HD DVD video

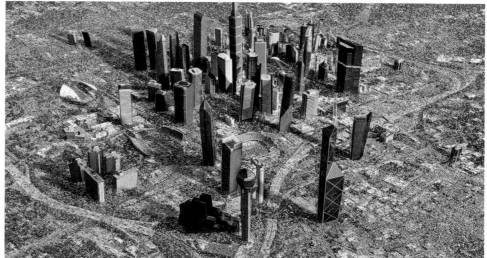

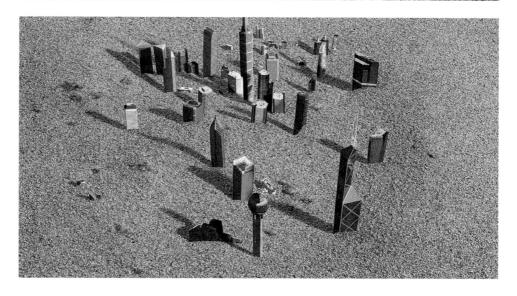

top to bottom:
Landscaping I (part 3), 2008
Cut paper; digital C-print
40 x 61 ¼ in. (101.6 x 155.6 cm)
Courtesy of the artist

Landscaping II (part 2), 2008
Cut paper; digital C-print
40 x 74 ½ in. (101.6 x 189.2 cm)
Courtesy of the artist

Fort Dallas, 2006
Cut paper; C-print
39 x 28 ½ in. (99.1 x 72.4 cm)
Courtesy of the artist

HEAVENS, 2009 (detail)
Cut Tyvek; edition of 3
Overall: 12 ft., 10 in. x 45 in.
(3.9 m x 114.3 cm)
Collection of the artist

Béatrice Coron

Born in Chambéry and raised in Lyon, France, Béatrice Coron has lived internationally, in such diverse places as Mexico, Taiwan, and Egypt. Today her studio is located in New York. Her work ranges from cut Tyvek panels of often extraordinary widths—such as the 27-foot panels for a series titled The Whole Nine Yards—to unique artist books, public art commissions in cut steel, and light sculptures. Coron's work has been collected by major institutions worldwide, including the Metropolitan Museum of Art, New York; the Walker Art Center, Minneapolis; the Pierpont Morgan Library and Museum, New York; the Library of Congress, Washington, DC; and by universities and colleges throughout the United States, including Yale University, Princeton University, and UCLA.

I invent cities, worlds, and situations. They are memories, associations of words, ideas, observations, and thought that unfold in improbable juxtapositions. Each observer makes his or her own story in this accumulation of real or imaginary lives, as a way to remember the past and foresee the future. My creative inspiration can come from a text, poem, or concept. The cutting blade traces labyrinths and poetic meandering. Everything is time and space. The viewer is invited to find his or her own way in these worlds.

above; and detail:
Animal Alphabet, 2001
Cut and stenciled Arches paper;
edition of 15
Dimensions variable; right:
6 x 6 x 6 in. (15.2 x 15.2 x 15.2 cm)
Collection of the artist

Bronx Literature, 2006
Faceted glass
15 x 4 ft. (457.2 x 121.9 cm)
Courtesy of MTA New York City,
commissioned by the Metropolitan
Transportation Authority/Arts for
Transit

opposite, top to bottom:
Water City, 2005
Cut Tyvek
31 x 48 in. (78.7 x 121.9 cm)
Collection of the artist

Habitats & Vagabonds (from the
Whole Nine Yards series), 2007
Cut Tyvek
27 ft. x 45 in. (8.2 m x 114.3 cm)
Collection of the artist

Thomas Demand

German native Thomas Demand studied sculpture at the Akademie der Bildenden Künste, Munich, and the Kunstakademie Düsseldorf. He earned his MFA from Goldsmiths, University of London. His first solo exhibition was held in 1992 when he was twenty-six years old, and since then he has had over fifty solo exhibitions at international galleries as well as such renowned museums as the Museum of Modern Art, New York; Louisiana Museum of Modern Art, Humlebæk, Denmark; and the Serpentine Gallery in London. His work has appeared in group exhibitions and is in major public and private collections around the world.

We all know what things look like when they don't look like anything. There's a total lack of ambition about surroundings, a lack of ideas or design. It leaves you alone. I like that.

Photography is less about representing than about constructing its objects. I think that is one of the central points of my work: to reconsider the status of the image by producing one particular moment of perfection.[1]

Paper is the material of temporary notation. It doesn't make a big difference whether this is in writing or is three-dimensional. Every model—indeed, every type of rapid visualization—is easiest to do with paper. It's also the material you can get rid of most quickly—not just in a practical sense, but in an emotional one, too. When a paper model is damaged, then it's damaged, no more, no less. It's a strange anything-material that can be anything, but is rarely itself. And for me, it (a blank sheet of paper lying in a room) can become the protagonist, the actor, as it were. But it's always the same piece of paper. Basically it's the "Zelig" of all materials.

1. Quoted in part from David Colman, "Possessed: Just the Basics, in Shades of Gray," *New York Times*, November 11, 2007; and Neville Wakefield, "Sites Unseen," *Art Review* (February 2005), 66.

Copyshop, 1999
Chromogenic print on photographic
paper and Diasec; edition of 6
72 ¼ x 118 in. (183.5 x 299.7 cm)
Courtesy of 303 Gallery, New York

Fence/Zaum, 2004
C-print on Diasec
71 x 90 ½ in. (180.3 x 229.9 cm)
Courtesy of 303 Gallery, New York

Landing, 2006
C-print on Diasec; edition of 6
71 x 112 ½ in. (180.3 x 285.8 cm)
Courtesy of 303 Gallery, New York

Brian Dettmer

Brian Dettmer studied art and design and art history at Columbia College in Chicago, where he was born. While still in school, he worked at a sign shop in which letters and language assumed sculptural, visual, and intellectual roles. His early studio works explored the physicality of language, and he began shredding books to include in his paintings. This ultimately led to modifications of entire books. Dettmer's work has been shown in both solo and group exhibitions at museums and galleries in the United States and Europe, and at numerous art fairs around the world. His work is in private and public collections throughout the United States, Latin America, Europe, and Asia.

As information evolves into smaller, faster forms, its physicality disappears and stability is lost in the constantly shifting liquid landscape of digital data. Old books, records, maps, tapes, and other media are often reduced to status symbols or decorative devices, rather than serving as true conveyors of content. By altering preexisting materials and shifting their functions, new and unexpected roles emerge. Through meticulous excavation or concise alteration, I edit or dissect communicative objects such as books, maps, and tapes to explore their inherent meanings and material conditions. I begin by sealing an existing book or series of books to create an enclosed vessel. I work with knives, tweezers, and other surgical tools to carve through one page at a time. As each new layer reveals itself, I cut around ideas and images of interest. Records of the past solidify, shift, or slip away, as new ideas fracture and reform.

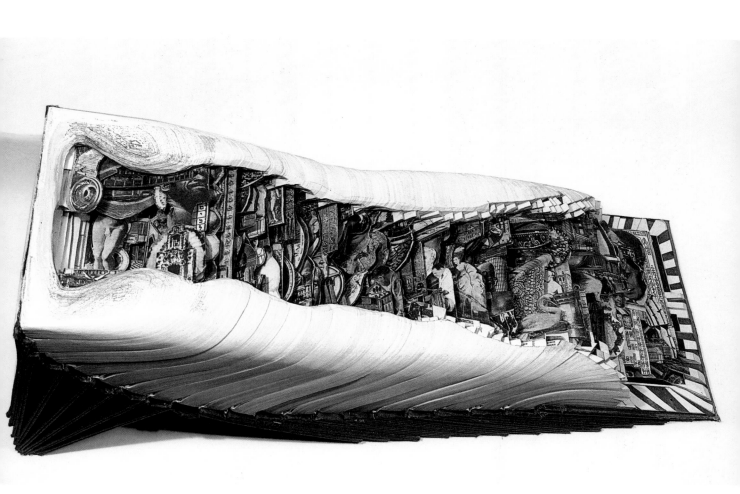

STANDARD AMERICAN, 2008
Altered set of encyclopedias
9 ¼ x 26 x 9 ½ in. (23.5 x 66 x 24.1 cm)
Courtesy of the artist and Kinz + Tillou
Fine Art

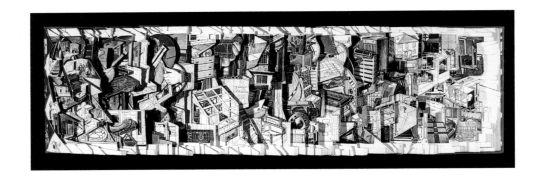

top; and detail:
Do It Yourself, 2009
Altered books
9 x 31 ½ x 4 ½ in. (22.9 x 80 x 11.4 cm)
Courtesy of the artist and
Packer Schopf Gallery

left; detail above:
Godfathers 1–3, 2007
Altered VHS tapes
62 x 27 x 23 in. (157.5 x 68.6 x 58.4 cm)
Courtesy of the artist and MiTO Gallery

Andrea Dezsö

A PAIR OF FEMALE LEGS RESTING IN A FOREST, 2009
THEM BEFORE US, 2009
ALIEN CHILD WITH HANGING MEAT, 2009
SELF PORTRAIT WITH INSIDE VIEW, 2008
Four from a series of thirty tunnel books
Hand-cut paper, thread, acrylic paint, mixed media
Each: 7 x 5 x 6 in. (17.8 x 12.7 x 15.2 cm)
Collection of the artist

Romanian-born Andrea Dezsö, a visual artist and writer, earned her BFA and MFA in visual communication at the Hungarian University of Design in Budapest. Following a year of teaching at her alma mater, Dezsö moved to New York, where she exhibited her work in galleries and held teaching positions at Parsons School of Design and the City University of New York. In addition to solo exhibitions in the United States, Europe, and Japan, she has participated in numerous group exhibitions. Her public art projects are found in Budapest and in the New York subway at the Bedford Park Boulevard–Lehman College station. Dezsö's illustrations have appeared in *The New York Times*, *Harper's Magazine*, *Time Magazine*, *Men's Health*, *McSweeney's*, *Blab*, and on book covers. Her writing was published in *McSweeney's*, *Print*, and *Esopus*. Currently, she is assistant professor of media design at Parsons The New School for Design in New York.

I started making one-of-a-kind books in 1992 as an exchange student in London. In my "tunnel books," cut-paper scenes are arranged in expandable layers, creating a miniature theater stage for presenting the narratives inside. My tunnel books reveal imagined worlds; scenarios arising from the subconscious, based on my personal experience— physical, psychological, spiritual, and the strange in-betweens; living in my body, in my mind, dreams, memories, and anxieties, hopes, obsessions. They refer back to my childhood, which never entirely went away.

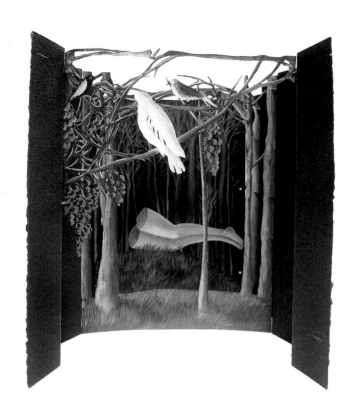

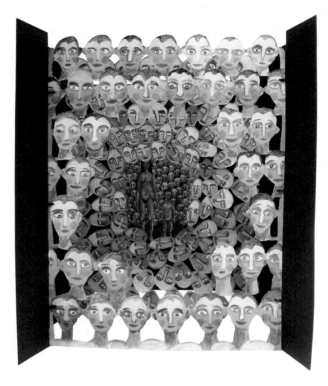

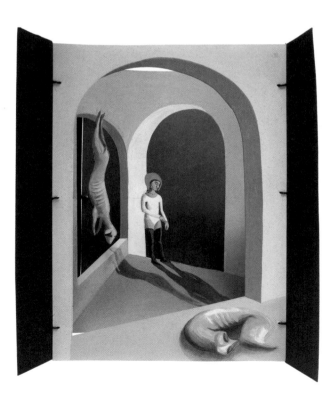

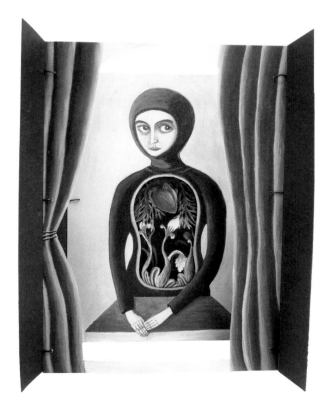

**The Day We Changed Our Lives
Forever—Devil's Cave**, 2005
(three details)
Hand-cut paper, thread, interactive
LED lights, computer
Each: 5 x 7 x 6 in. (12.7 x 17.8 x 15.2 cm)
Collection of the artist

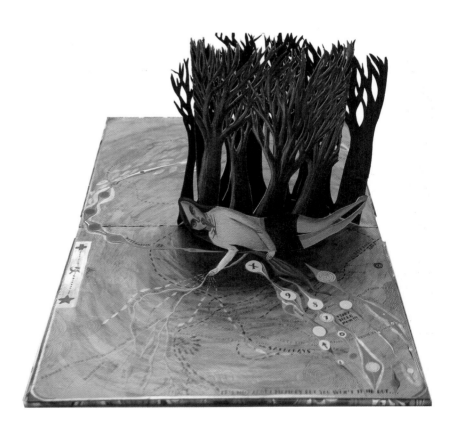

**Pioneers Give First Aid to
Their Comrades**, 2007
Paper, thread, acrylic paint,
mixed media
6 x 8 in. (15.2 x 20.3 cm)
Collection of the artist

Heart, 2004
Cotton embroidery thread on
white cotton canvas
8 x 10 in. (20.3 x 25.4 cm)
Collection of the artist

Lesley Dill

Maine-born Lesley Dill received her undergraduate degree in English at Trinity College, Hartford. She studied educational philosophy and earned a teaching degree at Smith College, and an MFA from the Maryland Institute College of Art, Baltimore, in 1980. She has been accorded fifty solo exhibitions throughout the United States and abroad. In addition to a wide range of visual art, Dill has created many performance works, including her experimental opera, *Divide Light,* which she conceived and produced in 2008, based on the writings of Emily Dickinson. Her work is found in numerous museum collections such as the Art Institute of Chicago; the Library of Congress, Washington, DC; the Metropolitan Museum of Art, New York; the Museum of Modern Art, New York; the Whitney Museum of American Art, New York; and Yale University Art Gallery, New Haven. Among her many awards and honors are a Joan Mitchell Foundation Grant, a sculpture fellowship from the National Endowment for the Arts, and the Anonymous Was a Woman award for 2008.

Ideas come to me in rivers, in buckets, in floods. So I have to sieve them for the best ideas. And the doubt that then comes after, in the process of choosing and making the art, helps to scour the work to finality and hopefully keeps an edge. There's an austere, difficult quality to making art because of the ruthless-ness with which one has to leave things out. As an artist, you have to be able to kill as well as give birth. You have to be able to bring an image out into the world, and then, if it doesn't work, if it doesn't make it in the eye of scrutiny, then you have to let it go. But my first impulse is just to let the ideas come.[1]

1. Quoted from Dede Young, "The Gesture of an Open Hand; Dede Young and Lesley Dill in Conversation September 2006," in *Lesley Dill: Tremendous World*, exh. cat. (Purchase, NY: Neuberger Museum of Art, 2007), 24.

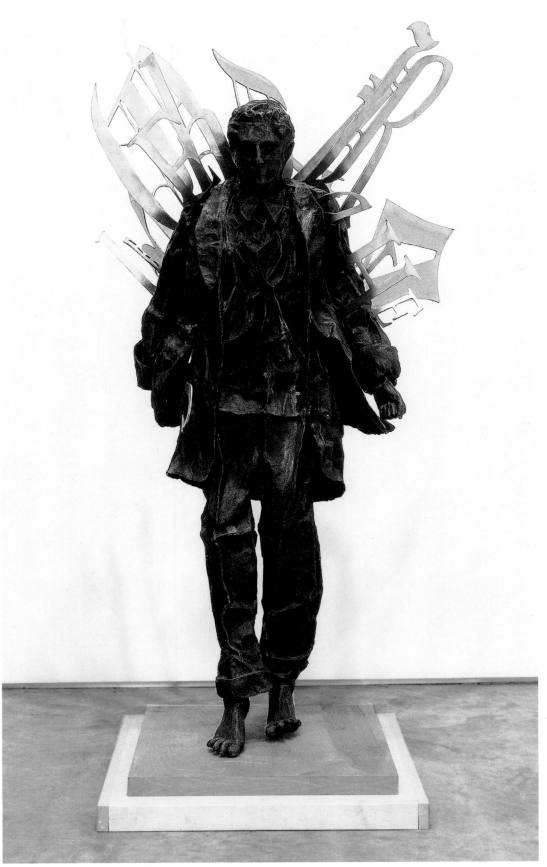

Standing Man with Radiating Words, 2006
Unique cast bronze
61 x 35 x 28 in.
(154.9 x 88.9 x 71.1 cm)
Collection of the New Orleans
Museum of Art, Louisiana

Rise, 2006–7
Laminated fabric, hand-dyed
cotton, paper, metal, silk organza
with cotton
Dimensions variable
Courtesy of the artist and
George Adams Gallery, New York

Still from **Divide Light**, 2008
Opera conceived and directed
by Lesley Dill; music by Richard
Marriott; filmed by Ed Robbins
Courtesy of the artists and
George Adams Gallery, New York

Olafur Eliasson

Olafur Eliasson was born in Copenhagen in 1967 and grew up in both Iceland and Denmark. He attended the Royal Danish Academy of Fine Arts in Copenhagen from 1989 to 1995, and since the mid 1990s, his work has been widely shown internationally. His projects range from photographic series to large-scale site-specific installations. Much of his work explores human perception, both as a cultural construction and as a natural phenomenon. In 2008, Eliasson's project *The New York City Waterfalls*, which consisted of four man-made waterfalls, was installed on the East River. This installation for New York followed the artist's immensely popular 2003 presentation of *The weather project* at the Tate Modern's Turbine Hall. The artist's mid-career retrospective, *Take your time: Olafur Eliasson*, which opened at the San Francisco Museum of Modern Art in 2007, has subsequently traveled to the Museum of Modern Art, New York, and PS 1 (2008), the Dallas Museum of Art (2008), and the Museum of Contemporary Art, Chicago (2009). In 2010, *Take your time* will travel to the Museum of Contemporary Art, Sydney.

Reading a book is both physical and mental. It is like walking through a house, following the layout of the rooms with your body and mind: the movement from one room to another, or from one part of the book to another, constitutes an experiential narrative that is physical and conscious at the same time.

Historically, reading has been seen as a mental activity, and the narrative of the story as taking place on the plane of the mind. The narrative may depict or evoke spaces, but these, being experienced through verbal descriptions, are understood as conceptual, not physical. And yet, when you are flipping through the pages of a book, your body continues to exist. On a basic level, gravity keeps you in your chair, but more than that, your body is tied up in the sensation of the narrative.

Since the Renaissance the dominant conception of space has separated the body from consciousness. The experience of space has been located either in the body or in the mind, but not in both simultaneously; and body and mind were polarized in our culture into different areas of research, discounting their influence on one another. Throughout the twentieth century, however, the relationship between body and consciousness was reconsidered, and by the end of the millennium, phenomenology had been integrated productively into the spatial sciences, as in recent research into the functioning of the nervous system. Following this, I like to see the body as a brain: everything in the mind is also in the body, and everything body-related is also in the mind. We cannot sense our body without consciousness.

The experience of body and brain as a whole has crucial consequences for our understanding of space, as it allows new ideas about space and movement to emerge. Space is no longer considered static but is seen as being of time, and engaging with space consequently becomes a temporal activity. It is our engagement with our surroundings that constitutes space. Ideas like this open up the possibility of reading the narrative sequence constituted by moving through a house as a book, and vice versa.

below; detail bottom:
YOUR HOUSE, 2006
Published by the Library Council of
the Museum of Modern Art, New
York; edition of 225; 25 artist's proofs
4 ½ x 17 ¾ x 11 ½ in. (11.5 x 45 x 29 cm)
Courtesy of the artist and Tanya
Bonakdar Gallery, New York

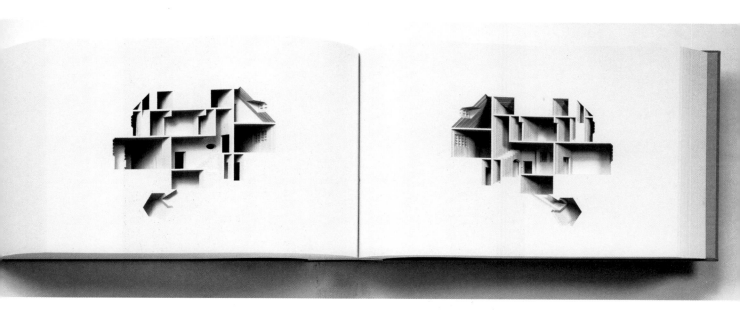

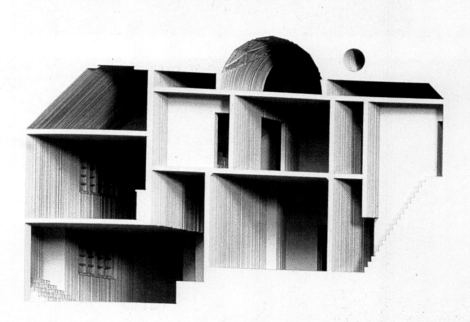

The weather project, 2003
Installation view at Turbine Hall,
Tate Modern, London 2003
Monofrequency lights, projection
foil, haze machine, mirror foil,
aluminum, scaffolding
Dimensions variable
Courtesy of the artist; Tanya
Bonakdar Gallery, New York; and
neugerriemschneider, Berlin

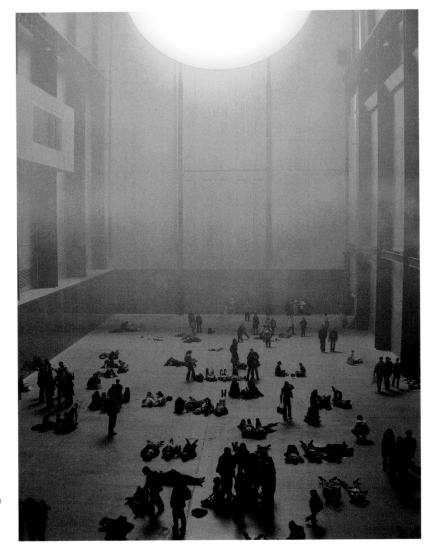

I only see things when they move,
2004
Installation view at Tanya Bonakdar
Gallery, New York
Wood, color-effect filter glass,
stainless steel, aluminum, HMI lamp,
tripod, glass cylinders, motors,
control unit
Dimensions variable
Collection of the Museum of Modern
Art, New York; gift of Marie-Josée
and Henry Kravis in honor of
Mimi Haas

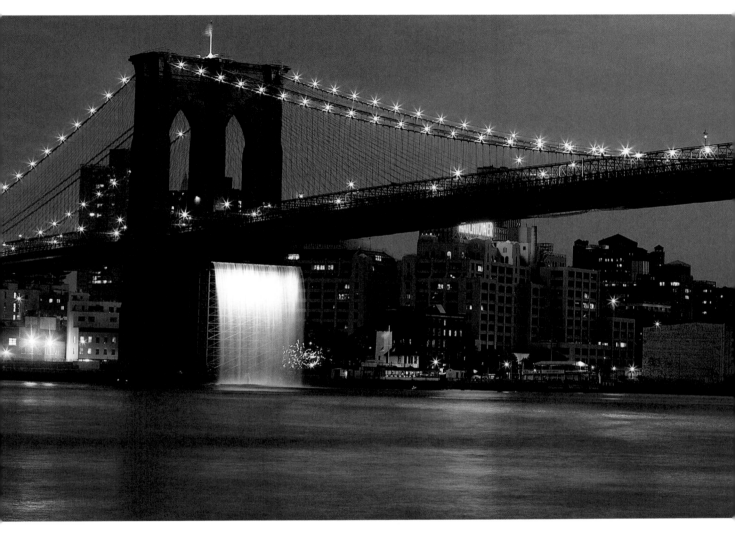

New York City Waterfalls, 2008
Presented by the Public Art Fund
in collaboration with the City of
New York
Courtesy of the artist and Tanya
Bonakdar Gallery, New York

Adam Fowler

Brooklyn-based artist Adam Fowler received his BFA from the Maryland Institute College of Art in Baltimore in 2001. His career has comprised four solo exhibitions since 2005 and over thirty-five group shows throughout the United States. Fowler was the recipient of a Pollock-Krasner Foundation Grant, as well as a Young Artist Program Grant from the DC Commission on the Arts and Humanities in Washington, DC.

I have always been drawn to paper as a medium. Paper is ubiquitous and readily available; the very ordinariness of paper appeals to me. I like to think of my work as falling somewhere between drawing, sculpture, and collage. My current body of work began as an experiment in drawing. My drawings became more and more dense, but I still wanted more. Then I realized that cutting away the ground and leaving only the drawn lines allowed me to achieve the depth I was seeking. Today, the work evolves from piece to piece by adding new elements to it, then refining and/or discarding them. The two processes—drawing and cutting—are physically and intellectually different. One is quick, the other slow. While the cutting requires a much bigger time commitment than drawing, it's not the time invested in each work that I want the viewer to think about when they first see my work. Rather, I hope that they are aware of a quiet intensity and concentration that comes from a meditative state.

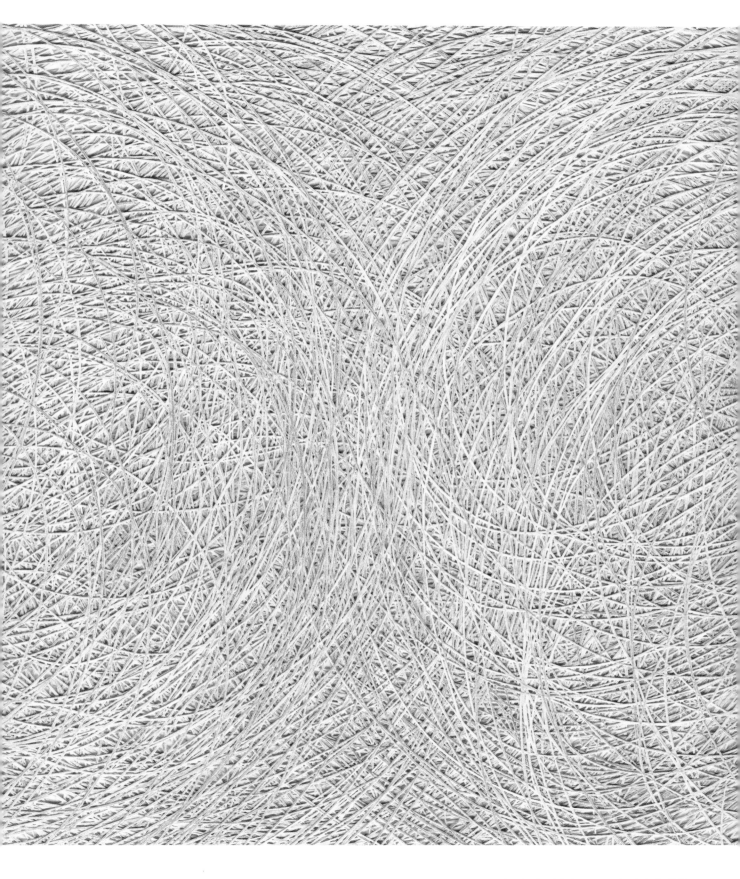

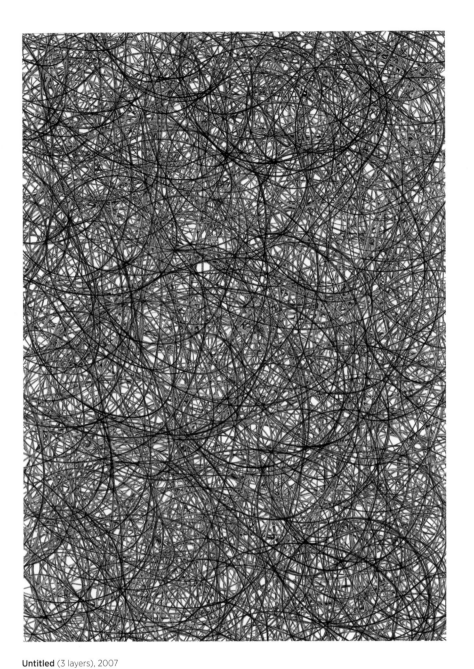

opposite:
Untitled (30 layers), 2008
Graphite on paper, hand-cut
and layered
13 x 14 in. (33 x 35.6 cm)
Courtesy of the artist and
Margaret Thatcher Projects

Untitled (3 layers), 2007
Graphite on paper, hand-cut
and layered
36 x 24 in. (91.4 x 61 cm)
Collection of Robert and
Felicia Lipson

Untitled (33 layers), 2008
Graphite on paper, hand-cut
and layered
16 ½ x 12 in. (41.9 x 30.5 cm)
Collection of Jerry Marksohn
and Doris Mukabaa Marksohn

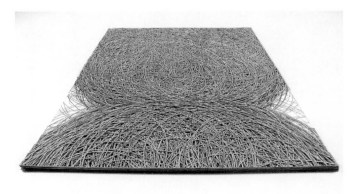

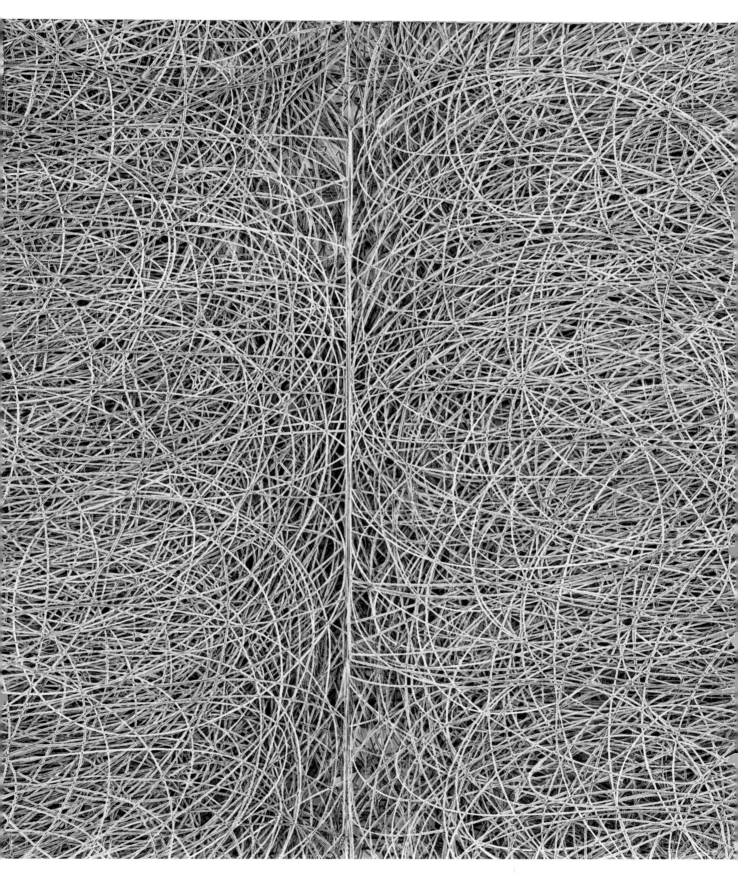

Mark Fox

Mark Fox received his BFA from Washington University, St. Louis, Missouri, and his MFA from Stanford University, Stanford, California. He was the co-founder and creative director of Saw Theater in Cincinnati, a nonprofit contemporary puppet theater that produced performances in collaboration with artists and writers. Since his first solo exhibition in 1991, Fox's body of work has included extensive performance pieces, videos, paintings, drawings, and large-scale installations. Among his many artist residencies, fellowships, and awards are those from the Detroit Institute of Arts, the Ohio Arts Council, the Jim Henson Foundation, Kultureferat (Munich, Germany), and, most recently, the Foundation and Center for Contemporary Art in Prague, Czech Republic. Fox's work is found in the collections of the Museum of Modern Art, New York; the Whitney Museum of American Art, New York; the Philadelphia Museum of Art, Pennsylvania; and the Cincinnati Art Museum, Ohio, among others.

opposite:
Untitled (We are Lost), 2007
Ink, watercolor, acrylic, marker, gouache, graphite pencil, colored pencil, ballpoint pen, and crayon on paper with linen tape, Mylar, metal pins
88 x 63 x 15 in. (223.5 x 160 x 38.1 cm)
Private collection; courtesy of
Larissa Goldston Gallery

My first cut-paper work developed out of a practice of examining images otherwise considered marginal or secondary. This was accomplished by accumulating random marks, stains, ancillary images, peripheral doodles, and incidental paint splatters, created on "scrap" paper while making more formal drawings in the studio. I then cut these images from their paper grounds, paying acute attention to the edges these marks created. These cut images were then arranged according to parameters I set for myself, which were faithful to the random nature of the mark-making itself. Throughout my career, beginning with my performance-based pieces in the early 1990s, I have been concerned with the theme of manipulation. The cut-paper work resulted in a kind of reverse manipulation wherein the process generated by-products that manipulated my movement and time.

After following the dictates of this work for a number of years, I am now concerned with transcribing and reevaluating various religious, political, and mythological texts, which describe accepted truths. By taking a razor to these transcribed doctrines, I am seeking to examine the edges of these dogmas; to scrutinize the ways in which their meanings and implications underpin contemporary culture. In reassembling these doctrines into forms that have meaning to me, I am also returning to the issue of manipulation and the constantly shifting locus of control between artist and subject. I often mount these forms on structures that reference vernacular materials, such as cardboard, plywood, sawhorses, and other construction supplies. I am concerned here with the irony of how seemingly simple lives and quotidian concerns often support (and are supported by) lofty and even preposterous dogma that is accepted at face value as Truth.

left; detail above:
Untitled (Barbelo), 2007
Ink, watercolor, acrylic, marker,
gouache, graphite pencil, colored
pencil, ballpoint pen, and crayon on
paper with linen tape and metal pins
48 x 22 x 14 in. (121.9 x 55.9 x 35.6 cm)
Private collection; courtesy of
Larissa Goldston Gallery

opposite:
White Sawhorseman, 2008
Acrylic enamel on paper with linen
tape, wood, and metal pins
72 x 29 x 48 in. (182.9 x 73.7 x 121.9 cm)
Private collection; courtesy of
Larissa Goldston Gallery

Tom Friedman

Tom Friedman studied graphic illustration at Washington University, St. Louis, where he received his BFA, and sculpture at the University of Illinois, Chicago, receiving his MFA in 1990. Friedman's first solo exhibition was in 1991, and since that time he has had more than thirty solo exhibitions in Italy, the United Kingdom, Poland, Switzerland, Japan, the United States, and elsewhere. World-renowned museums have hosted shows of Friedman's work: the Museum of Modern Art, New York; the Art Institute of Chicago; the Fondazione Prada, Milan; and the South London Gallery. A major exhibition toured the United States from 2000 to 2002.

opposite:
QUAKER OATS, 2009
Quaker Oats boxes, Quaker Oats, glue
115 ½ x 12 x 12 in.
(293.4 x 30.5 x 30.5 cm)
Courtesy of the artist and Gagosian Gallery

1. Purchase 35 Quaker Oats boxes.
2. Remove all the Oats from inside and save.
2a. Save one of the lids.
3. Take 12 of the boxes and place in warm water for one hour.
4. Remove the boxes from the water.
5. Gently, without tearing, remove the labels on all 12 boxes.
6. Remove all excess cardboard attached to labels.
7. Lay labels flat between blotter paper and plywood sheets to flatten and dry.
8. Choose one label as the standard.
9. Cut off, using a sharp X-Acto knife, all the white around the label.
10. Tape down flat to a light table this label.
11. Orient each label to the standard label and cut exactly the same.
12. On the computer
a. Create a template of 90 thin horizontal lines ⅛" apart.
b. Sub-divide the first ⅛" bar into 12 bars.
c. Number each sub-divided line in sub-divided bar from top down 1–12.
13. Print out the template.
14. Tape down template, perfectly parrallel to the board of a horizontal ruling table.
15. Unroll a sheet of light tack contact paper.
16. Mount each label to the contact sheet.
17. Cut the contact sheet precisely to the edge of each label.
18. Using a strong tack adhesive spray, mount each label to bristol board.
19. Cut the bristol board precisely to the edge of each label except from ½" at the bottom.
20. Number each label from 1–12 somewhere on the ½" excess of bristol board.
21. Tape down label #1 onto the template such that the top is precisely aligned to line #1 on the template.
22. Using a sharp X-Acto blade, precisely cut along all un-numbered horizontal lines except #12.
23. Don't cut through the bristol board.
24. Remove label #1.
25. Tape down label #2 onto the template such that the top is precisely aligned to line #2.
26. Repeat 22, and 23.
27. Repeat this system for the remaining 12 labels.
28. Take the remaining Quaker Oats boxes and sand off the labels using first rougher sand paper then finer sand paper.
29. Using as a cutting edge a 3" strip of aluminum flashing that is wrapped around the tubed box, cut off the bottom of all remaining boxes.
30. From 11 of these remaining boxes cut off a ½" vertical band from top to bottom.
31. These 11 boxes are used to attach the 12 remaining sanded boxes together into a long tube. This is done by sliding them halfway into the 11 remaining sanded boxes.
32. Use a white glue to adhere them in place.
33. The last remaining sanded box slides onto the top and adhered.
33a. Cut out a circle from 4 ply matboard that can fit snuggly 1" from the top of the long tube.
33b. Adhere with white glue into place.
34. Layout the labels arranged from 12–1.
35. Using a long straight edge and pencil, draw a perfectly vertical line down the entire tube.
36. Wrap snuggly around the long tube a 3" strip of aluminum flashing. This is used as a guide to keep the ⅛" label strips perfectly horizontal around the tube.

37. Using an archival white glue, adhere the top full ⅛" label strip from label #12 to the chosen top of the long tube. The left edge of the strip should be flush to the vertical pencil line. All left edges of strips should be flush to vertical pencil line. Use the aluminum-flashing guide to orient the strip.

38. Below this adhered label, adhere the top full ⅛" label strip from label # 11.

39. Repeat this system for #10 to #1 using the aluminum-flashing guide to orient each label strip.

40. Begin again from label #12. Adhere to the tube directly below the label strip from #1, the label strip that is directly below the one already adhered.

41. Repeat this system from 12 to 1 until all full ⅛" label strips have been used.

42. If there is any remaining tube exposed at the bottom, cut it off using the aluminum-flashing guide.

43. With a large soft brush, apply a thin coat of mat medium over the entire surface.

44. Cut a sheet of plastic to 48" x 48".

45. Tape the plastic sheet taut to a level floor.

46. Stand the elongated Quaker Oats box upright centered on the plastic sheet.

47. In a large bowl, thoroughly mix 12 cups of the saved oats with 2 cups of mat medium and 2 cups of an archival white glue.

48. Sand the underside of the saved lid with rough sand paper.

49. Place into the compartment in the top of the tube an amount of the mixed oatmeal so that when the saved lid is placed on the top, the oatmeal oozes down the sides of the elongated box.

50. Place dollops of the mixed oatmeal on the elongated box to simulate dripping oatmeal dripping down the entire box.

51. Place dollops of the mixed oatmeal at the very bottom of the elongated box to simulate an accumulation of the dripped oatmeal.

52. Let the oatmeal dry overnight.

53. Lift the elongated oatmeal box off the taut plastic sheet and place on a level floor.

54. Build a rectangular box out of 2" blue Styrofoam board to accommodate the elongated oatmeal box. There should be 3" excess space around its largest dimensions.

55. Cut out of 2" blue Styrofoam board, 5 sections with negative hemispheres, to support the elongated box in the blue Styrofoam box.

56. Hot glue these sections to locations in the blue Styrofoam box that do not touch the applied hardened oatmeal.

57. Lay box in box and secure with strips of bubble wrap and strapping tape.

57a. Tape box shut.

58. Write name, date, and description of contents on top of box.

59. Write boxing, de-boxing and installation instruction on a computer.

60. Print out.

61. Tape to top of packing box.

62. Indicate shipping orientation and rules.

63. Call shipper.

64. Shipper picks the Artwork up.

65. Builds wooden crate if necessary.

66. Sends to destination.

67. Preparators remove blue Styrofoam box from wooden crate.

68. Preparators read deboxing instructions.

69. Preparators read installation instructions.

70. Preparators place artwork in its location.

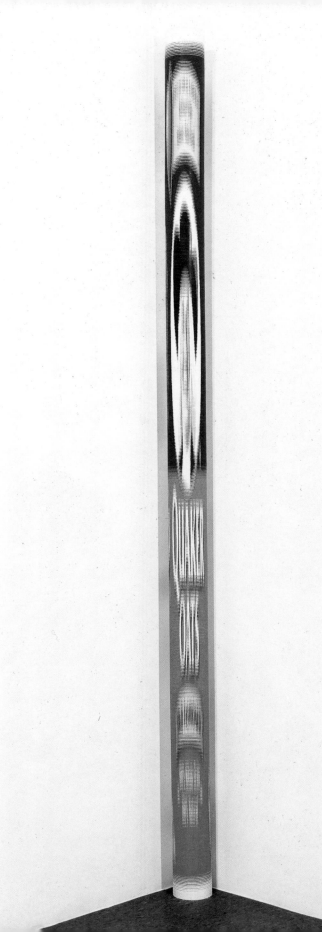

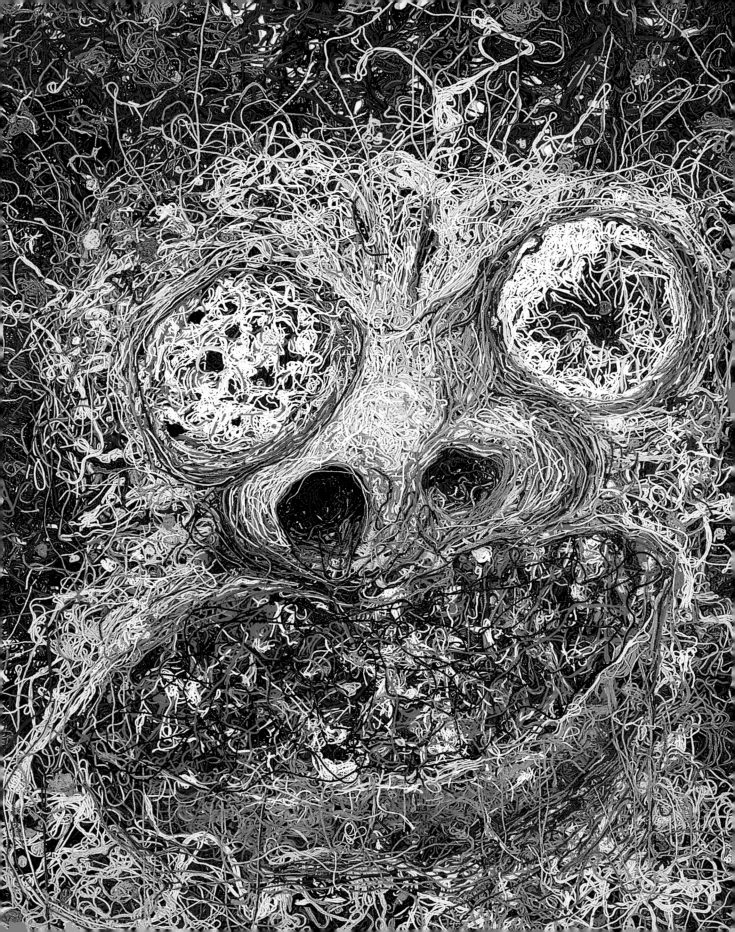

above; detail opposite:
flatyarnmonster, 2006
Yarn
62 x 66 in. (157.5 x 167.6 cm)
© Tom Friedman; private collection

Untitled, 2004
Laundry detergent boxes
47 ½ x 40 x 14 ½ in. (121 x 102 x 37 cm)
© Tom Friedman; private collection

Untitled, 2000
Construction paper
12 x 114 x 120 in. (31 x 290 x 305 cm)
© Tom Friedman; private collection

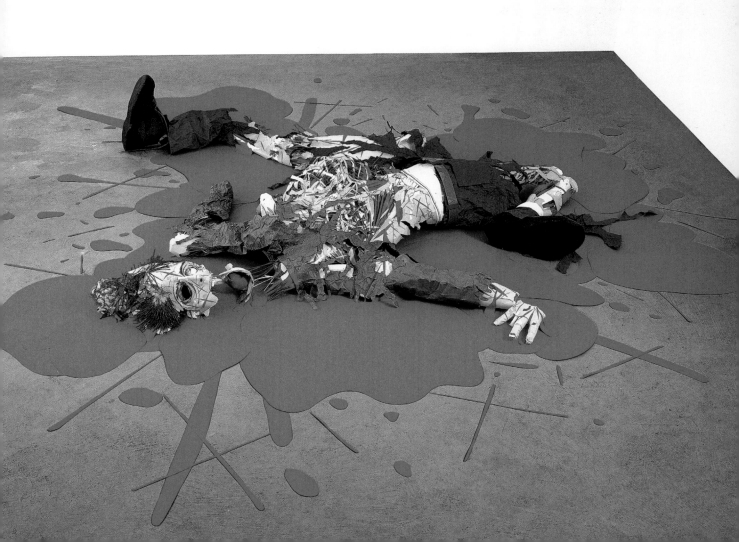

YANG LI (from the Shanghai series), 2006
Acrylic on paper, perforated
30 ¼ x 22 ¾ in. (76.8 x 57.8 cm)
Collection of the artist

Anne-Karin Furunes

Anne-Karin Furunes was born in Trondheim, Norway, and studied at the Royal Academy of Fine Arts, Copenhagen; the Architektenschule, Oslo; the Städtische Kunstakademie, Oslo, and the Architectural Association, London. Her solo exhibitions began in 1994, and since then she has exhibited worldwide, in Toronto, Cologne, Helsinki, Sydney, Rome, and New York, among other locales. Furunes has received numerous public commissions in such venues as Deutsche Bank in Sydney and the Trondheim Airport in Norway. Her work has been collected extensively in Europe and the United States.

I've always had a particular interest in found images that carry a hidden or unknown history. Early in my painting career, I wanted to create images that captured a glimpse in time or a distant memory. I incorporated my interest in painting and photography to develop my own way of "building" imagery. With scissors and a knife, I began to cut away at the canvas. Instead of adding paint to the surface, I wanted to take something away—to destroy and rebuild the painting at the same time. A major part of my process involves investigating photographic archives, private albums, and photos with lost stories and anonymous people. Photography allows and enables us to preserve history, but the perception of the past will always change, depending on what the future will be.

To create images, I use punches making each hole in the canvas and paper. I place the painted canvas or paper face-down on the floor and sit on top of it with a hammer and a punch. I use approximately thirty different punches, each one varying in size by half a millimeter from one to the next. It's possible that one painting may have as many as 30,000 holes. Making each hole by hand is a very slow process and often meditative.

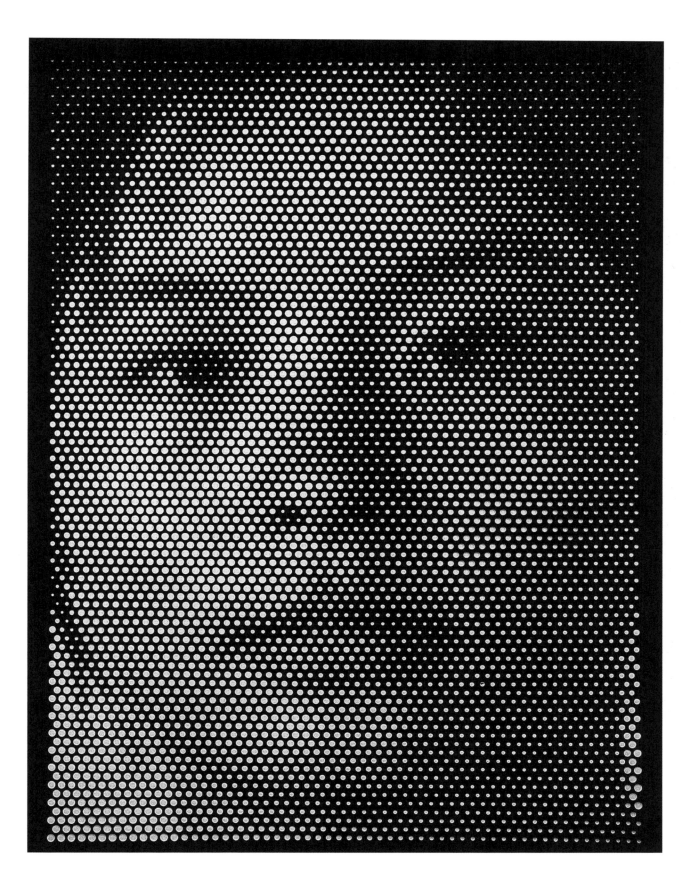

Unknown X, 1998
Dyed and perforated canvas
88 x 63 in. (224 x 160 cm)
Collection of the Museum of
Contemporary Art Kiasma,
Helsinki, Finland

left:
Untitled Wall in Telenor, Bergen,
2000
Painted and perforated aluminum
35 ft., 3 ¼ in. x 22 ft., 11 ½ in.
(10.8 x 7 m)
Collection of the Telenor Group
at Kokstad, Bergen, Norway

below:
Untitled Wall in the Nationaltheatret
Station, Eastbound Platform, Oslo,
1999
Perforated stainless steel plate,
332 plates total
78 ¾ x 59 in. (200 x 150 cm)

Tom Gallant

Tom Gallant received his BA in graphic design from the Southampton (UK) Institute of Higher Education (now Southampton Solent University) and his MA in fine art printmaking from Camberwell College of Arts, London. He has been awarded a fellowship in fine art printmaking from the Royal Academy Schools and an artist residency at the Stichting b.a.d., Rotterdam. Gallant has been accorded solo exhibitions in the United Kingdom and Italy, and participated in group exhibitions in London, New York, Dresden, Berlin, Glasgow, Paris, and Tel Aviv.

I grew up in a middle-class ex-colonial family, and for the first eleven years, I lived in Athens, Greece. Both my parents came from colonial backgrounds— Nairobi and Mombasa, Kenya, and Simla in Northern India. Since an early age I have been aware of sexuality, attraction, abuse, and power. Led by a continued fascination with literature, these factors reveal themselves in my work through the language of the collector, the collection, and the collected. To me, pornography encompasses so many aspects of our visual culture. It speaks on many levels that, on closer inspection, disappear into the tangle of flesh, taboos, icons, repetition, and banality. Holding up a mirror to all we hold sacred, divine, private, it reveals truth where they are to be found while ultimately just being about tits and ass.

right; detail above:
Climbing Rose, 2005
Cut paper
Framed: 86 ½ x 14 ½ in.
(219.7 x 36.8 cm)
Courtesy of the artist

Collaboration between Marios
Schwab and Tom Gallant
Golden Lily Column Dress, 2008
Silk, grosgrain trim
Marios Schwab, Autumn Winter
2008/2009 collection, P3 Building,
London

108 Moths, 2004
Paper and steel pins
47 ¼ x 55 ⅛ x 2 in.
(120 x 140 x 5 cm)
Courtesy of the artist

ST. GEORGE AND THE DRAGON,
2009 (sketch)
Pencil on paper
11 ¾ x 8 ¼ in. (30 x 21 cm)
Collection of the artist

Chris Gilmour

Born in the United Kingdom, Chris Gilmour lives and works in Udine, Italy. He received his BA from the University of the West of England, Bristol, and studied at South Trafford College, Manchester. Gilmour began exhibiting his work in group exhibitions in 1998, especially in Italy. Since 2001, he has had five solo exhibitions in both Padua and New York City. He received Italy's Premio Cairo award in 2007.

I love the idea of such a powerful and enduring image of the conflict of good and evil—specifically the very "black-and-white" idea of the triumph of good—being played out in a material which is weak, disposable, and a cast-off from our commerce-driven world. I think it is an intriguing consideration to use the packaging of goods which we also use to define ourselves, and which in some way remains as evidence of an unclear moral situation. This idea has been obsessing me since I saw the MAD museum space—I think it ties into the Columbus statue we can see outside. It raises issues beyond simply a clever use of the material, asking questions about the nature of the material beyond its physical properties.

above; interior left:
Aston-Martin DB5, 2004
Cardboard, glue
Life-size
Courtesy of Perugi
Artecontemporanea, Padua, Italy

Church (Tabasco), 2004
Packaging box, glue
2 ¾ x 4 ¾ x 2 ⅜ in. (7 x12 x 6 cm)
Courtesy of Perugi
Artecontemporanea, Padua, Italy

Piano, 2004
Cardboard, glue
Life-size
Courtesy of Perugi
Artecontemporanea, Padua, Italy

Queen Victoria, 2008
Cardboard, glue
Life-size
Courtesy of Perugi
Artecontemporanea, Padua, Italy

opposite; detail below:
Rain Follows the Plow, 2007
Hand-cut paper
47 x 95 in. (119 x 241 cm)
Courtesy of the artist

Dylan Graham

New Zealand–born Dylan Graham has lived and worked in Amsterdam for over fifteen years. He originally went to the Netherlands to study at the Gerrit Rietveld Academie in Amsterdam in 1993, and he received his BFA from that institution in 1997. Further study at the Sandberg Institute in Amsterdam earned him an MFA. Graham began showing his work in group exhibitions the same year he received his MFA and since then has shown throughout Europe and the United States, as well as in Australia. Graham has been artist in residence at the Stiftung Künstlerdorf Schöppingen in Germany and at the International Studio & Curatorial Program (ISCP) in New York. His work has been collected by the West Collection, Philadelphia; the Herbert F. Johnson Museum of Art, Ithaca, New York; the 21st Century Museum, Louisville, Kentucky; and the Scope Foundation, New York.

The political content of my first cut-paper works concentrated on the social aspects and repercussions of colonialism and the historic and modern cultural context of colonialism, immigration, and forced migration. In more recent works I have continued to address these issues as well as expand my gaze to include broader historical events that examine class, politics, servitude, and world war. I explore the impact of these events from a personal perspective, and look at how that in turn affects collective society on a massive scale. The repercussions of colonialists, explorers, and settlers manipulating their logic/reasoning to justify inhumane practices is still being felt today. My work comments on the seemingly benign, and indeed revolutionary missions of discovery dating back to Cortez and the Dutch East/West India Companies, to the modern-day realities of the new colonialists—refugees, adventure seekers, multinational corporations. My work takes a close look at the icons and enduring symbols of these subjects and juxtaposes the perspectives, from the conquered to the conquerers, from the empowered citizen to the rootless newcomer, presenting a subtle analysis of these historical events from the perspective of an individual living in seemingly very different times.

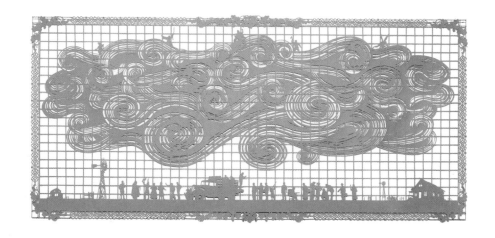

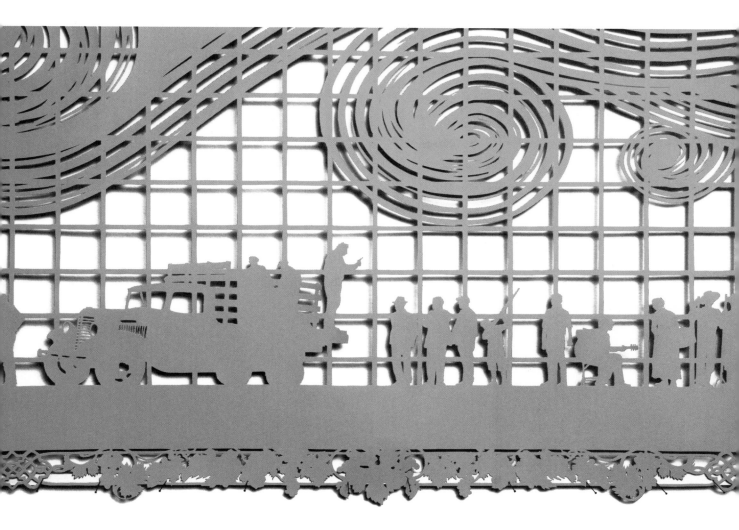

above; detail left:
Kingdom, 2006
Hand-cut pine, hand-cut poplar,
medium density fiberboard, acrylic,
foamcore board, cardboard, hand-
cut paper
20 x 20 x 15 ft. (6.1 x 6.1 x 4.6 m)
Courtesy of the artist and RARE
Gallery, New York

top; and detail:
Armada, 2006
Hand-cut paper
36 x 96 in. (91 x 245 cm)
Courtesy of the artist and RARE
Gallery, New York

top to bottom:
UNTITLED (CUT OUT 1), 2005
Tissue paper
15 x 17 ½ x 1 ⅛ in. (38.1 x 44.5 x 2.8 cm)
Courtesy of White Cube

UNTITLED (CUT OUT 2), 2005
Tissue paper
15 x 17 ½ x 1 ⅛ in. (38.1 x 44.5 x 2.8 cm)
Courtesy of White Cube

Mona Hatoum

Mona Hatoum was born in Beirut into a Palestinian family. After studies at Beirut University College, she relocated to London and attended the Byam Shaw School of Art, London, 1975–79, and the Slade School of Art, London, 1979–81. Her first solo exhibitions were in 1989 in Montreal, Canada, and in London. Since that time, she has had solo exhibitions at the Musée National d'Art Moderne, Centre Pompidou, Paris; the Museum of Contemporary Art, Chicago; the Hamburger Kunsthalle, Hamburg, Germany; and at SITE Santa Fe, New Mexico. She was the 2004 recipient of the Roswitha Haftmann-Preis, Zurich; the Sonning Prize, Copenhagen; and the 2000 George-Maciunas-Preis, Wiesbaden-Erbenheim. Her work is found in major museum collections worldwide, notably the Tate Gallery, London; the Museum of Modern Art, New York; and the Centre Pompidou, Paris.

You first experience an artwork physically. I like the work to operate on both sensual and intellectual levels. Meanings, connotations, and associations come after the initial physical experience as your imagination, intellect, psyche are fired off by what you've seen.[1]

1. Quoted from "Mona Hatoum—A Major Survey," March 26–May 31, 2004, Hamburger Kunsthalle, www.hamburger-kunsthalle.de/archiv/seiten/en_hatoum.html (accessed May 2009).

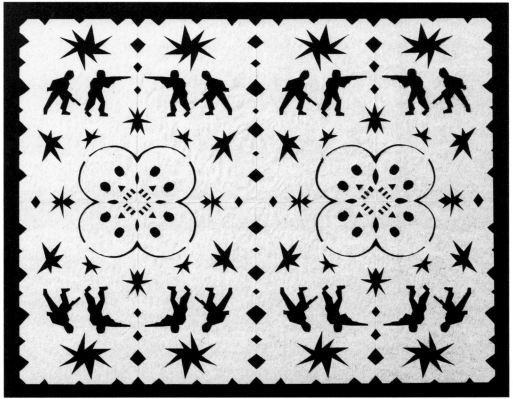

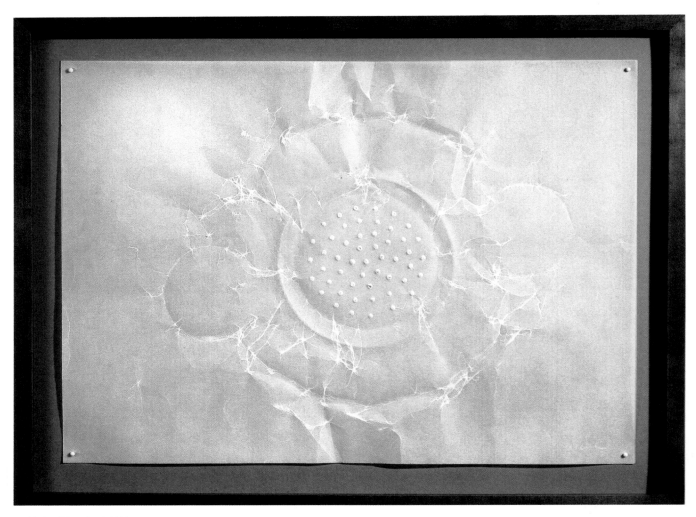

Untitled (milk strainer), 1996
Wax paper
10 ¾ x 15 ¾ in. (27.5 x 40 cm)
Courtesy of Alexander and Bonin

Clouds (18), 2008
Oil and ink on cardboard
6 ½ x 9 ¼ in. (16.5 x 23.5 cm)
Courtesy of Alexander and Bonin

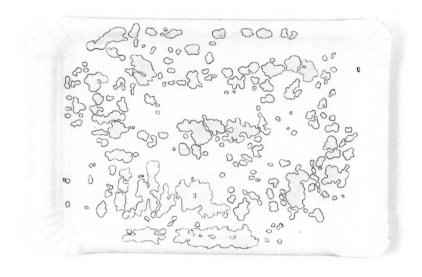

Clouds (21), 2008
Oil and ink on cardboard
6 ½ x 9 ¼ in. (16.5 x 23.5 cm)
Courtesy of Alexander and Bonin

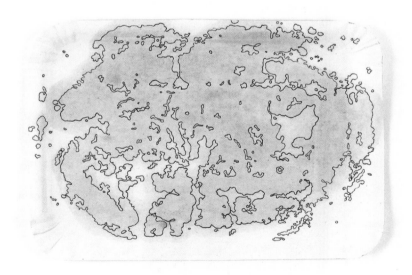

Oliver Herring

Oliver Herring was born in Germany and lives and works in New York City. He received his BFA from the Ruskin School of Drawing and Fine Art at the University of Oxford, England, and his MFA from Hunter College in New York. His first solo exhibition was at the New Museum of Contemporary Art in 1993, and since that time he has had solo exhibitions in Germany, England, and France. Institutions that have hosted solo exhibitions or initiated projects include the Hirschhorn Museum, Washington, DC; the Museum of Modern Art, New York; and the Guggenheim Museum, New York. Most recently, Herring has organized a series of participatory, socially engaged projects called TASK. Herring has received a Joan Mitchell Foundation grant and a New York Foundation for the Arts grant.

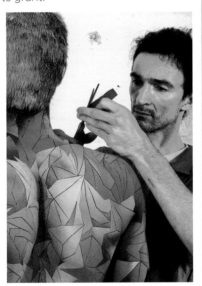

opposite:
ALEX, 2009 (detail)
Digital C-prints, museum board, foamcore, polystyrene
Overall: 74 x 24 x 16 in. (188 x 61 x 40.6 cm)
Courtesy of the artist and Max Protetch Gallery, New York

The photo-sculptures take time and dramatically slow down my interaction with the persons I work with. I usually seek an interpersonal experience I haven't had but am curious about. For example, at the beginning of the Iraq War, I worked for over a year with a US Marine (Leon) who, during our time together, left for and returned from Iraq. Cheryl, a life-sized female nude, came about after I watched the French film Anatomy of Hell *by Catherine Breillat, which is a graphic rumination on the female body as seen through the eyes of a man.*

Alex came about differently. In 2007, in order to open-up my process further, I made a resolution to say yes to absolutely every request, as long as it was nonsexual and nonviolent. Many of the projects that ensued were non-art related. Alex approached me with the request/offer that I make a photo-sculpture of him. He told me that he had recently endured a series of operations for stomach cancer, during one of which he had flat-lined and had been in effect clinically dead. Up to that point I had always initiated the experience, but for this project I decided to cater to Alex's interests and needs.

Alex decided to be in the nude (scars and all), and he chose the pose. I decided to make the piece as vivid as possible, translated through hundreds of photographs, each a different color and tone. In some of my work, I intend in part to use subjective gestures such as introducing artificial color or patterns onto the structure, to demonstrate that the overall piece is not to be taken too literally. The overt gestures demonstrate my engagement through decision-making and hand.

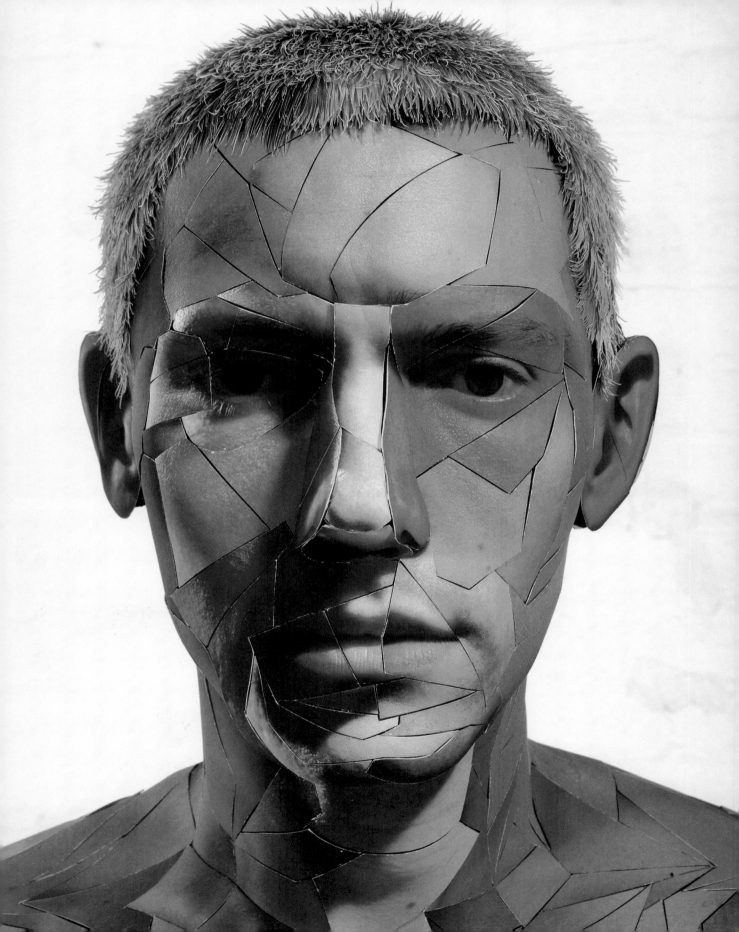

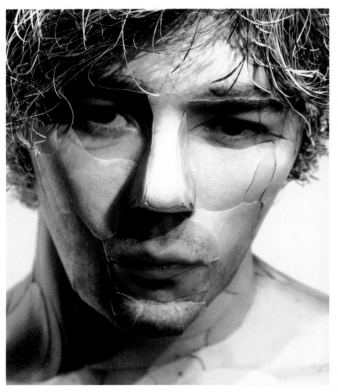

top left:
Queensized Bed with Coat, 1993–94
Knitted silver Mylar
12 x 57 x 88 in. (30.5 x 144.8 x 223.5 cm)
Collection of Peter Norton

An Age for Hands, 1996
Knited silver Mylar, steel
117 x 156 x 5 in. (297.2 x 396.2 x 12.7 cm)
Courtesy of the artist and Max Protech
Gallery, New York

top right:
Doublerocker, 1999
Knitted silver Mylar, wire
44 x 24 x 50 in. (111.8 x 61 x 127 cm)
Collection of Kent and Vicki Logan

opposite; detail right:
Wade 1, 2006
Digital C-print, museum board,
foamcore, polystyrene
68 x 22 ½ x 15 in.
(172.7 x 57.2 x 38.1 cm)
Courtesy of the artist and
Max Protech Gallery, New York

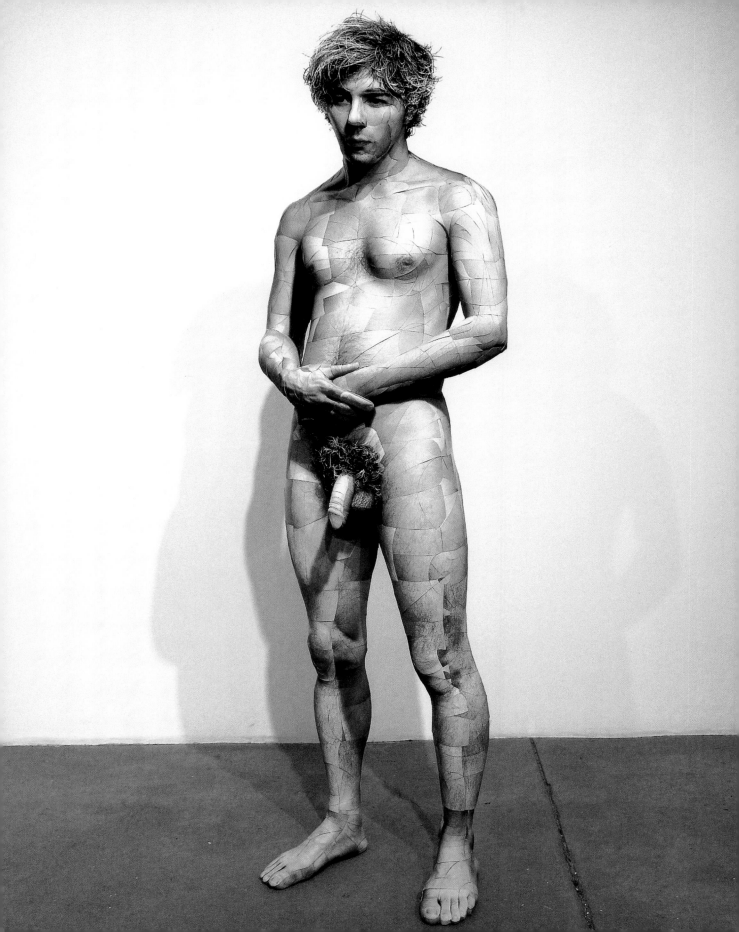

HEAD OF SPAIN, 2008
C-print
25 x 28 in. (63.5 x 71.1 cm)
Courtesy of the artist; Sara Meltzer
Gallery, New York; and Catharine
Clark Gallery, San Francisco

Nina Katchadourian

Nina Katchadourian was born in Stanford, California, and grew up spending every summer on a small island in the Finnish archipelago, where she still spends part of each year. Her work exists in a wide variety of media including photography, sculpture, video, and sound. She earned degrees in both visual arts and literature and society from Brown University, Providence, Rhode Island, and her MFA from the University of California, San Diego. The artist's over thirty solo exhibitions have taken place worldwide, from Stockholm, Sweden, to Sheboygan, Wisconsin. Residencies and awards include a New York Foundation for the Arts award (video), a Tiffany Foundation for the Arts Award, and a grant from the Anonymous Was a Woman Foundation, among others. Artist residencies ranged from the International Artists Studio Program in Stockholm (IASPIS) and the MacDowell Colony in Peterborough, New Hampshire. She has exhibited domestically and internationally at places such as P.S.1 Contemporary Art Center/ MoMA, New York; the Serpentine Gallery, London; the Museum of Contemporary Art, San Diego; Artists Space, New York; Sculpture Center, New York; and the Palais de Tokyo, Paris. In June 2006 the Tang Museum in Saratoga Springs exhibited a 10-year survey of her work and published an accompanying monograph entitled *All Forms of Attraction*. Katchadourian is represented by Sara Meltzer Gallery in New York and Catharine Clark Gallery in San Francisco.

I work in a wide variety of media, including sculpture, photography, video and sound. Maps have been a long-standing theme in my work, most often manifest as elaborate dissections of paper road maps. Cutting out all the freeways from a road map becomes a form of surrogate travel, and I have often performed these "surgeries" on maps of places where I have not yet been as a way of getting to know them. Another body of work takes up the human relationship to the natural world via "uninvited collaborations," such as attempting to repair a spider's web with red sewing thread, or patching a mushroom using rubber bicycle tire patches. I also work a great deal with language and translation; Talking Popcorn (2001), for example, is a translation machine that listens to the sound of popping popcorn and uses Morse code to translate it into spoken language. In Accent Elimination (2005), *my foreign-born parents and I worked intensively with a professional accent coach to help me acquire my parents' accents.*

Self-portrait as Sir Ernest Shackleton, 2002
C-print
6 ½ x 4 ½ in. (16.6 x 11.4 cm)
Courtesy of the artist: Sara
Meltzer Gallery, New York;
and Catharine Clark Gallery,
San Francisco

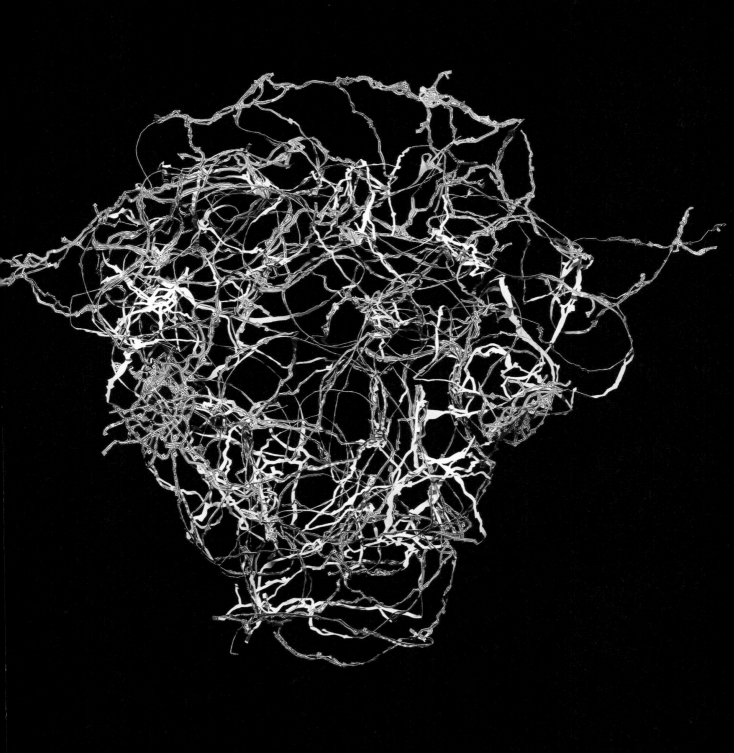

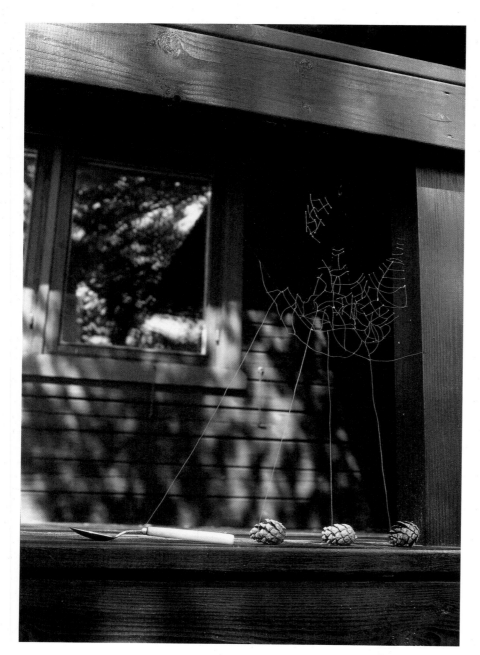

**Mended Spiderweb #14
(Spoon Patch)**, 1998
Cibachrome
30 x 20 in. (76.2 x 50.8 cm)
Courtesy of the artist; Sara Meltzer
Gallery, New York; and Catharine
Clark Gallery, San Francisco

Geographic Pathologies (Japan), 1996
Cut paper
Framed: 14 ⅛ x 15 ½ in. (35.9 x 39.4 cm)
Courtesy of the artist; Sara Meltzer Gallery, New York; and Catharine Clark Gallery, San Francisco

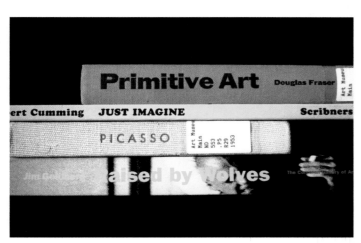

Primitive Art from The Akron Stacks, 2001
C-print
19 x 12½ in. (48.3 x 31.8 cm)
Courtesy of the artist; Sara Meltzer Gallery, New York; and Catharine Clark Gallery, San Francisco

Chris Kenny

Chris Kenny was born in London in 1959 and studied history of art at the Courtauld Institute of Art. The artist began as a painter, but in the 1990s, he shifted almost exclusively to working with paper to create collages and three-dimensional constructions. Kenny's work has been exhibited regularly in London and throughout the United Kingdom, and in recent years he has made installations for exhibitions at the Courtauld Institute and at Dr. Johnson's House Museum in London. His work is represented in numerous private and corporate collections, and in public collections including the Museum of London, the Victoria and Albert Museum, and the Artists' Book Collections of Tate London and of the University of South Australia.

In my map-works, the cartographer's logic is replaced with an absurd imaginative system where unlikely combinations allow one's mind to ricochet back and forth between disparate locations and associations. This work is a jagged landscape or choppy seascape made up of shapes and lines cut from maps. These apparently abstract forms actually represent features of the earth made by man, nature, or both. A red-veined fillet is a hazardous area of Salisbury Plain isolated for artillery practice; a yellow rhomboid is the print room of a major art gallery; a variegated blue and green leaf is a section of suburban park with a boating lake. The work celebrates different symbolic vocabularies created for a variety of purposes—unconsciously decorative and colorful schemes that give us geological, political, statistical, or pedestrian information, prised from their original contexts. The circular composition suggests a view through a telescope directed at distant constellations or through a microscope trained on a crowded Petri dish, or perhaps a new jumbled globe that ignores established hierarchies.

top; detail opposite:
GRAND ISLAND, 2008
Construction with map pieces
38 x 38 x 3 in. (96.5 x 96.5 x 7.6 cm)
Courtesy of England & Co.

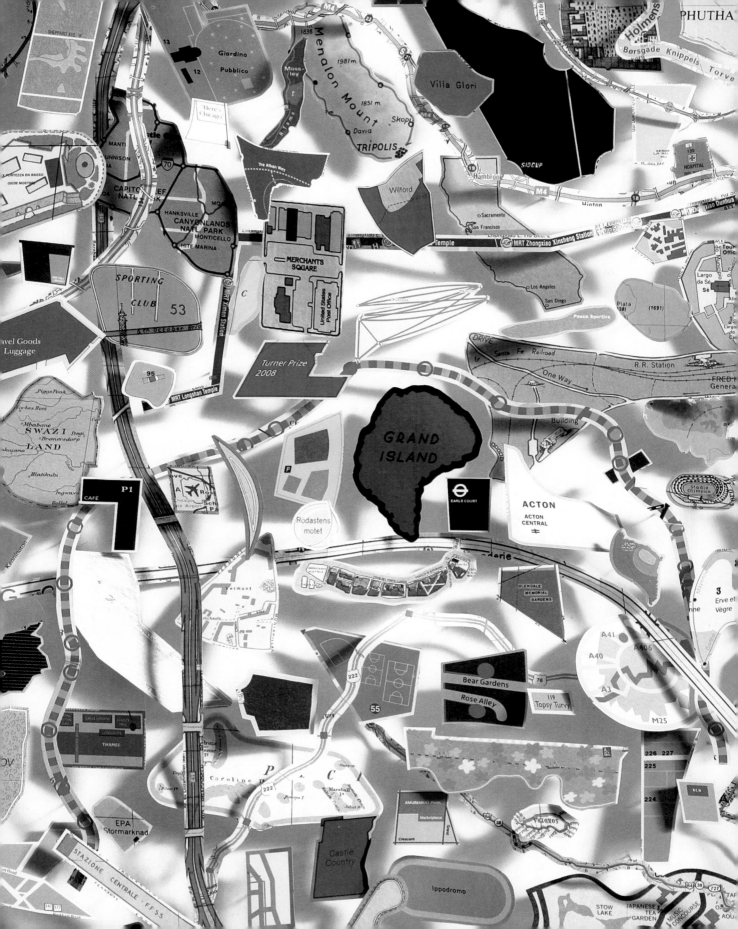

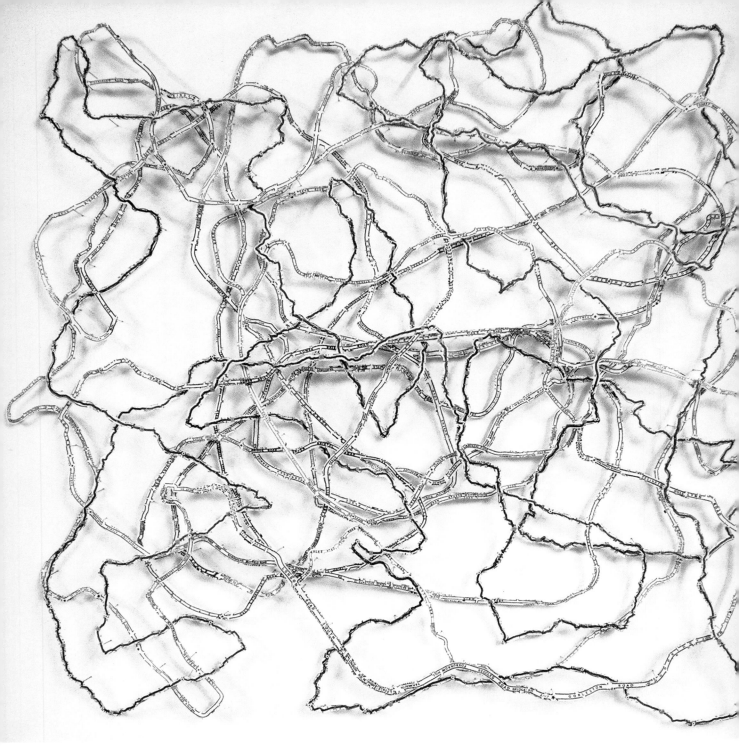

Red and Black Road Drawing, 2002–6
Collage construction with maps
30 ½ x 30 ½ x 3 in. (77.5 x 77.5 x 7.6 cm)
Courtesy of England & Co.

Nonsuch (White Map Circle), 2007
Construction with map pieces
24 x 24 x 3 in. (61 x 61 x 7.6 cm)
Courtesy of England & Co.

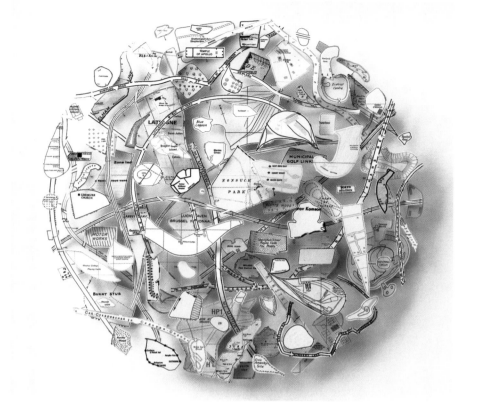

Black Map Circle, 2007
Construction with map pieces
16 x 16 x 3 in. (40.6 x 40.6 x 7.6 cm)
Courtesy of England & Co.

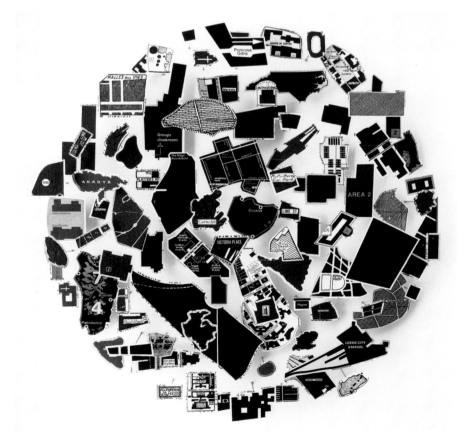

Model for **PAPERWORK #935G**, 2009
Watercolor paper
Collection of the artist

Andreas Kocks

Andreas Kocks lives and works in Munich and New York City. A graduate of the Kunstakademie Düsseldorf, where he studied fine art, Kocks went on to earn his MA in education at the University of Düsseldorf and his MFA in sculpture from the Kunstakademie. In 2006 he was awarded a Pollock-Krasner Foundation fellowship. In addition to exhibiting at major museums and galleries in Europe and the United States, he has received numerous commissions from private and public clients. Most recently, Kocks installed a 52-foot-wide (16 meter) work in the corporate offices of the advertising firm TBWA Vienna. Kocks's work is found in public collections such as the Museum für Konkrete Kunst, Ingolstadt; and the Bayerische Staatsgemäldesammlungen, Munich.

I am interested in space, as an event, as an experience, as a sensuous perception. I use paper to realize my ideas, because as a medium it's neutral, timeless, and universal. Its fragility contains an easiness, which is liberating for me. I can react immediately to what I've done, just as I can with drawing.

The cut-paper sections create a three-dimensional space through the modulation of light and shadow. The entire piece is specifically installed as a conscious kind of architecture. I want my work to relate directly to its setting. This is why my pieces are unframed and mounted directly on the wall. The contrast between my organic shapes and the orthogonal space is significant. In this way, especially if the work is large, the viewer is invited to move, to change his position and thus modify his viewpoint. He then experiences the dynamic processes inside the work and is forced to look at real space in a different way.

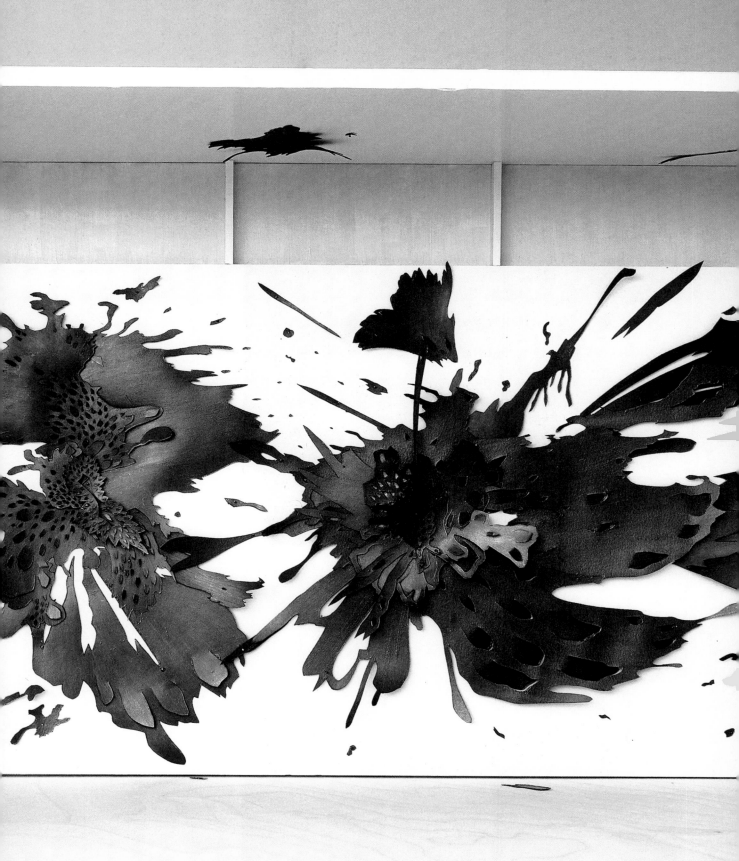

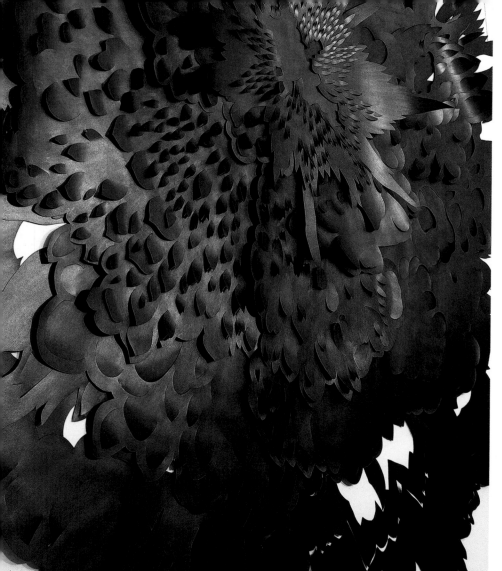

left:
paperwork #701G (in the beginning),
2007 (detail)
Installation view at DG Galerie, Munich,
Germany
Graphite, watercolor paper
Overall: 19 ft., ⅜ in. x 34 ft., 9 ⅜ in. x 6 in.
(5.8 m x 10.6 m x 15 cm)

below:
Beehive, 2001
Gold on bronze
6 ¼ x 6 ¼ x 6 ¼ in. (16 x 16 x 16 cm)
Courtesy of the artist

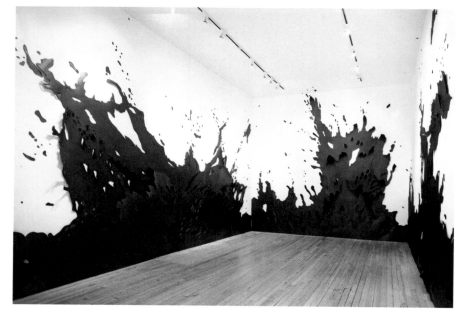

left:
paperwork #703G (Cannonball), 2007
Installation view at Jeannie Freilich
Contemporary, New York
Graphite, watercolor paper
10 ft., 9 ⅞ in. x 54 ft., 9 ½ in. x 5 ⅛ in.
(3.3 m x 16.7 m x 13 cm)

opposite:
paperwork #704 (Splatter), 2007
(detail)
Installation view at Neue Werkstätten,
Munich, Germany
Watercolor paper, acrylic varnish
Overall: 13 ft., 9 ¾ in. x 45 ft., 11 in. x 6 in.
(4.2 m x 14 m x 15 cm)

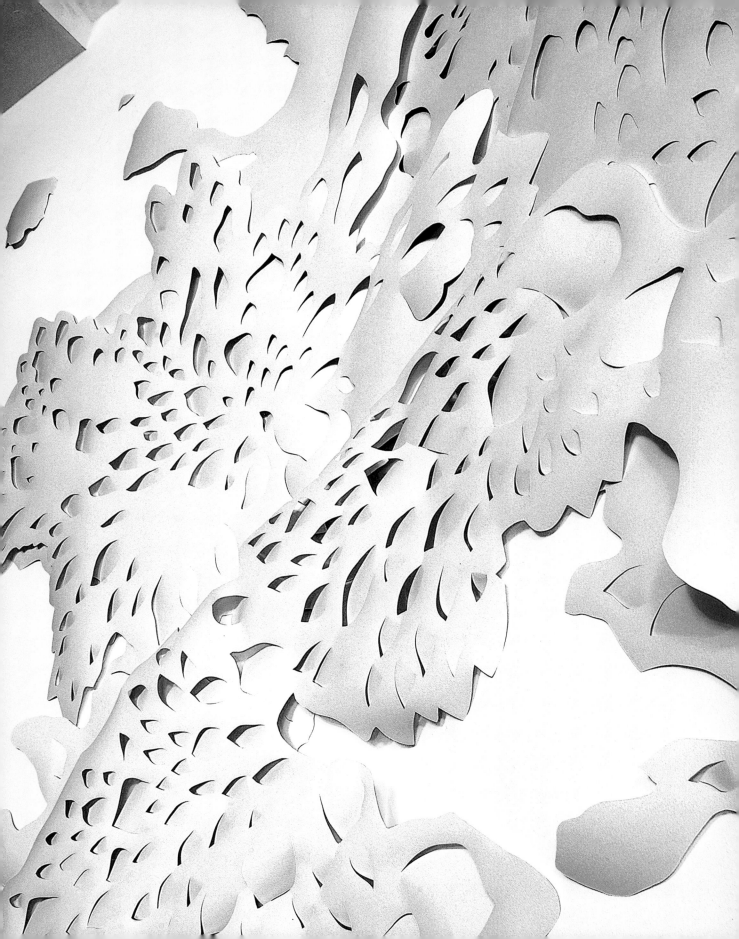

Carole P. Kunstadt

Carole P. Kunstadt received her BFA from the Hartford Art School in West Hartford, Connecticut, concentrating on two-dimensional studies, and went on to postgraduate studies at the Akademie der Bildenden Künste in Munich, Germany. Her interest in tapestry design and weaving led to an assistantship in the tapestry studio of Helena Hernmarck. With Janet Kennedy, she founded Kennedy/Kunstadt Tapestries in 1981. The artist has participated in solo and group exhibitions throughout the United States. Her works are found in many private collections and in the Montclair State University Collection in Montclair, New Jersey.

The pages in this work are taken from a Parish Psalmody dated 1844. The pages are manipulated and recombined, resulting in a presentation that evokes an ecumenical offering—poems of praise and gratitude. The disintegrating pages suggest the temporal quality of our lives and the vulnerability of memory and history. The intended use, as well as the nature of a psalm as spiritual repository, implies a tradition of careful devotion and pious reverence. The physical text evocatively and powerfully serves as a gateway to an experience of the sacred and the realization of the latent power of the written word. This process of interaction is played out visually in the piece, mimicking the internal experience.

o cheer ... head ... his hours how sh
y ... cra... ...o the g...esus.
yes and ears no... his vital A th
shall an be... den TT s of de
k my ... peace aga... fly, or now I wel.
... for ever said
I hear and ... man was on, I a
wished below l... sorr... and the
... sweet... vants, day Thy
world of joy, ...aves, turned
M... thy kindr... Shall
...OND PART. ...r tho
The C... o This the ...romis... to thy s
...sant thing ...d, a heaven 29.
...plan... ...d sen... ...ndulge
Wy thy
courts be s... d be the L A,
cedar... W... in faith... ...oly wo
...y sain... ...surrection
ine in F... ...d be l... ord.
all its trees... saints a lon
omely... W... as ...toil, ...ach, a
...e shall... as ...and all abo
but A... mus... ...drous
...ai... things els... ...eat their l... Le

Sacred Poem XI, 2009
(detail)
Pages from 1844 Parish
Psalmody, thread, gampi
tissue; cut, altered
Overall: 7 ½ x 8 x 1 ¼ in.
(19.1 x 20.3 x 3.2 cm)
Collection of the artist

SACRED POEM XVI, 2006
Pages from 1844 Parish Psalmody,
thread; cut, altered, sewn
6 x 8 x 1 ½ in. (15.2 x 20.3 x 3.8 cm)
Collection of the artist

SACRED POEM XXVII, 2006
Pages from 1844 Parish Psalmody,
gampi tissue; cut, altered, sewn
4 ¼ x 9 ¾ x 1 ¾ in. (10.8 x 24.8 x 4.4 cm)
Collection of the artist

THE PAPER VASES, 2007
700 paper prints, ink, wood glue,
copper plate
Dimensions variable
Collection of the artist

Tomáš Gabzdil Libertiny
(Studio Libertiny)

Tomáš Gabzdil Libertiny was born in Slovakia in 1979, son of architect Róbert Gabzdil and academic historian Soňa Libertíny. In 1999 he enrolled in the industrial design department at the Technical University in Slovakia but found this discipline to be too limiting. In 2001 he was awarded George Soros's Open Society Institute Scholarship to study at the University of Washington in Seattle, where he explored painting and sculpture. As a result, in 2002 he transferred to the Academy of Fine Arts and Design in Bratislava to study both product design and painting. After completing his BA, Gabzdil Libertiny enrolled in the Design Academy Eindhoven to further develop his design vision under the direction of Gijs Bakker of Droog Design. After completing his MFA in 2006, he opened Studio Libertiny in Rotterdam. His works have been acquired by the Museum of Modern Art, New York, and Museum Boijmans van Beuningen, Rotterdam.

I put a lot of intellectual effort into justifying the existence and defining the meaning of the objects I make, as I am too aware of the abundance of objects around us. However, in the end, objects are what they are. I like my objects to be very simple, very pure; when successful they can be understood without an instruction manual. They can be experienced and not just seen. At the same time, I hope they communicate "to those who see" a story larger than the obvious one. While creating The Paper Vases, *I posed the question: What is Nature? This gave me a lot think about. I didn't want to arrive at a single concrete answer but rather to explore the dialectic of nature and culture. I found the juxtaposition of two artifacts as the most outspoken: the wood and the paper. The relationships between wood transformed to paper, paper transformed to "wood," and paper transformed to reveal a tree intrigued me. My ideas have always been about repetition, addition of materials, and growth. These are recurring themes in my work.*[1]

1. Tomáš Gabzdil Libertiny to David McFadden, email correspondence, May 23, 2009.

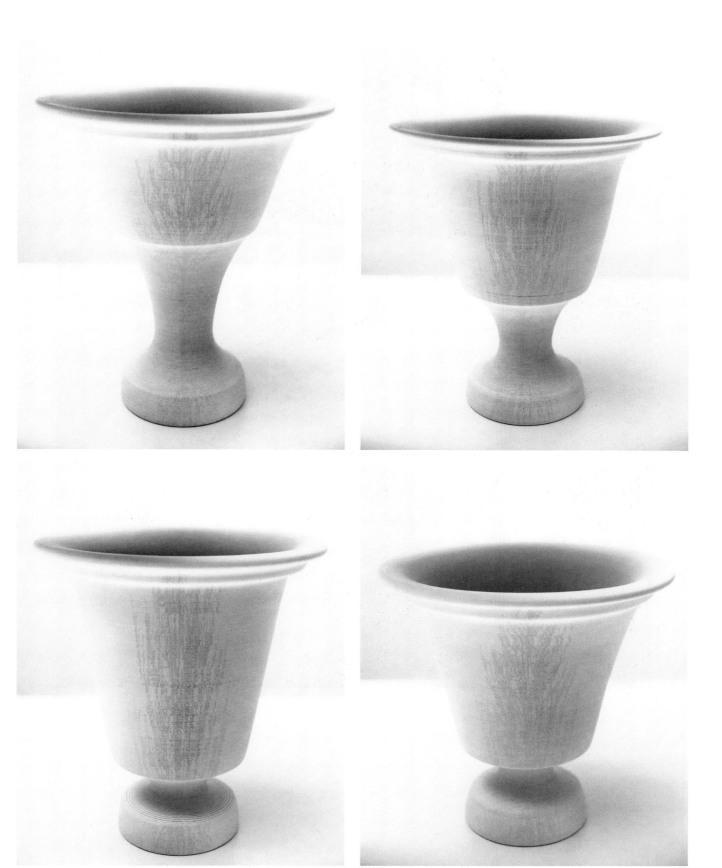

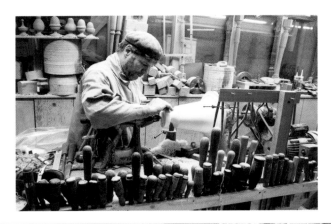

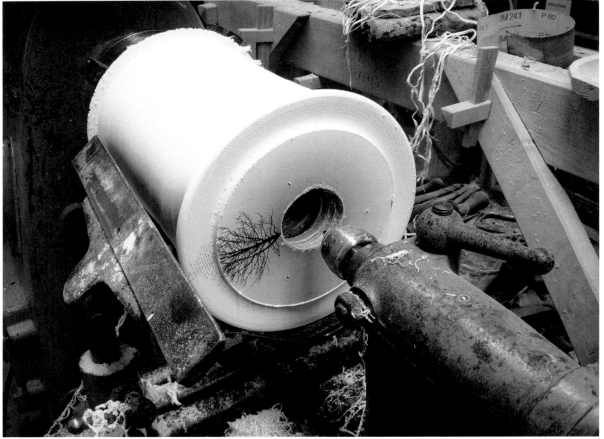

above; two views:
The Paper Vases, 2007
Making of **The Paper Vases** by
woodturner Joost Kramer

The Honeycomb Vase
"Made by Bees", 2006–8
Beeswax
9 7/16 x 6 5/16 in. (24 x 16 x 16 cm)

opposite; detail bottom:
CRUSH, 2008
Cut and shredded love letters, glue
1 x 38 x 38 in. (2.5 x 96.5 x 96.5 cm)
Courtesy of the artist and LMAK
projects, New York

Nava Lubelski

After earning a BA in Russian literature and history at Wesleyan University in Middletown, Connecticut, Nava Lubelski went on to receive a certificate in Russian language from the Moscow State Institute of Steel and Alloys/Moscow Energy Institute in Russia. Since 2005, she has been accorded six solo exhibitions and has participated in group exhibitions across the United States, as well as in Sweden and Mexico. Among Lubelski's many awards are fellowships from the Pollock-Krasner Foundation, the New York Foundation for the Arts, and the Vermont Studio Center. She has also held residencies at the Constance Saltonstall Foundation for the Arts, Ithaca, New York; the Marie Walsh Sharpe Art Foundation, Brooklyn; and CUE Art Foundation, New York. Lubelski is a published author and has created book illustrations.

My cut-paper sculptures are inspired by the feeling of reluctance to part with certain types of paper, the written content creating conceptual value out of something otherwise valueless. The pieces are all made from paper that has been stored for reasons of sentiment, reference, or obligation. The pages are first read, then cut and compressed, thereby transferring their value from a dependence on content (which is no longer accessible) to a result of artistic form (which may or may not be inspired by the content). The sculptures reconfigure these quantities of paper into slabs reminiscent of cross sections of trees on which the climate of a given year, and the tree's overall age are visible. The paper shreds are coiled into a library of scroll-like minifiles, while the cellular coils spiral outward, mimicking biological growth, lichen, doilies, or disease.

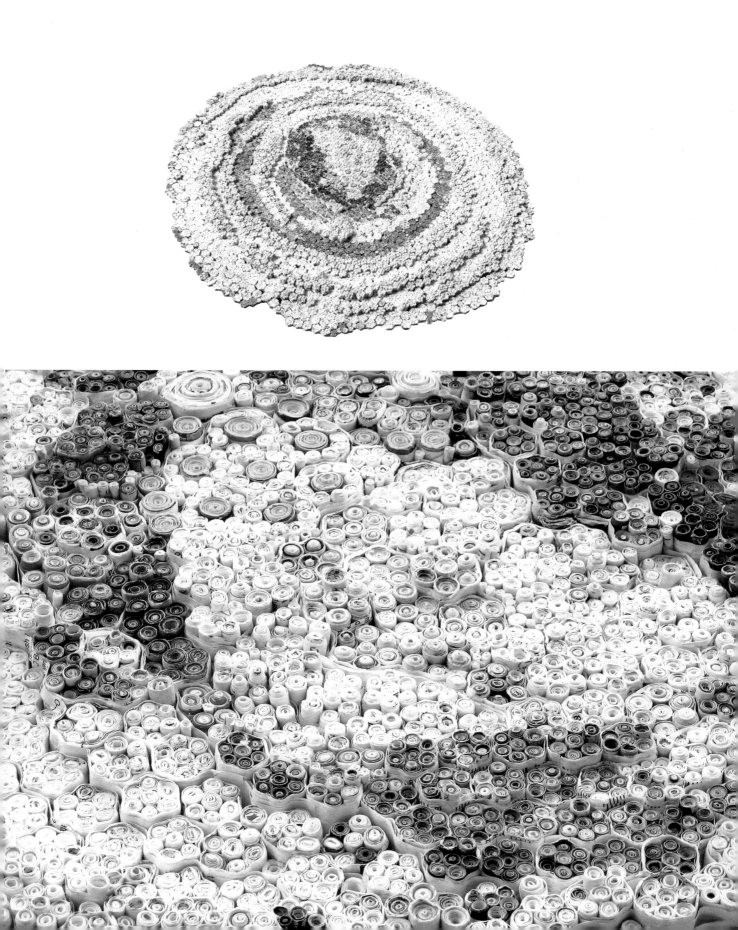

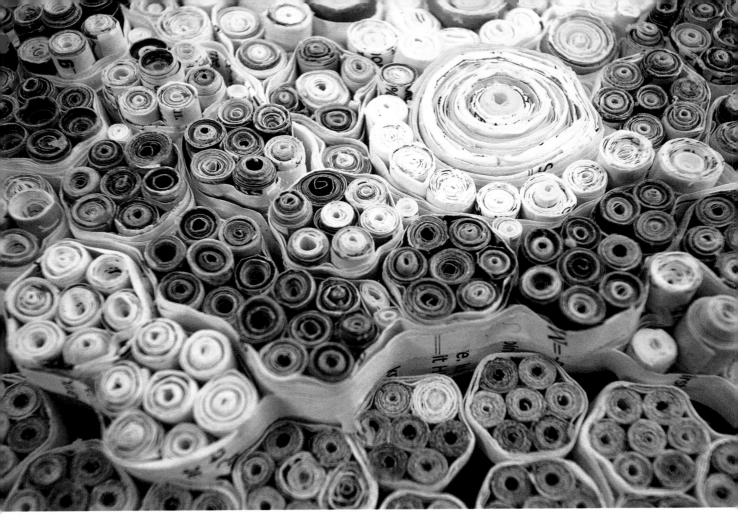

CRUSH, 2008 (detail)

[A cast of my left hand in the shape of a] Glove v. 4, 2008
Thread, found trimmings and pins
10 x 5 x 2 in. (25.4 x 12.7 x 5.1 cm)
Courtesy of the artist and LMAK
Projects, New York

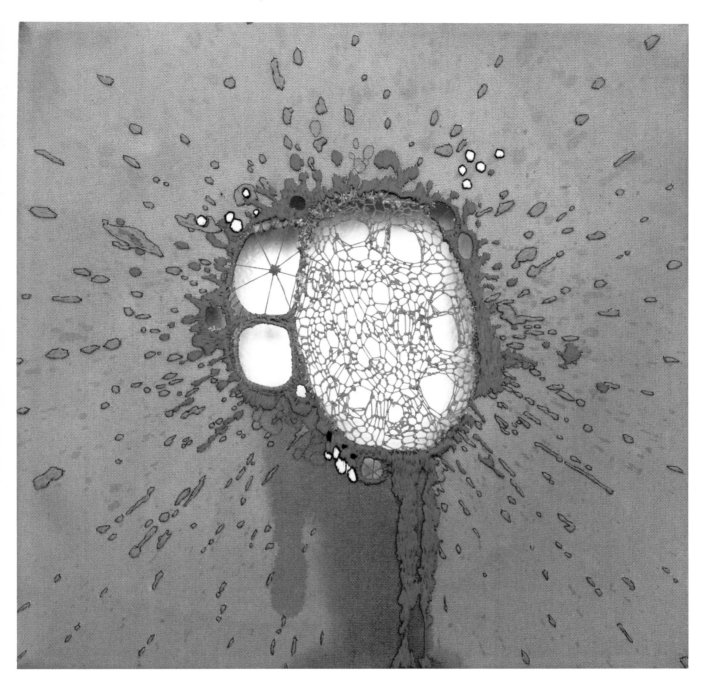

Gooey, 2009
Thread on stained canvas
12 x 12 in. (30.5 x 30.5 cm)
Courtesy of the artist

Andrea Mastrovito

Andrea Mastrovito was born in Bergamo, Italy, in 1978. He received his MFA in 2001 from the Accademia Carrara di Belle Arti in Bergamo, Italy. He was the recipient of the New York Prize awarded by the Italian Ministry of Foreign Affairs, and the Analix Forever Residency award. In 2003 he installed his first solo exhibition in Milan, Italy; this was followed by solo exhibitions in Florence, Geneva, Brussels, Paris, and New York. He has shown his work at MAXXI National Museum of the 21st Century, Rome; the Palazzo delle Esposizioni, Rome; and the Centro per L'Arte Contemporanea Luigi Pecci in Prato, Italy.

I want to show how things are born and are filtered through my work. The main value of reference is that of the work itself—of how the event, the spectacle, the film, or the fantasy comes to life. I never paid much attention to theater in my work, though I often hear people say that my paper installations are teatrini, *theater models. I like to hide my intervention. When I work with my cutting knife, I make clean but totally impersonal cuts. Once I took a work to a restorer and he asked me what kind of machine I had used to make it. When I said I had done it by hand, he didn't believe me. Actually I become a machine when I am cutting things out. For this exhibition, I based my work on a well-known Italian comedy filmed in 1984,* Non Ci Resta Che Piangere *(Nothing Left To Do But Cry), with Roberto Benigni and Massimo Troisi. In the film the two protagonists suddenly find themselves lost in the past, in 1492. The two attempt to reach Spain in order to prevent Christopher Columbus from sailing to the New World. As the Museum of Arts and Design is located on Columbus Circle in New York, I am creating a scene from this history upside down on the museum lobby ceiling, depicting a sudden storm that overtakes the* Santa Maria, *preventing Columbus from reaching San Salvador.*

opposite, top to bottom:
NON CI RESTA CHE PIANGERE
(There's Nothing Left To Do
But Cry), 2009
Preparatory sketch; pencil on
acid-free paper
9 ⅞ x 15 ¾ in. (25 x 40 cm)
Collection of the artist; courtesy of
Foley Gallery, New York

NON CI RESTA CHE PIANGERE
(There's Nothing Left To Do
But Cry), 2009
Maquette; paper, board, wood, balsa
wood, acetate
31½ x 19 ¹¹⁄₁₆ in. (80 x 50 cm)
Collection of the artist; courtesy of
Foley Gallery, New York

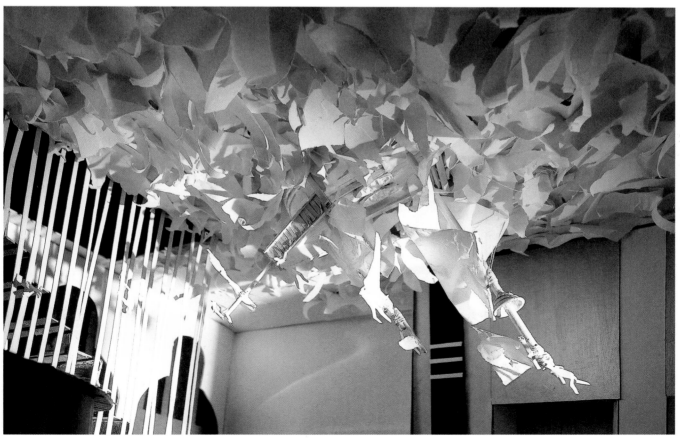

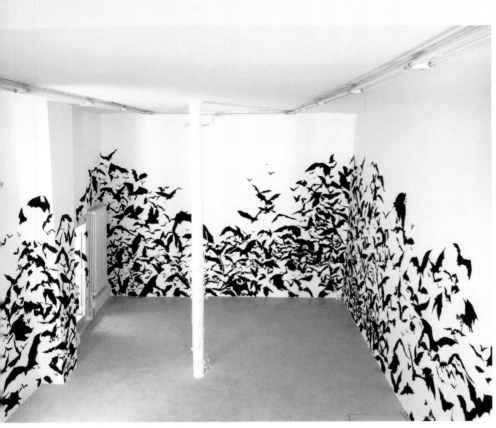

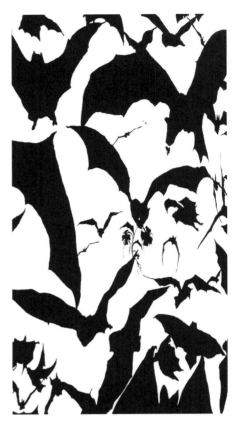

above; detail right:
Portrait of the Artist as a Young Batman, 2005
Acrylic paint on wall
Dimensions variable
Courtesy of Analix Forever Gallery, Geneva

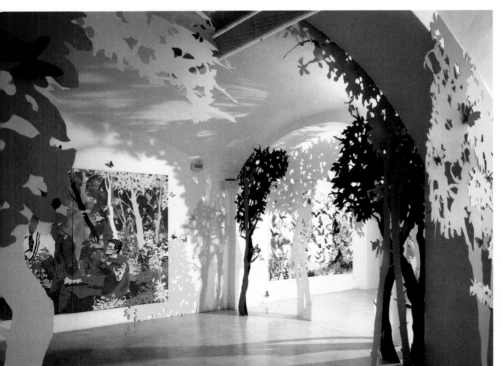

left:
In & Out of Life, 2006
Paper and collage on walls
Dimensions variable
Courtesy of Antonio Colombo Arte Contemporanea, Milan

below; detail opposite:
Enciclopedia dei fiori da giardino, 2009
1500 hand-cut books, glass
Dimensions variable
Courtesy of 1000 eventi gallery, Milan

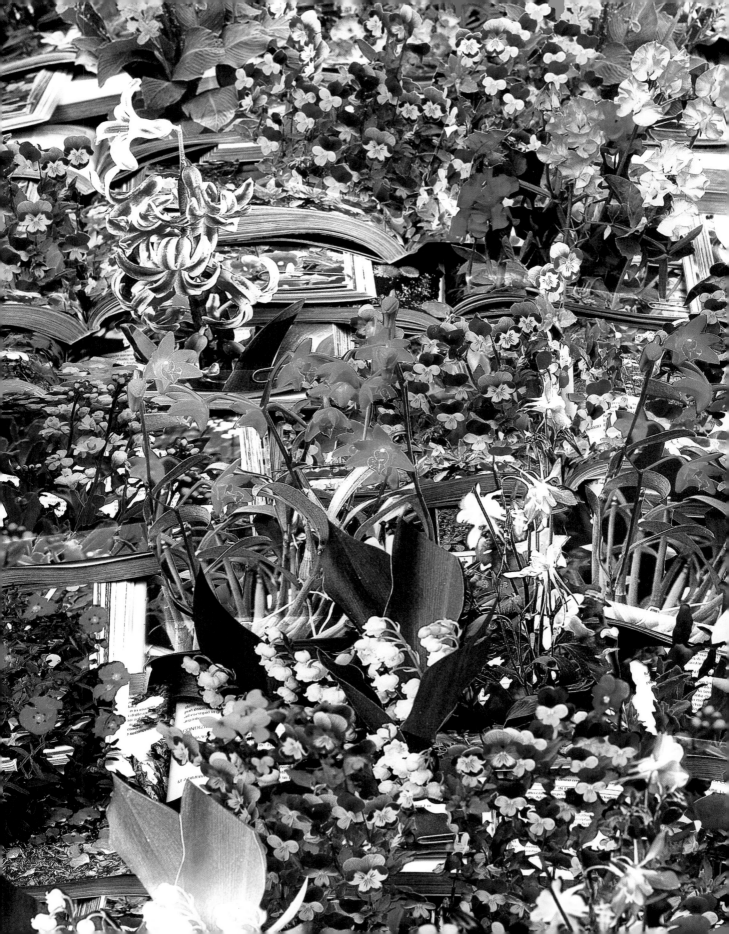

Aric Obrosey

Aric Obrosey received his MFA from the University of Michigan in 1979 but had already begun exhibiting his prints in group exhibitions in 1977. Since then, he has been represented in numerous exhibitions primarily in New York City, but across the United States and in Germany as well. His solo exhibition in 1997 at James Graham & Sons, New York, brought Obrosey's work to the attention of a wide public. Obrosey has been the recipient of many awards, notably a Pollock-Krasner Foundation Award, a fellowship from the New York Foundation for the Arts, and another from the Mid-Atlantic/National Endowment for the Arts. He has also been accorded two Yaddo residencies. Obrosey's work is found in major collections, including the Whitney Museum of American Art, New York; the Fogg Art Museum, Harvard University, Cambridge; and the Contemporary Museum, Honolulu.

The piece I have made for this exhibition is part of an ongoing body of work that mines the rich visual tradition of lacework for its formal qualities, but also examines it as a symbol of past and lost economies which were based on unique, hand-produced consumer objects. Sensibilities within the tradition of lace-making parallel my personal devotion to the work of the hand, as well as a love of detail, complexity, pattern, and linear structure.

My hand-cut paper pieces emphasize a meticulous, transformative process which starts with the formal elements from lacemaking as a vocabulary for creating new work. The precision required in the cutting, the creation of negative space, and the play of shadow as an active visual component, all mimic the complexity found in hand-made lacework. The edge of each line has an individual identity; each contains silhouettes that impart the line with a specific content, such as industry, labor, mass-production, handwork, technology, and obsolescence. Old LPs or 45 records, mandalas, starbursts, houses, circuitry, auto emblems, architectural motifs, light bulbs, tantric fire, cardboard boxes, pop icons, and other entities are embedded in each line's profile.

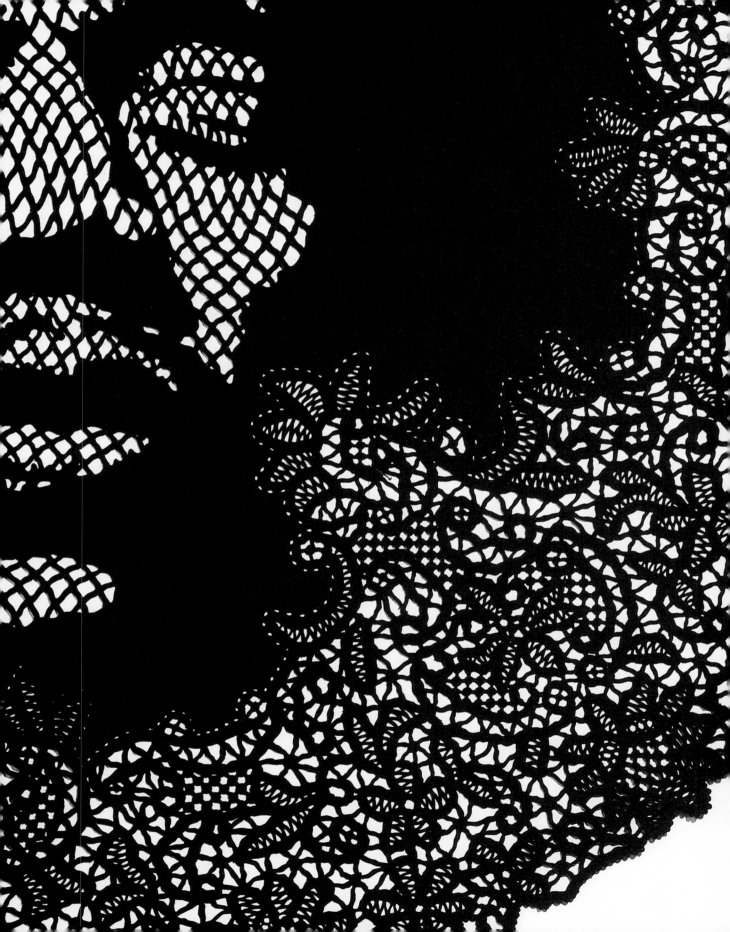

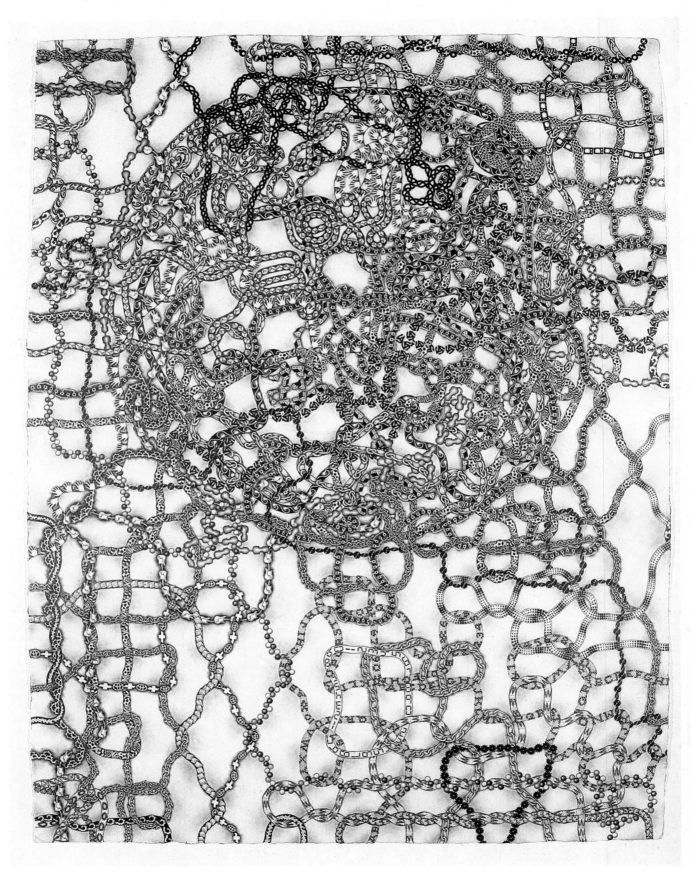

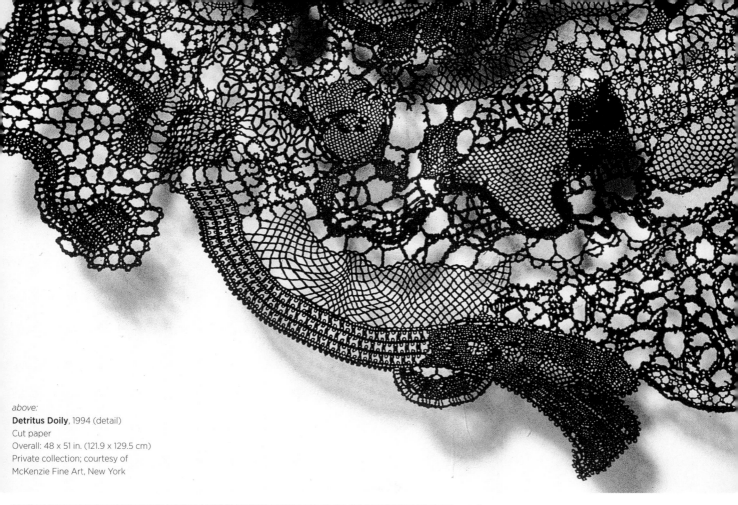

above:
Detritus Doily, 1994 (detail)
Cut paper
Overall: 48 x 51 in. (121.9 x 129.5 cm)
Private collection; courtesy of
McKenzie Fine Art, New York

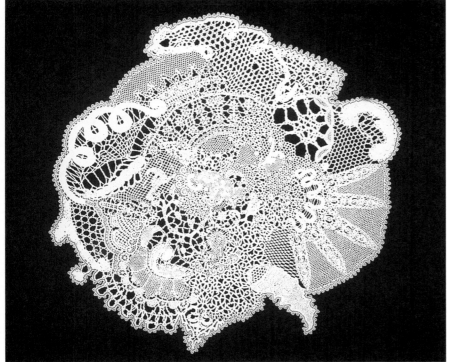

left:
Wonder Wander Doily, 1994
Cut paper
51 x 54 in. (129.5 x 137.2 cm)
Private collection; courtesy of
McKenzie Fine Art, New York

opposite:
Mirror Ball Fond, 2008
Graphite on paper
24 x 18 in. (61 x 45.7 cm)
Collection of A.G. Rosen; courtesy of
McKenzie Fine Art, New York

Mia Pearlman

Mia Pearlman received her BFA in painting from Cornell University, Ithaca, New York. She began exhibiting while a student at Cornell, and since that time has participated in group exhibitions at galleries and museums in New York City, London, Minneapolis, Boston, and Indianapolis. Her solo exhibitions have included those at the Centre for Recent Drawing in London; Septième Étage in Geneva, Switzerland; and the Montgomery Museum of Fine Arts in Alabama. Pearlman has been artist in residence at Byrdcliffe Arts Colony in Woodstock, New York; the Vermont Studio Center in Johnson, Vermont; Urban Glass in Brooklyn; and Proyecto'Ace, in Buenos Aires. In 2008 she received a Pollock-Krasner Foundation grant.

I make site-specific cut-paper installations, ephemeral drawings in both two and three dimensions that blur the line between actual, illusionistic, and imagined space. To create them, I make line drawings on large rolls of paper in India ink. Then I cut out selected areas to make a new drawing in positive and negative space, on the reverse. Installed in a room, these drawings and their shadows capture a weightless world in flux, frozen in time, tottering on the brink of being and not being. My work is very intuitive, based on spontaneous decisions in the moment, a meditation on chance, control, and the transient nature of reality.

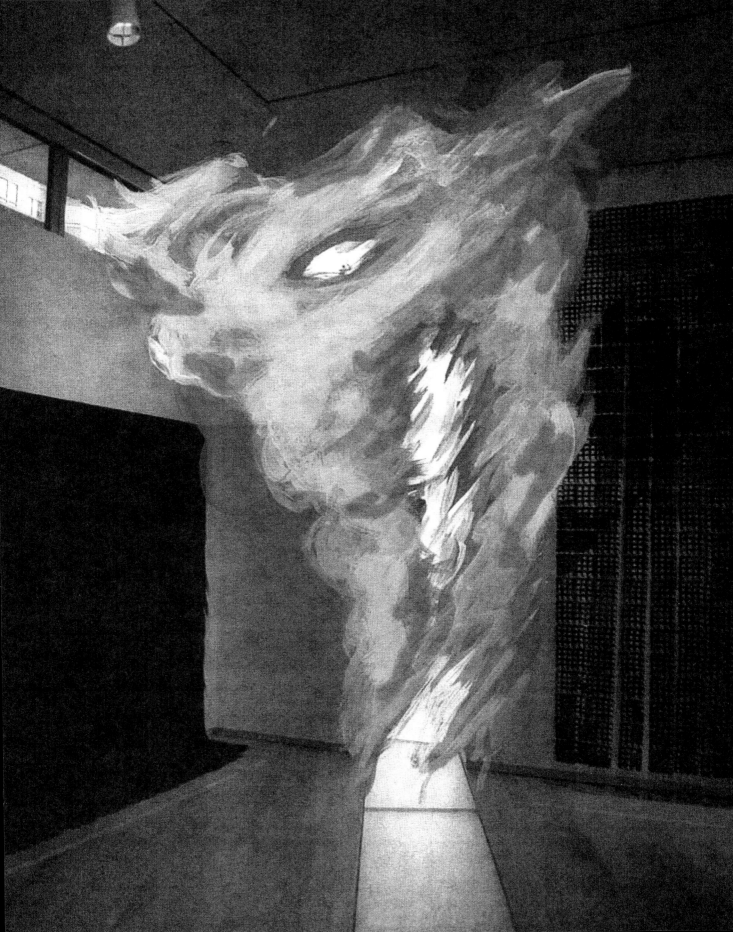

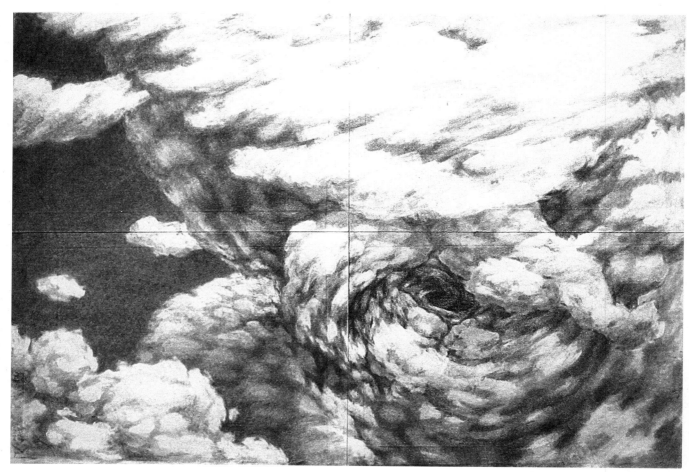

Cloudscape, 2005
Graphite on paper
22 x 28 in. (55.9 x 71.1 cm)
Anna and Bob Kelly

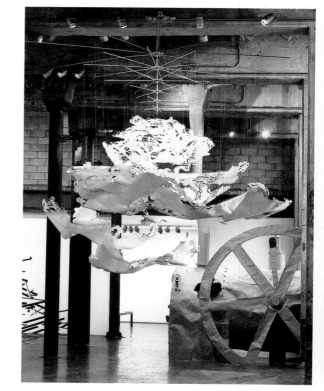

Maelstrom, 2008
Site-specific installation at
Smack Mellon, Brooklyn, NY
Steel, aluminum, wire, paper,
India ink, monofilament
11 x 12 ft. (3.4 x 3.7 m)

Influx, 2008
Site-specific installation at
Roebling Hall Gallery, NY
Paper, India ink, tacks,
paper clips
Dimensions variable

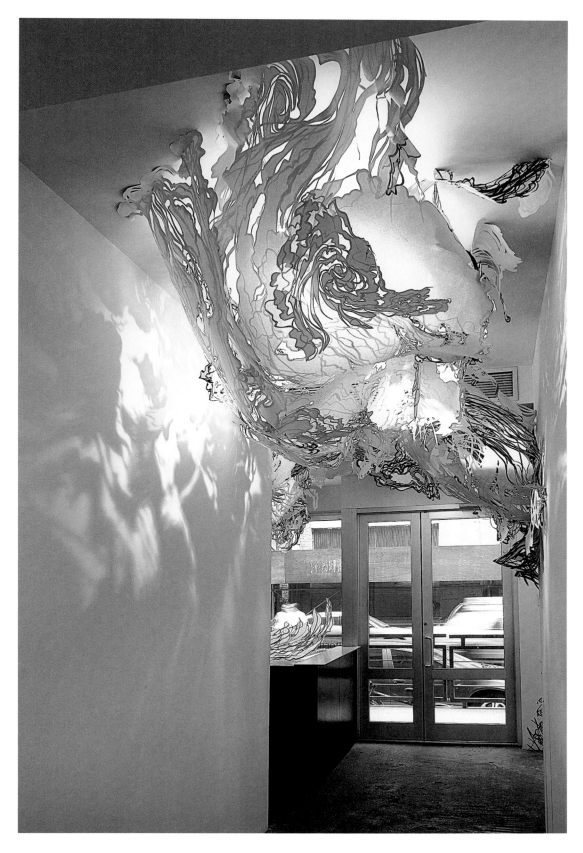

Judy Pfaff

British-born Judy Pfaff received her BFA from Washington University, St. Louis, and her MFA from Yale University. Since 1973 she has been accorded well over one hundred solo exhibitions. Pfaff has been featured in three Whitney Museum of American Art Biennials (1975, 1981, 1987), in the 1998 Bienal de São Paolo, Brazil, and in the Biennale de Venezia, Italy, in 1982. She has also designed for the performing arts, most recently the set design for the opera *Regina* by Marc Blitzstein, performed by the American Symphony Orchestra at the Richard B. Fisher Center, Annandale-on-Hudson, New York. Pfaff's grants and awards have included a MacArthur Fellowship, Nancy Graves Foundation grant, Guggenheim Fellowship, National Endowment for the Arts grant, and a Barnett and Annalee Newman Foundation fellowship, among others. Pfaff has been artist in residence and visiting artist at museums and educational institutions throughout the United States. She serves as professor of art and co-chair of the art department at Bard College, Annandale-on-Hudson, New York. Her work is found in such institutions as the Museum of Modern Art, New York; the Brooklyn Museum, New York; and the Whitney Museum of American Art, New York, as well as in many noted private collections. She is a newly elected member to the American Academy of Arts and Letters.

My work follows my life directly, and if this new work is any indication, life is good. Living much of the time in upstate New York, I have been largely building and repairing spaces. Lately the land, the weather, and plant life have gained priority. With so much of my time spent moving earth, planting, and gardening, the results are showing up in my new work.

Paper has been a major material for quite a while. I discovered mulberry, gampi, and rolls of Hosho twenty years ago while making prints, and have been hooked ever since. The mutability of paper, its beauty, its deep history, and especially the ease of assembling offer up so many forms. As a sculptor I am usually fabricating and moving large and small unwieldy steel and plaster objects. Paper affords a kind of freedom and joy. . . . at this time, for me, this is something essential.

New Morning, 2008
Perforated and burned bond and
Crown Kozo paper, silk flowers,
coffee filters, wire
91 x 91 in. (231.1 x 231.1 cm)
Collection of the artist

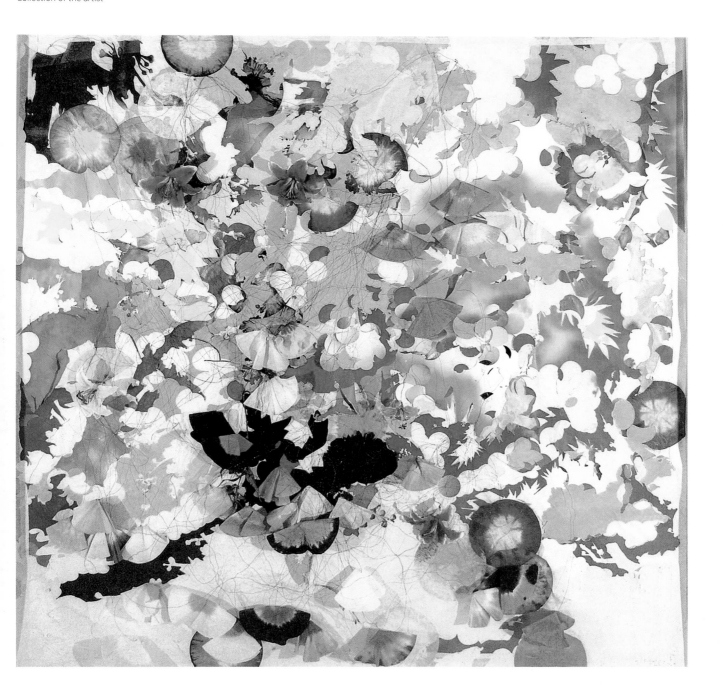

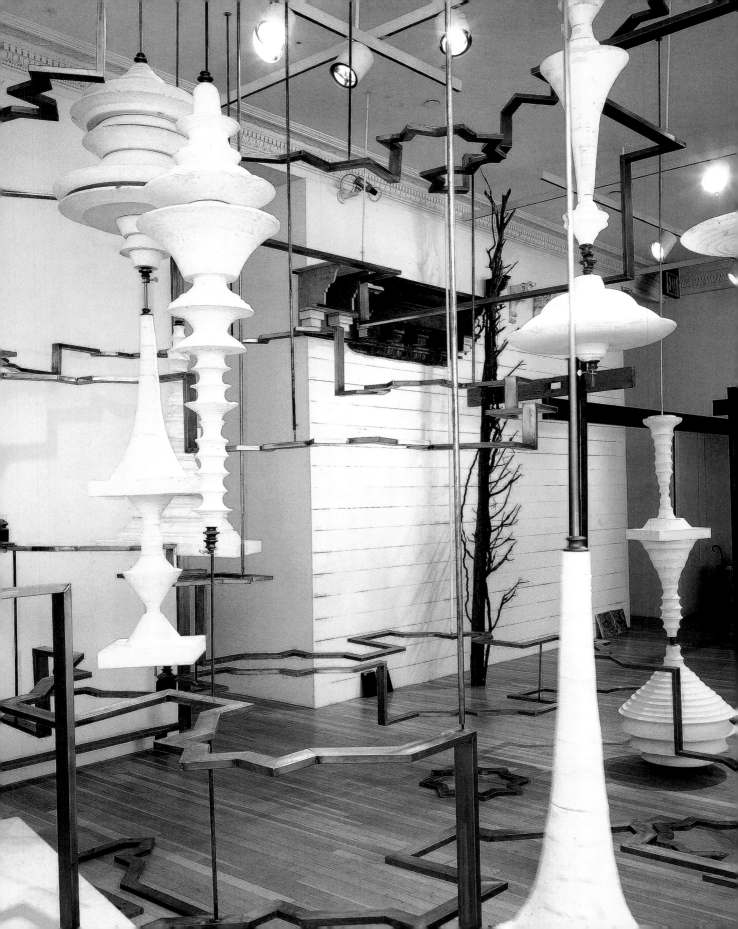

right:
Buckets of Rain, 2006
Installation at Ameringer Yohe
Fine Art, New York, NY
Wood, steel, wax, plaster,
fluorescent lights, paint, black foil,
expanding foam
Dimensions variable

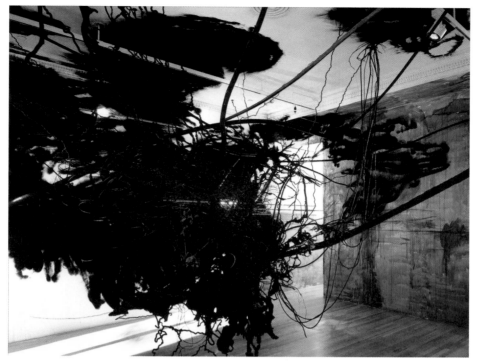

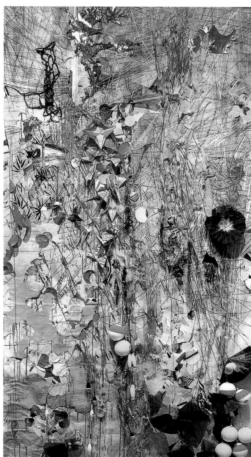

left:
Beaufort Scale, 2008
Multiple layers of paper (Japanese,
Hosho, joss, newsprint), coffee
filters, magazines, origami, fishing
floats, wire, shellac, dye, ink,
encaustic, acrylic
95 ½ x 49 x 5 ¾ in.
(242.6 x 124.5 x 14.6 cm)
Collection of the artist

opposite:
Neither Here Nor There, 2003
Installation at Ameringer Yohe
Fine Art, New York, NY
Mechanical tubing, wood, rigid
foam, paint, tape
Dimensions variable

Ed Pien

Ed Pien was born in Taipei, Taiwan, and emigrated to Canada with his family at age eleven. He received his BFA from the University of Western Ontario in London, Ontario, and his MFA from York University in Toronto, where he lives and works. Pien's work has been exhibited at the Drawing Center, New York; the Art Gallery of Ontario, Toronto; the Museum of Contemporary Art, Monterrey, Mexico; the Bellevue Arts Museum, Washington; and Goethe-Institut, Berlin, among others. Pien has taught at the Emily Carr University of Art and Design, Vancouver, the Ontario College of Art and Design, Toronto, and the Nova Scotia College of Art and Design, Halifax. He currently teaches at the University of Toronto.

Through my work, I investigate the convergence of history, beliefs, and mythology from diverse cultures in an attempt to make more critical and engaging art. Using drawing, papercuts, installation and video work, I explore curiosity, wonder, and enchantment, with a particular focus on the strange and grotesque as a means of overcoming our fears and vulnerabilities. By questioning and challenging the concept of normality and reconsidering preconceived notions of difference, it is possible to celebrate diverse ways of being in the world.

In my papercuts I combine real and imaginary images in order to realize a realm that is at once familiar and strange. Furthermore, I am interested in the potential of silhouettes that this process and medium afford. The silhouette form is more ambiguous, suggestive, and much more open to a wide range of interpretations.

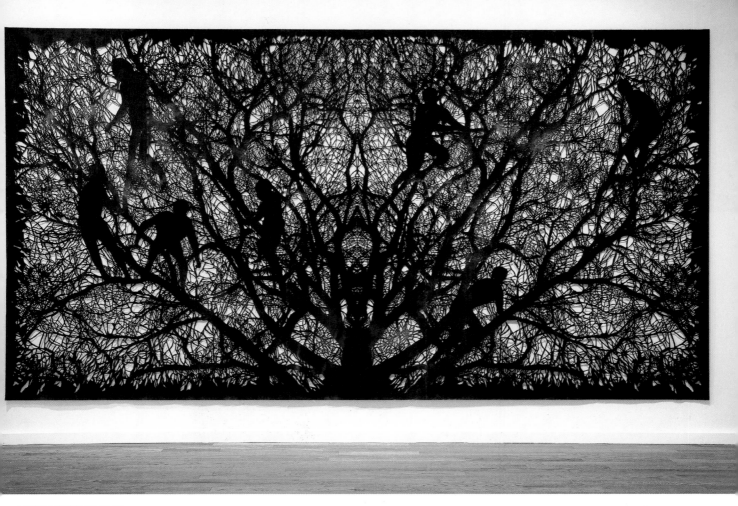

NIGHT GATHERING, 2005
Ink on Shoji paper
8 ft., 1 in. x 16 ft., 1 in. (2.5 x 4.9 m)
Collection of Joe Battat; courtesy
of Joe Battat and Pierre-François
Ouellette Art Contemporain,
Montreal

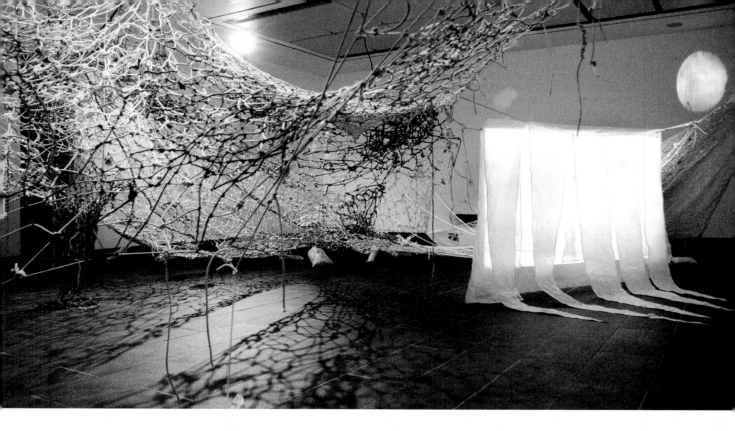

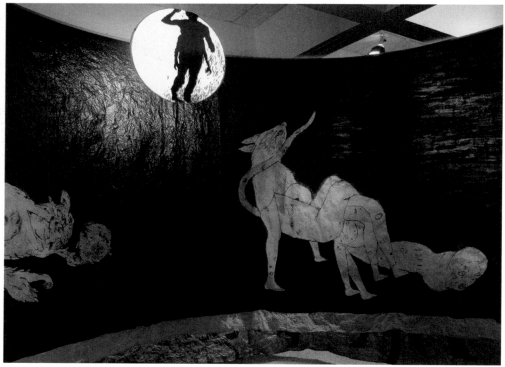

Memento, 2009
Rope, cut tarpaulin, mirrors; video, sound
11 x 28 x 40 ft. (3.4 x 8.5 x 12.2 m)
Collection of the artist; courtesy of Birch Libralato, Toronto

Tracing Night, 2004
Ink, glassine; sound, video
13 x 18 x 45 ft. (4.0 x 5.5 x 13.7 m)
Collection of the artist; courtesy
of Pierre-François Ouellette Art
Contemporain, Montreal

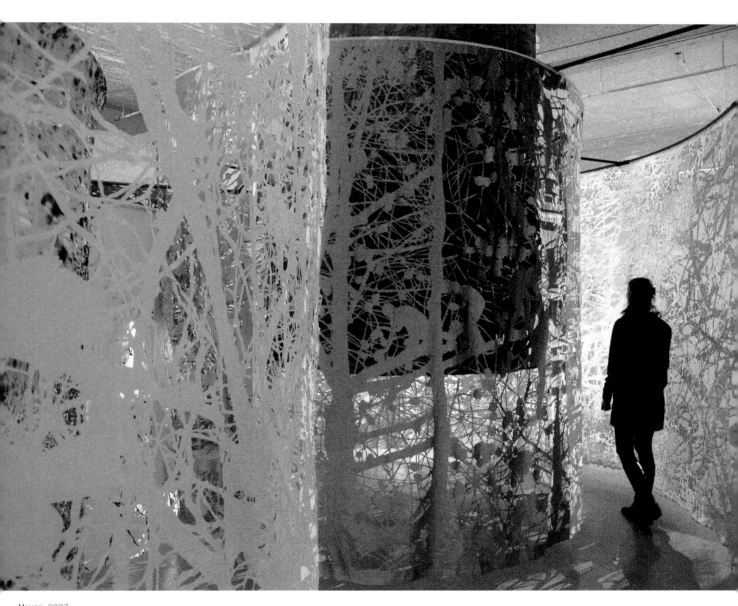

Haven, 2007
Ink, Shoji paper, 3M reflector film;
sound, video
13 ft., 1 ½ in. x 20 ft., 4 ⅛ in. x 17 ft., ¾ in.
(4 x 6.2 x 5.2 m)
Collection of the artist; courtesy
of Pierre-François Ouellette Art
Contemporain, Montreal

Ishmael Randall Weeks

Ishmael Randall Weeks divides his time between New York City and Peru, where he was born. Randall Weeks studied at Bard College, Annandale-on-Hudson, New York, where he received his BA (Judy Pfaff, also represented in this exhibition, was one of his teachers) and later at the Skowhegan School of Painting and Sculpture, in Maine. Since 2000, he has had solo exhibitions in New York, Mexico, Bolivia, and Peru, and he has also been included in numerous international group exhibitions including the 10th Havana Biennial, as well as the 9th Cuenca Biennial. He has received fellowships, residencies, and awards from a range of institutions, including the Foundation for Contemporary Art, New York; Art Matters, New York; Vermont Studio Art Center, Johnson; Sculpture Space, New York; the Kiosko Galeria, Santa Cruz, Bolivia; and La Curtiduria art center in Oaxaca, Mexico, among others.

My work encompasses site-specific installations, sculpture and video, and small-scale paper cutouts and drawings. In these works, issues of urbanization, transformation, regeneration, escape, collapse, and nomadic existence have been predominant. While the work in the drawing studio serves as a means for a more intimate exploration of these issues, the foundation of my larger scale work lies in the alteration of found and recycled materials and environmental debris, often on site (including such source materials as books and printed matter, empty tins, old tires, bicycles, boat parts, and building construction fragments) that are often altered to create architectural spaces or conveyances—carts, cranes, carriages— that potentially could have a use and/or movement but where the possibility of use is refused (in an economically productive sense) in favor of an allegorical narrative within a personal and shared cultural vocabulary. In recent work, such as Landscape *and* Architect *(both 2009), where I have carved miniature landscapes and erosions into stacked slabs of architectural plans and used educational books, firmly glued down to old drafting tables, I try to point at an underlying sense of anxiety and fragility that I feel about our recent production through technology and science, specifically the problematic combination of utility and aesthetics in relation to our environment and ourselves.*

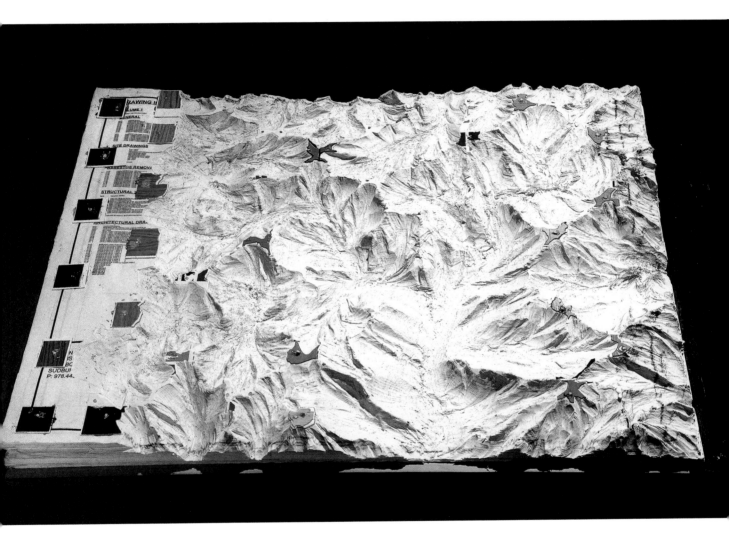

LANDSCAPE, 2009
Carved architectural plans, wood,
steel table
58 x 46 x 34 in. (147.3 x 116.8 x 86.4 cm)
Courtesy of Eleven Rivington Gallery,
New York

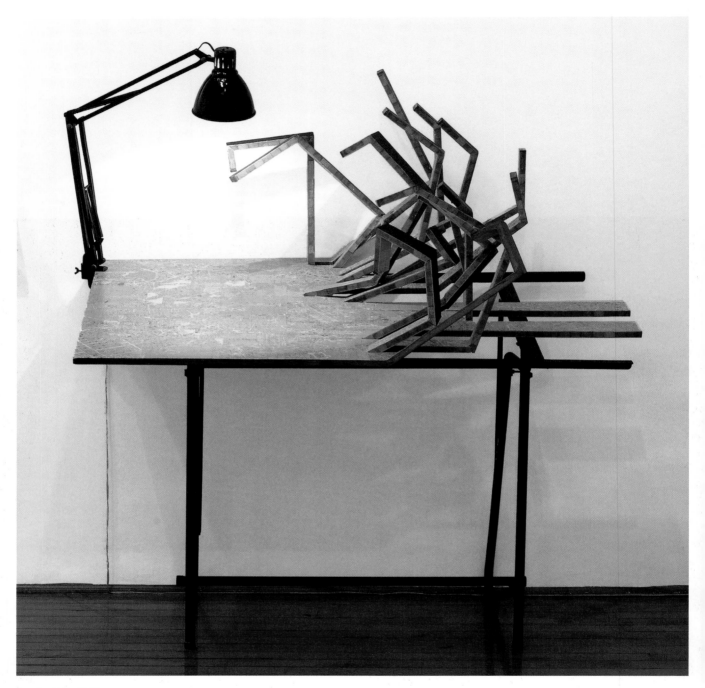

Drawing Table, 2008
Architect's drawing table, collage of
maps, lamp
39 ½ x 59 x 34 ½ in.
(100 x 150 x 90 cm)
Collection of Federica Schiavo

Streets (detail set Refugio), 2008
Cut paper, cut photos, photo tape
11 x 8 ¾ in. (28 x 22 cm)
Collection of Ignacio Garza Medina

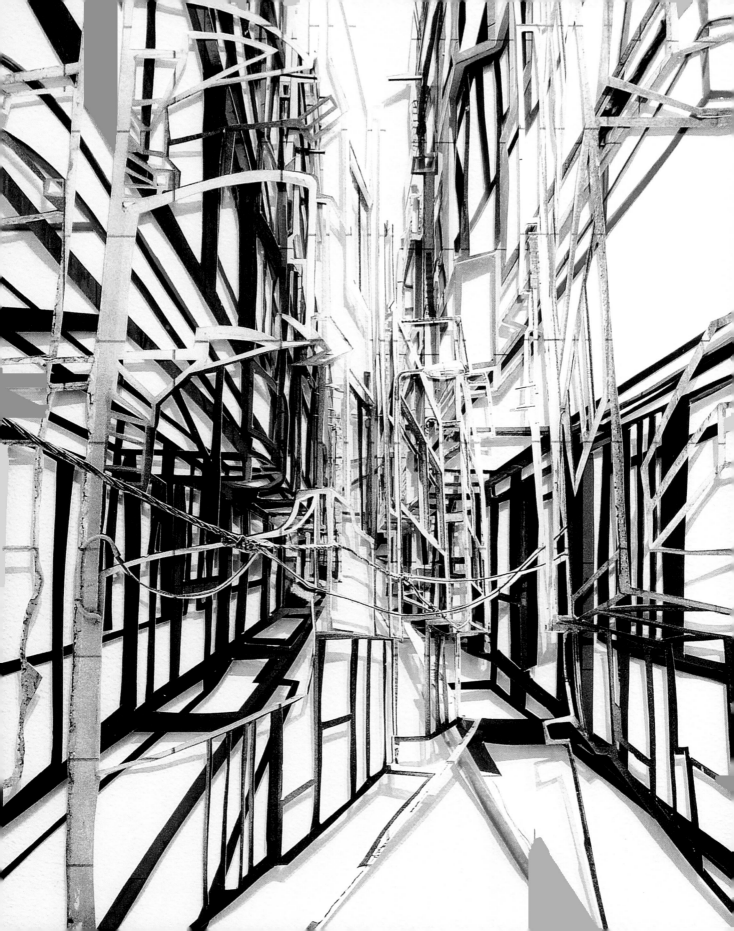

opposite; detail below:
Garland, after Pierre Esquie, 2006
Installation at Museo de Arte
Contemporáneo, MAC, Santiago
de Chile
Wallpaper; drawing, painting,
cutting, peeling
13 ft., 1½ in. x 39 ft., 4 ⁷⁄₁₆ in. (4 x 12 m)

Tomás Rivas

Tomás Rivas was born in Santiago, Chile, where he lives and works today. Rivas attended the Pontificia Universidad Católica de Chile in Santiago, receiving his BFA in art in 1999. His MFA was awarded by the University of Notre Dame in Indiana. Rivas studied lithography and engraving at the Taller Experimental de Gráfica in Havana, Cuba. After studies at the University of Genoa in Italy, where he received a scholarship to pursue Italian studies, he worked in Milan as a printmaking apprentice. Over the years, his work has been exhibited in museums and galleries in Latin America, Europe, and the United States.

My work vacillates between drawing, sculpture, and architecture. My installations are created by carving, hollowing out, and exposing the exterior layers of plaster or wallpapered walls. The motifs that I choose are borrowed from old master paintings and ornamental elements of classical architecture, such as capitals, columns, and cornices. Their removal from their "natural" sphere situates them in an intimate context, while simultaneously pointing to their ephemerality and their potential destruction. My intention is to investigate the ornamental components of classical Western architecture by focusing on decorative details that are considered marginal in the context of these monumental structures. My ongoing investigation of the representation of space addresses the complexity of art production today, where the center and the periphery vie for political clout within the mainstream. Playing with linear perspective, ornamentation, and unorthodox materials, I intend my work to investigate how the viewer's cultural expectations frame perception.

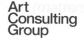

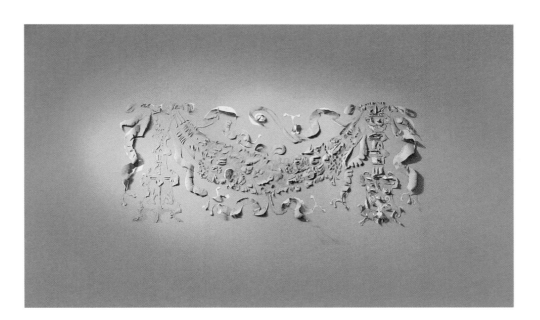

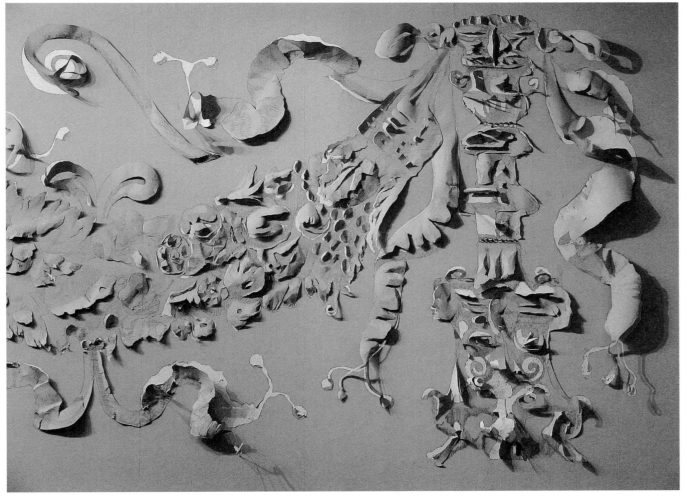

After the Fall, 2007
Installation view at Douz and Mille,
Washington DC
Carving on gallery walls
Dimensions variable

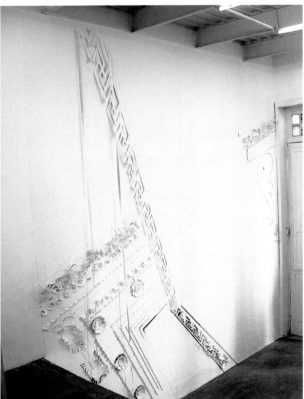

**Persuasión, después de Edmond
Guillaume**, 2007
Installation view at Galería A Gentil
Carioca, Rio de Janeiro, Brazil
Wallpaper; drawing, painting,
cutting, peeling
Dimensions variable

The Ideal City, 2009
Drywall, wallpaper; drawing, cutting,
carving
26 ft., 3 in. x 11 ft., 6 in. (8 x 3.5 m)
Courtesy of Zavaleta Lab, Buenos
Aires, Argentina

Dario Robleto

NURSES NEEDED NOW, 2006
Homemade paper (pulp made from soldiers' letters home from various wars, ink retrieved from letters, cotton), colored paper, thread and fabric from soldiers' uniforms from various wars, WWI gauze bandage, braided hair, crepe, cast military medal, needles, ribbon, colored pencil, pen, foamcore
33½ x 26 x 6 in. (85.1 x 66 x 15.2 cm)
Framed: 41 ¼ x 34 ¼ x 9 in.
(104.8 x 87 x 22.9 cm)
Collection of Nancy and Stanley Singer

Texas-based Dario Robleto received his BFA from the University of Texas at San Antonio in 1997. The artist has had over twenty solo exhibitions since 1997 at museums such as the Frances Young Tang Teaching Museum and Art Gallery at Skidmore College, Saratoga Springs, New York; the Whitney Museum of American Art at Altria, New York; the Museum of Contemporary Art, San Diego–Downtown; and the Frye Art Museum, Seattle, as well as in galleries in the United States and France. Notable group shows include *Whitney Biennial 2004*, Whitney Museum of American Art, New York; *Old, Weird America*, Contemporary Arts Museum, Houston; and *Human/Nature: Artists Respond to a Changing Planet*, Museum of Contemporary Art, San Diego. Robleto has been visiting artist and lecturer at many colleges and universities, including Cranbrook Academy, Bloomfield Hills, Michigan; Harvard University, Cambridge; and the Rhode Island School of Design, Providence. His awards have included the International Association of Art Critics Award in 2004 for the best exhibition in a commercial gallery at the national level.

In the broadest sense of my artistic practice, I have been concerned with the nature of grief and mourning historically, and how it has fueled new leaps in logic and aesthetics. A logic of loss in a sense. I look to these topics not as an ending, but as a starting point to discover how hope and redemption continually seem to counteract the pain of loss. Counterintuitively, I have to look as deeply into loss as possible to find the truly extraordinary aspects of humanness. It is this bordering-on-the-miraculous form of hope that I am ultimately after. It offers a sense of wonder and reenchantment with the world that counterattacks the effects of extreme grief. This leads to a last broad theme in my work—the nature of belief, faith and doubt in relation to loss and materials. It is a central tenet of my work that all story topics and materials be based in fact and real world experience, while pressing toward the fantastical edge of belief, doubt, and hope. I am interested in asking art to embrace these extremes and by extension I have to ask the same of myself.

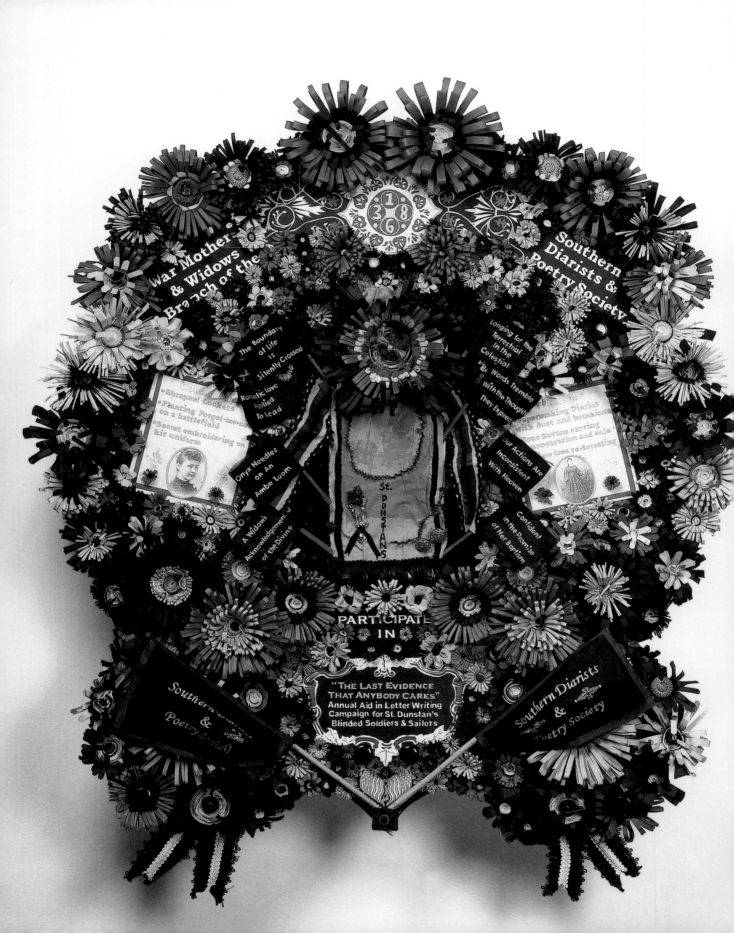

opposite:
The Southern Diarists Society, 2006
Homemade paper (pulp made from brides' letters to soldiers from various wars, ink retrieved from letters, cotton), colored paper, fabric and thread from soldiers' uniforms from various wars, hair flowers braided by war widows, mourning-dress fabric, silk, ribbon, lace, cartes de visite, antique buttons, excavated shrapnel and melted bullet lead from various battlefields
45 x 37 x 6 in. (114.3 x 94 x 15.2 cm)
Vitrine: 48 ½ x 42½ x 8 ¼ in.
(123.2 x 108 x 30.5 cm)
Courtesy of the artist and D'Amelio Terras, New York

above; detail below:
What the Elegist Seeks You Will Surrender, 2007
Ribbon, typeset, colored paper, fabric and thread from mourning dresses, 19th-century top hat, hair flower braided by a war widow intertwined with a stretched audio tape recording of Walt Whitman reciting his poem "America" (1889), melted excavated lead from various wars, metal lockets, cartes de visite, ink-stained willow, glass
44 x 44 x 55 in.
(111.8 x 111.8 x 139.7 cm)
Courtesy of the artist and D'Amelio Terras, New York

Andrew Scott Ross

A native New Yorker, Andrew Scott Ross received his BFA from the Atlanta College of Art, Georgia, and his MFA at the School of the Art Institute of Chicago. He subsequently studied at the Skowhegan School of Painting and Sculpture in Maine. His solo exhibitions have been held at the Museum of Contemporary Art of Georgia in Atlanta. As part of the Works and Process series at the Guggenheim Museum in New York, he created an installation of paper sculptures for a production of Prokofiev's *Peter and the Wolf*. Ross has received numerous fellowships, including the Skowhegan Fellowship, a National Endowment for the Arts/Chashama Grant (with Dos Pestaneos), and a Joan Mitchell Foundation grant. He has lectured and served as visiting artist at colleges, universities, and museums across the United States, including the School of the Art Institute of Chicago, Florida Atlantic University, Alfred University, and the Museum of Contemporary Art of Georgia.

By intersecting biological and archaeological themes with personal and primitive mythology, my art practice explores the elusive framework of cultural beliefs, and our often-peculiar relationship with the natural world. I have partitioned my practice into two ongoing series, which usually address themes of biology and culture separately.

Throughout these series, the aesthetics of cultural and scientific institutions intermingle with materials that are both common and ironic. Crumbled paper can take the place of a prehistoric diorama. Birdseed can stand in for stars in a planetarium. A parking space can become a ground plan for an archaeological dig. Materials such as mud, branches, and tree roots are manipulated into flimsy artifice, while nightcrawlers may become spiritually charged through simple camera tricks. When the work is amassed, I hope to portray a museum-like environment that is both messy and deeply personal—an open institution that seems to be stuck in a curatorial drift.

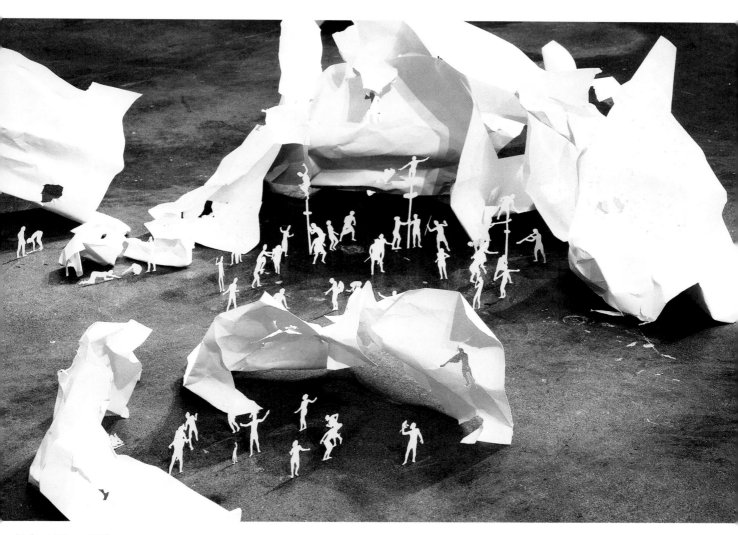

Rocks and Caves, 2006
Office paper
Dimensions variable
Collection of the artist

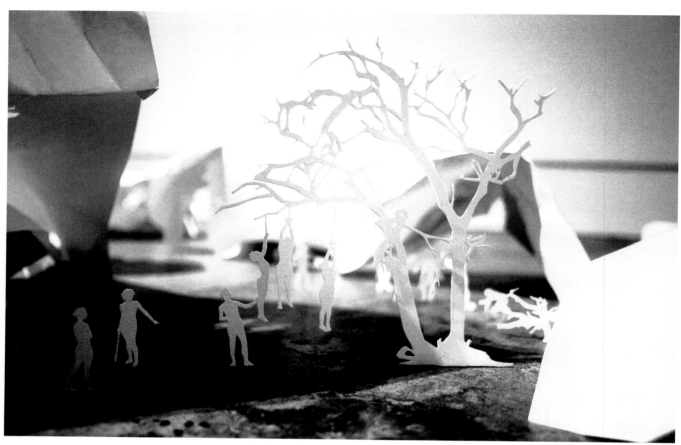

Rocks and Caves, 2006
Office paper
Dimensions variable
Collection of the artist

The MET (Study 3), 2009
Screen-print on paper
40 x 30 in. (101.6 x 76.2 cm)
Collection of the artist

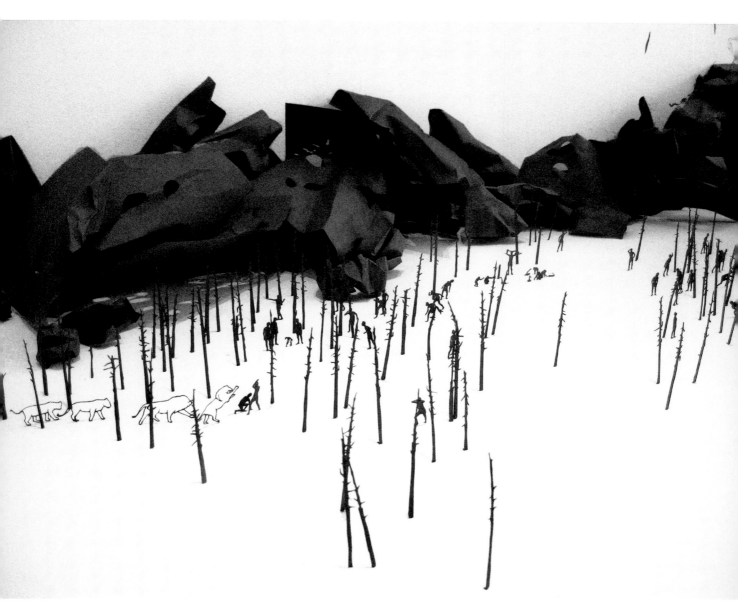

Rocks and Caves, 2006
Office paper
Dimensions variable
Collection of the artist

Pietro Ruffo

Pietro Ruffo was born in Rome, where he studied architecture and maintains his studio. Ten solo exhibitions have been organized in Italy, but his work has also been seen in London, New York, Berlin, and Sendai, Japan. He created a site-specific permanent installation at Rome's Santo Volto di Gesú Church, designed by Piero Sartogo and Nathalie Grenon, and commissioned by the Vatican. In 1999 he organized a workshop to complete a permanent installation at the Center for Contemporary Art at the Union Nationale des Arts Culturels of Algeria. Ruffo has conducted several art therapy classes with patients: one in the Center for Psychiatric Health of Colmar, in Alsace; and, in 2005, another in Beslan, Russia, for children who survived the horrific massacre carried out by Chechen and Ingush terrorists.

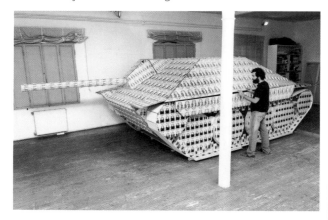

Each of my projects comes from a specific interest. I approach a theme by analyzing it, using investigative methods I learned when studying architecture, like relief and cartography. I do not intend to reveal a single "truth," but to offer differing points of view and establish a dialogue. Youth of the Hills, *a response to the Israeli-Palestinian conflict, is a model of a World War II tank, covered with Hebrew prayers that have been cut to create three-dimensional insects. They are stag beetles, which, in desert lands, often live under the sand. They are symbols of both stratification and affiliation with their territories. The work is essentially a question mark: how will the Israeli-Palestinian conflict evolve or be resolved? What will the role of our generation in this conflict be? How much does religion become a determining force in our lives and world? The tank is covered with prayers, yet these prayers are infested by the insects, posing the question of how religion and the defense of one's beliefs come to be used in committing acts of force.*

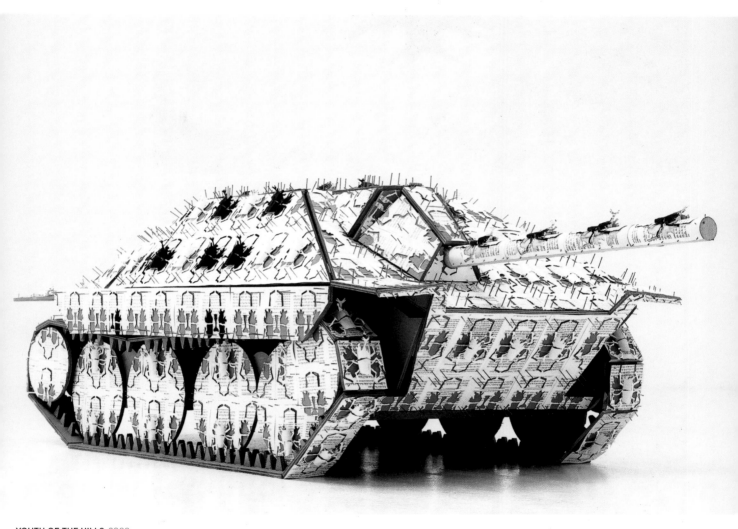

YOUTH OF THE HILLS, 2008
Wood, paper, Hebrew prayer script,
nails
31 ⅞ x 23 ⅝ x 74 ¹³⁄₁₆ in.
(81 x 60 x 190 cm)
Courtesy of Galleria Lorcan O'Neill,
Rome

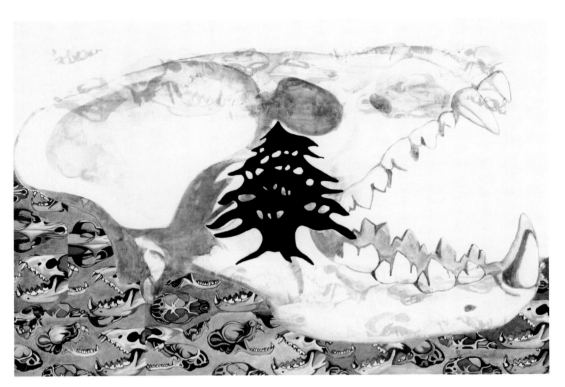

Libano Flag, 2007–8
Watercolor on geographical
map on canvas
27 ⁹⁄₁₆ x 39 ⅜ in.
(70 x 100 cm)
Courtesy of Galleria
Lorcan O'Neill, Rome

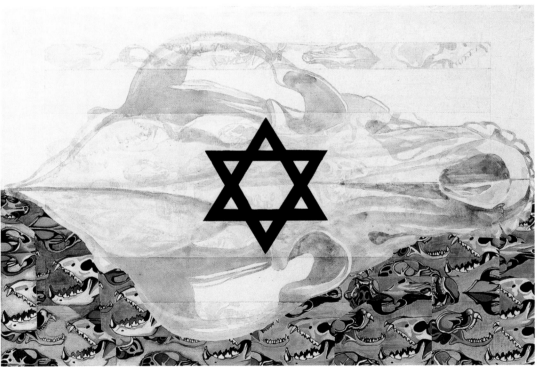

Israel Flag, 2008
Watercolor on geographical
map on canvas
27 ⁹⁄₁₆ x 39 ⅜ in.
(70 x 100 cm)
Courtesy of Galleria
Lorcan O'Neill, Rome

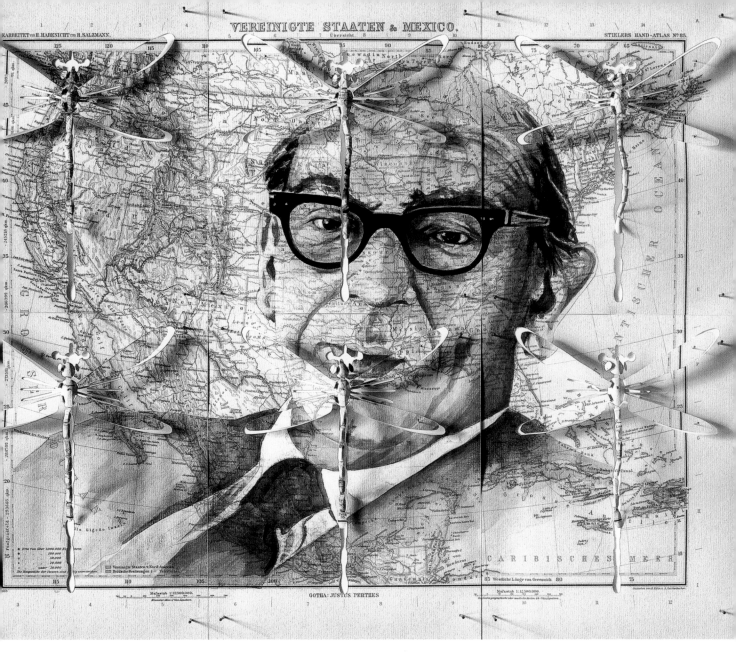

Isaiah Berlin, 2009
Watercolor on geographical map,
nails
21 ½ x 25 ⅝ x 4 in. (54.5 x 65 x 10 cm)
Courtesy of Galleria Lorcan O'Neill,
Rome

Georgia Russell

Born in Scotland in 1974, Georgia Russell studied at Aberdeen College and earned a BA in fine art from Aberdeen University. She has an MA in printmaking from the Royal College of Art, London, and since leaving there she has worked consistently as an artist and educator. She has been a visiting lecturer and tutor at institutions such as Brighton University; Gray's School of Art, Aberdeen; the American University of Paris; and Camberwell College of Arts, London. The Royal College of Art gave her a residency in Paris and awarded her the Aurora Prize for Fine Art in 2000. In recent years, Russell has exhibited regularly at England & Co in London and has been included in international institutional exhibitions. Her work has been featured in several books and catalogues, and has been the subject of numerous articles in magazines and periodicals in Europe and the United States.

In my work there is always the notion of past and passing time. Time passing is described by the intensive time-consuming cutting or manipulation of my material, the actual act or process of throwing the object into another realm of meaning. What is left is time past, non-returnable, the essence of what was. Everything I make is made from fragments and scraps which are rebuilt and gathered together to make a mass. I would like to gather up memory like these fragments. I want to extract information from these inanimate objects, to "read" them again and then "listen" to them—to almost hear the past; but all that can be grasped are fragments that give clues. There is a simultaneous sense of loss and preservation in each work. Values constantly shift, something once valuable is changed, suspended, and put on show for the viewer to ask: What did this object once mean? What memories does it yield? What does it mean now?

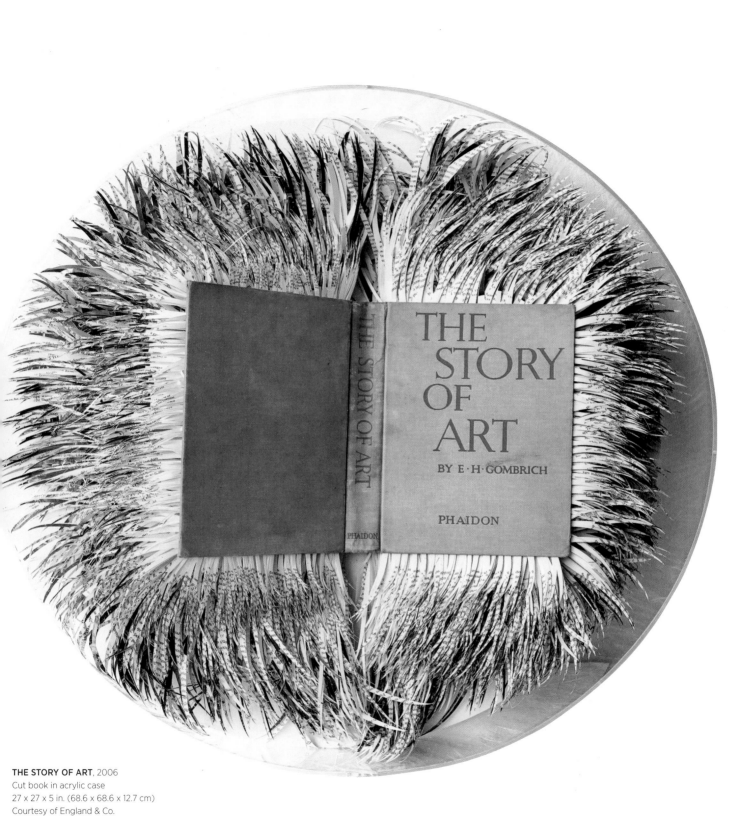

THE STORY OF ART, 2006
Cut book in acrylic case
27 x 27 x 5 in. (68.6 x 68.6 x 12.7 cm)
Courtesy of England & Co.

Paroles, 2009
Cut book in acrylic case
27 x 19 x 3 ½ in.
(68.6 x 48.3 x 8.9 cm)
Courtesy of England & Co.

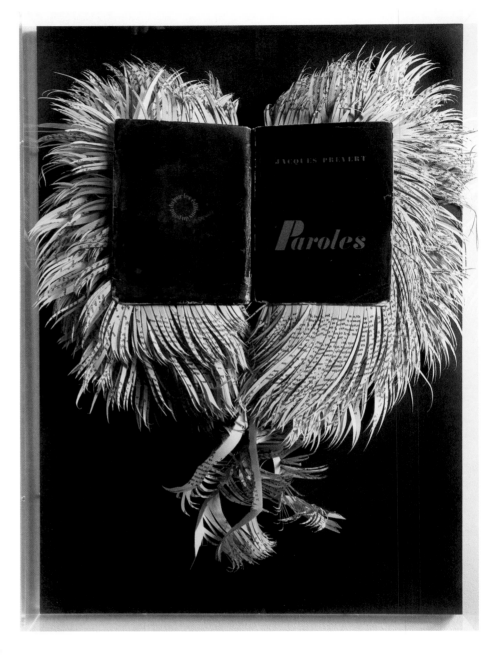

Leurs Secrets, 2007
Cut book in acrylic case
26 ¼ x 3 ¾ in. (66.7 x 9.5 cm)
Courtesy of England & Co.

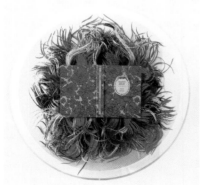

opposite:
De Baudelaire au Surréalisme,
2007
Cut book in bell jar
25 ¾ x 10 ½ in. (65.4 x 26.7 cm)
Courtesy of England & Co.

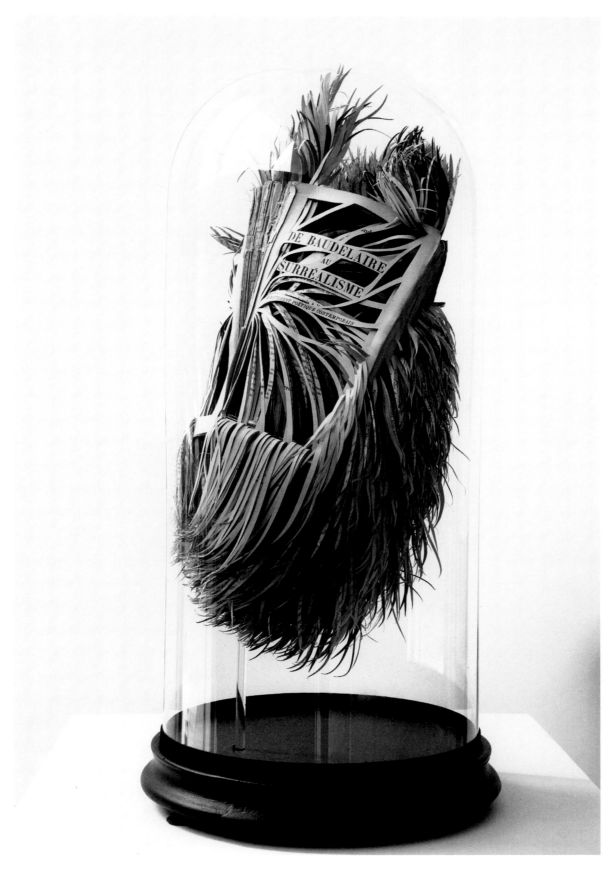

DE BAUDELAIRE
AU
SURRÉALISME

Rob Ryan

Rob Ryan, who lives and works in London, was born in 1962 in Akroti, Cyprus. He studied fine art at the Nottingham Trent Polytechnic in England and at the Royal College of Art in London where he specialized in printmaking. Since 2002 he has been working principally in the papercutting medium. Although he views himself first and always as an artist, his intricate cut-paper work has been adapted to screen printing and transferred to ceramics, fabrics, and other surfaces. Ryan has also designed record album and book covers. He has collaborated with Paul Smith, Liberty of London, Fortnum and Mason, and *Vogue,* along with many other established companies. He is also the author of *This Is For You* (2007), a volume of his cut-paper writings.

To me papercutting means that every-thing is stripped down as much as possible. There is no tone, no varia-tion of color, no pencil mark, no brush strokes. There is only one piece of paper, broken into by knives; within this is the picture, the message, the story, written and traced in silhouette. Such simplicity, I somehow feel, makes my work more readily accessible and easier to digest. Years ago, I could make a painting that could be as heart wrenching as throw-ing my guts onto the gallery wall and having people walk by and ignore it. Now I make a papercut, a little delicate flowery thing with the same message, same imagery, and people stop and look closely. My work is still as much about sadness, being alone, longing for love, as it ever was. I am by nature a nervous and unsettled person. People who have seen and felt my work tell me they find it reassuring and calming, this is why it is made, to help settle and calm myself. We all really share only one story, and my work tells that story over and over.

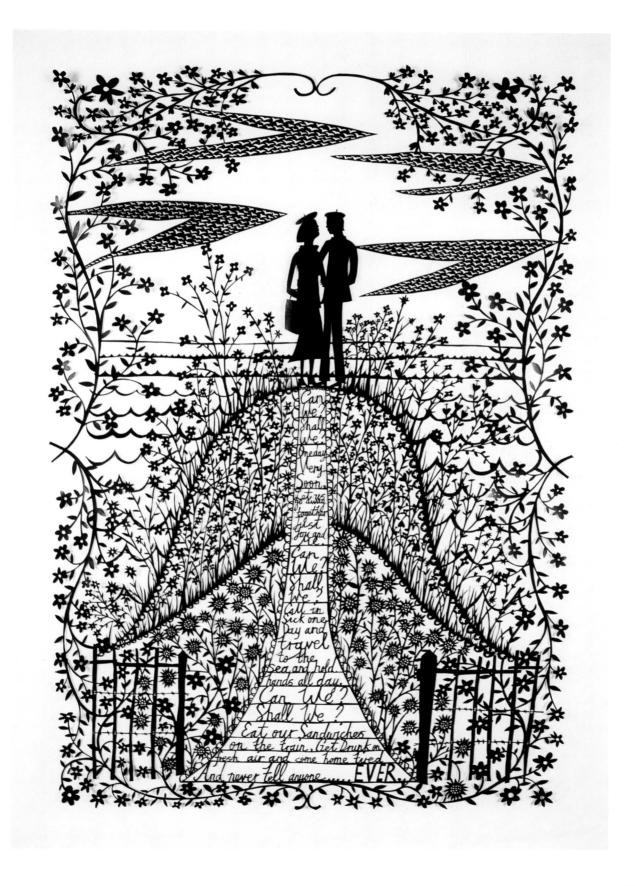

opposite:
Our Adventure (Boy and Girl), 2008
Water-based inks and paper
19 ¼ x 15 ¾ in. (49 x 40 cm)
Courtesy of Robert Ryan screenprints

left; detail below:
We Don't Fly North, 2008
Cut paper
21 ⅞ x 12 ⅝ in. (55.6 x 39.7cm)
Courtesy of Robert Ryan papercuts

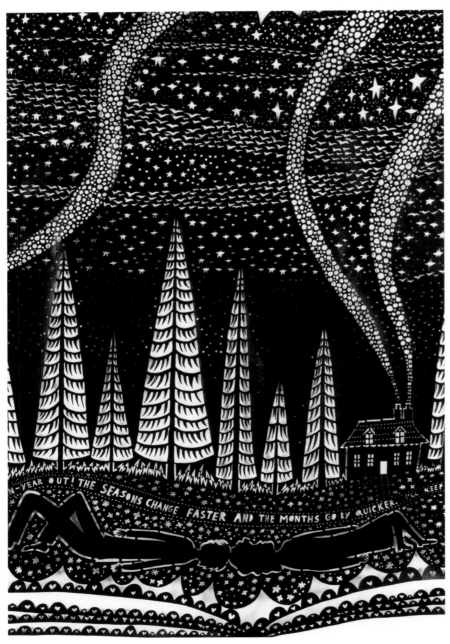

below:
Vogue Dress, 2007
Collaboration between Rob Ryan
and Paul Smith; Tyvek
Courtesy of Robert Ryan and
Gary Paige for Vogue

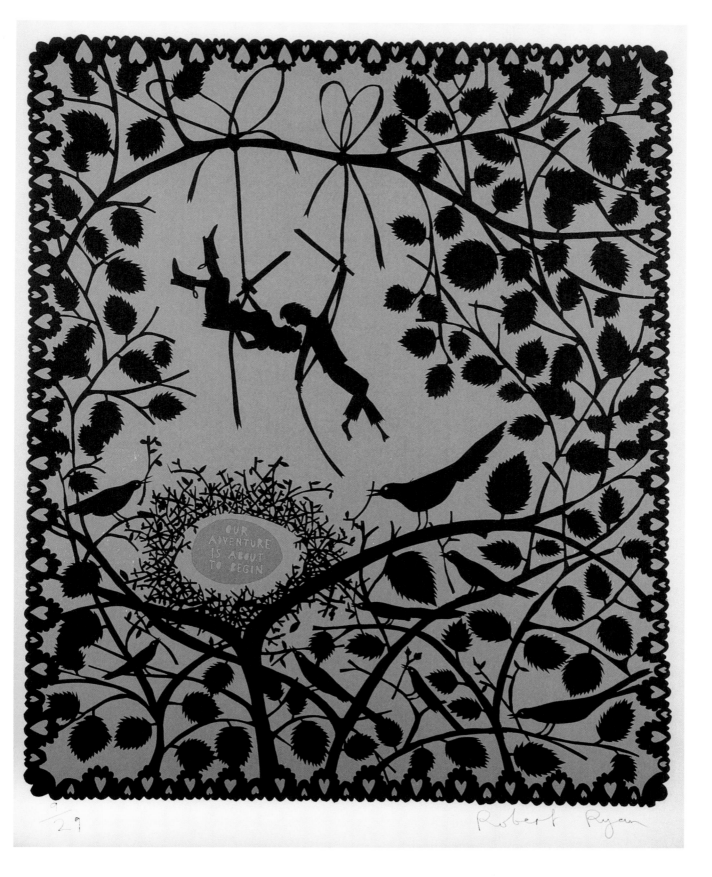

Sangeeta Sandrasegar

Australian artist Sangeeta Sandrasegar, who currently lives and works in London, received her BFA in painting from the Victorian College of the Arts, Melbourne, Australia, and went on to receive her graduate diploma in visual art and a doctorate of philosophy from the same institution. In 2000 she was accorded her first solo exhibition. Her work has been exhibited worldwide at galleries and museums in China, Malaysia, New Zealand, and Singapore, as well as Australia, the United Kingdom, and the United States. Her awards have ranged from the Freedman Foundation Travelling Scholarship for Emerging Artists in Australia to the Lucato Peace Prize (2001), then being awarded by the Victorian College of the Arts. Her work was also featured in the Asia/Pacific Triennial of Contemporary Art at the Queensland Gallery of Modern Art in 2005.

This series is about states of war, and the complicit role(s) we are made to take either in or far from actual physical war zones. These chair templates refer to recognizable design classics. The chairs frame images of war sourced from news agencies in print or from the internet. The chair and image provoke constructs of looking/seeing: as bystander, spectator, onlooker, observer, and the range of power/powerlessness these positions convey. Other contrasts are suggested: between first and third worlds, the safe worlds where the furniture exists and the unsafe worlds in which bombs and raids exist; creation and destruction; wealth and poverty. There is the knowledge of free time and money which the aesthetics of design imply, and how this is fraught with paradoxical discrepancies of consumer, production, and space.

UNTITLED #24 (from The Shadow
of Murder Lay Upon My Sleep
series), 2009
Cut paper
19 5/16 x 20 7/8 in. (49 x 53 cm)
Courtesy of the artist

UNTITLED #26 (from The Shadow
of Murder Lay Upon My Sleep
series), 2009
Cut paper
18 1/2 x 17 11/16 in. (47 x 45 cm)
Courtesy of the artist

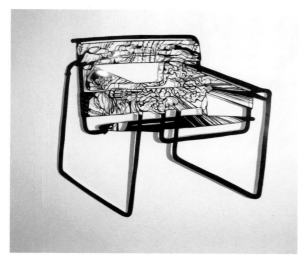

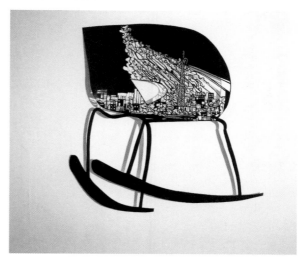

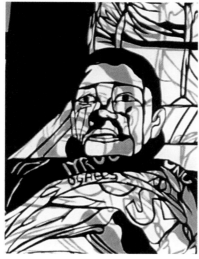

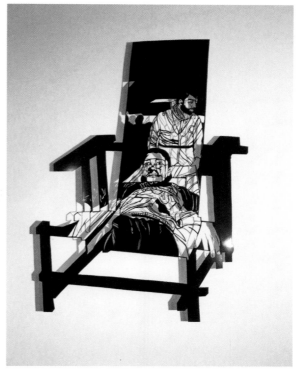

right; detail above:
UNTITLED #25 (from The Shadow of
Murder Lay Upon My Sleep series), 2009
Cut paper
25 9/16 x 17 11/16 in. (65 x 45 cm)
Courtesy of the artist

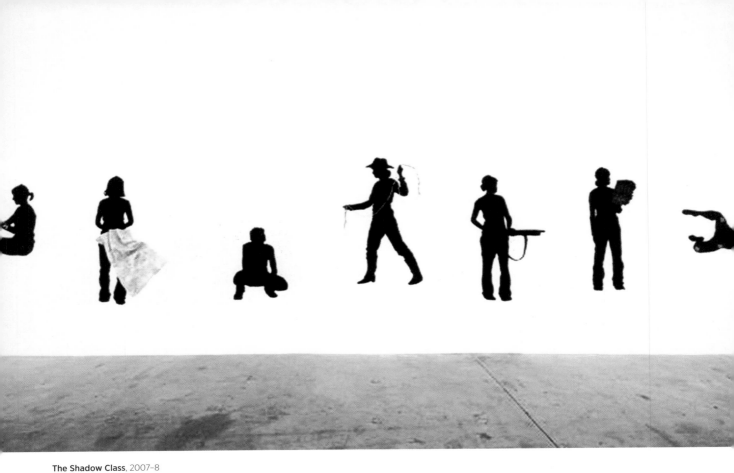

The Shadow Class, 2007–8
Felt, SUPA cloth cotton thread,
nylon thread, nylon organza,
sequins, glass beads, plastic beads,
hosiery
Dimensions variable
Private collections; courtesy of
Murray White Room, Melbourne

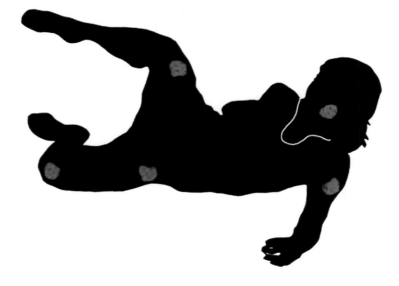

right:
**The Shadow Class, Untitled
(Sex Worker)**, 2007–8
Felt, cotton thread, plastic beads,
hosiery
29 ⅛ x 48 ⅜ in. (74 x 123 cm)
Courtesy of Murray White Room,
Melbourne

opposite:
Untitled #20 (from the Theatre of
the Oppressed series), 2007–8
Cartridge paper, foil paper,
watercolor
28 ¾ x 13 ¾ in. (73 x 35 cm)
Collection of the artist; courtesy of
Murray White Room, Melbourne

Saraben Studio

Saraben Studio is a collaborative enterprise founded by Sara Shafiei and Ben Cowd in 2007. Saraben's design practice includes teaching and experimental architectural design research. Their projects have ranged from residential developments and schools to sustainable floating homes and retail and furniture design. Shafiei graduated from the Bartlett School of Architecture, University College London, where she received the Sir Banister Fletcher Bronze Medal, the REID Student Prize, and the Hamilton Associates Prize. She won the TECU Architecture Award from KME, the German manufacturer of copper products, for her innovative use of copper cladding in *Theatre for Magicians*, which is included in the *Slash* exhibition. Shafiei has shown her work in South America, Europe, and the United Kingdom. Ben Cowd also graduated from the Bartlett School of Architecture, after undergraduate work at the Leicester (UK) School of Architecture. Cowd worked with the architectural firm Foster and Partners in London and North Africa. Both Shafiei and Cowd currently teach at the Leicester School of Architecture and are visiting critics at several universities including the École Spéciale d'Architecture, Paris; Architecture Association School of Architecture, London; Cardiff University in Wales; and the Royal College of Art, London. Shafiei and Cowd are members of Horhizon, a network of young designers, to promote contemporary digital design and research in London and Paris.

Our work attempts to move conventional architectural drawings, such as sections and plans, off the page, from two-dimensional surfaces to three-dimensional constructs. The purpose of the work is to redefine and exceed the traditional limits of drawing, using new technology, such as laser cutting, to layer, wrap, fold, and use the inherent burn from the laser cutter to convey depth and craft. These means of representation are what drive us to use traditional materials including paper in unexpected yet contemporary ways. We strive to establish a tentative balance between ideas of craft while using newly established modes of design and technology and recognizing the intrinsic link of drawing to innovative manufacturing techniques, transforming paper into models.

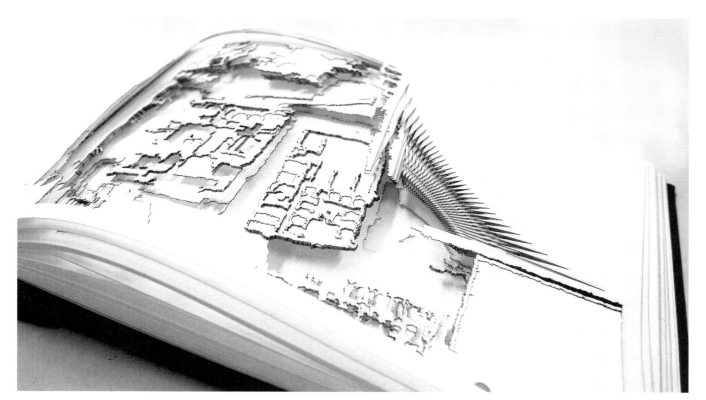

Ben Cowd
SOLAR TOPOGRAPHIES, 2007
Laser-cut watercolor paper bound
into book
8 ¼ x 11 ⅝ in. (21 x 29.5 cm)
Collection of the artist

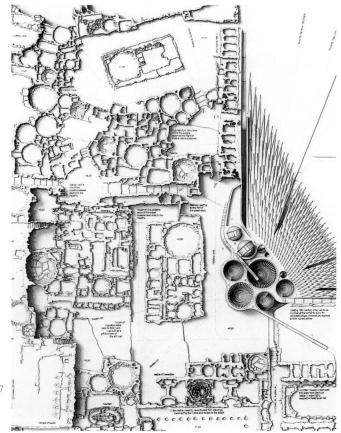

Ben Cowd
SOLAR TOPOGRAPHIES: PLAN, 2007
Laser-cut watercolor paper
23 ¼ x 33 ⅛ in. (58.9 x 84 cm)
Collection of the artist

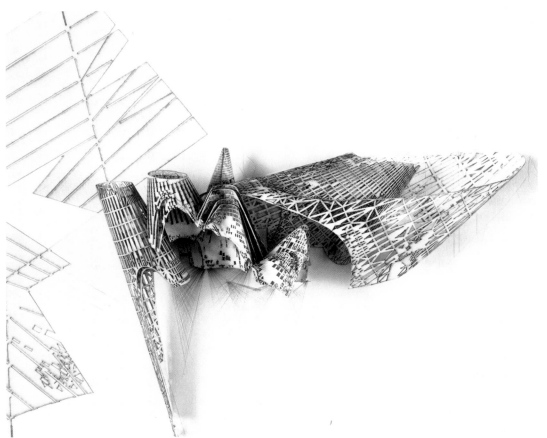

Sara Shafiei
SECTIONAL MODEL, THEATRE FOR MAGICIANS, 2007
Watercolor paper
27 ⅝ x 39 ⅜ in. (70.1 x 100 cm)
Collection of the artist

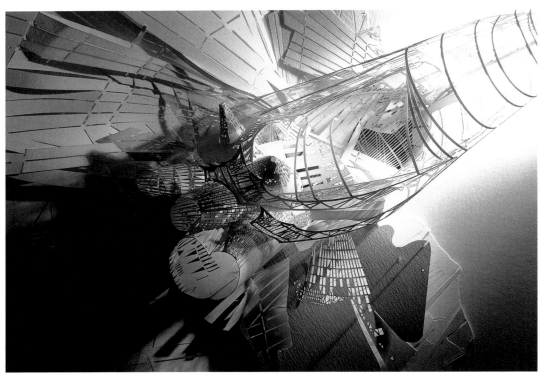

Sara Shafiei
THEATRE FOR MAGICIANS, 2007
Watercolor paper
31 ½ x 39 ⅜ in. (80 x 100.1 cm)
Collection of the artist

Sara Shafiei
Beacons of Sunflower Island, 2009
Yellow drafting paper, watercolor
paper; laser cut
19 ¾ x 19 ¾ in. (50 x 50 cm)
Collection of the artist

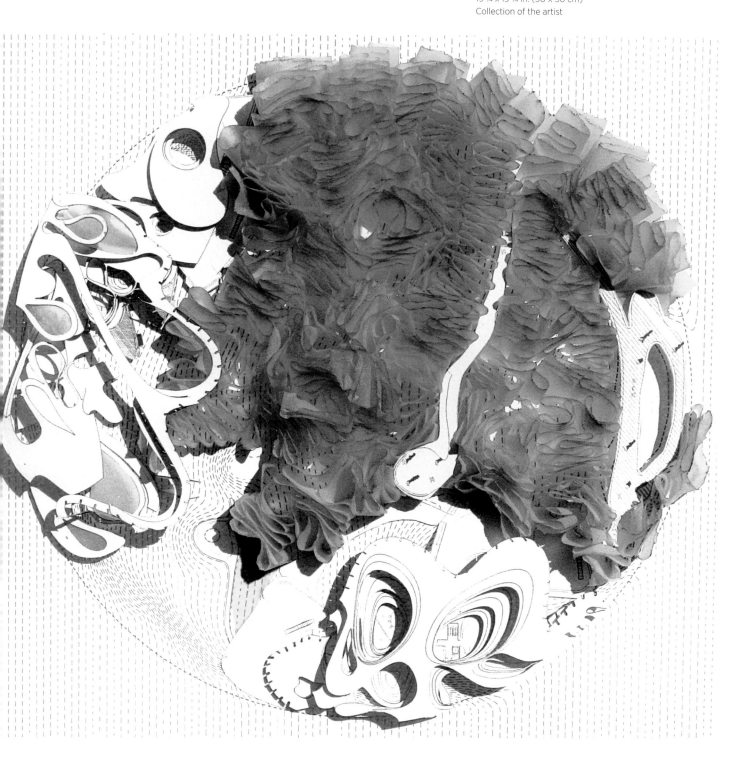

Lu Shengzhong

Lu Shengzhong was born in Shandong, China, during the Cultural Revolution. After serving in the army, he studied art at Shandong Normal University, graduating in 1978. He went on to receive his master's degree from the department of folk arts at the Central Academy of Fine Art (CAFA) in Beijing. Presently he teaches in the experimental art department at CAFA. His history of solo exhibitions is extensive, with major showings in China, Taiwan, Germany, Japan, Russia, and the United States. His use of paper began with cutouts made for his graduation exhibition at CAFA in 1987.

As I cut paper with my scissors and separate the shapes that result from my activity, I am making a statement against the separation of body and soul in contemporary thought. Summoning the detached forms of the souls so they can be reunited with their bodies can be compared to the juxtaposition of positive and negative forms or the perfect coexistence of the curves of ying and yang.

I was not meant to join the New Wave movement. At the time, to study from the vernacular was considered old-fashioned. Later, I felt that traditional folk art and contemporary art were only separated by a piece of very thin paper. It was like wearing clothes. If we do not take off our clothes to show our naked bodies, it is hard to tell who is in better shape.[1]

1. Quoted from press release, Chambers Fine Art (Gallery), New York, 2007; and Lu Shengzhong, "Life is Out of Control," in *The New Emerging from the Old Lu Shengzhong: Works, 1980–2005*, exh. cat. (New York: Chambers Fine Art; Albany: University Art Museum, University at Albany, SUNY, 2005), 8-16, (quote on p. 14).

HUMAN BRICK II, 2004
Cut paper, Plexiglas, silk thread
39½ x 60 x 3 ⅛ in.
(100.3 x 152.4 x 7.9 cm)
Private collection; courtesy of
Chambers Fine Art

First Encounter, 2000
Cut paper, mixed media
Dimensions variable
Courtesy of the artist and Chambers
Fine Art

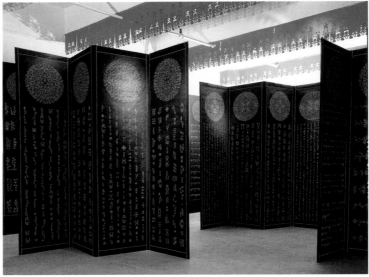

below:
Being and Nothingness, 1991
Cut paper
75 x 90 in. (190.5 x 228.6 cm)
Courtesy of the artist and Chambers
Fine Art

opposite:
The New Emerging from the Old,
2005
Installation view at University Art
Museum, University at Albany, State
University of New York
Mixed media
Dimensions variable

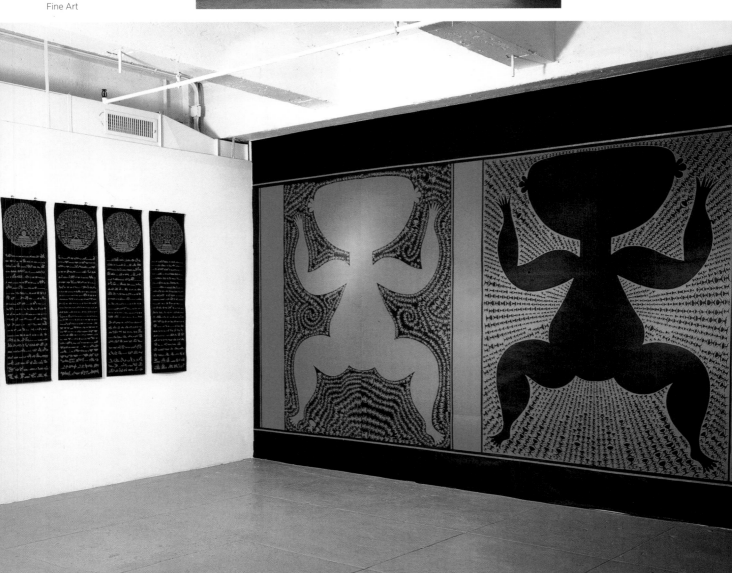

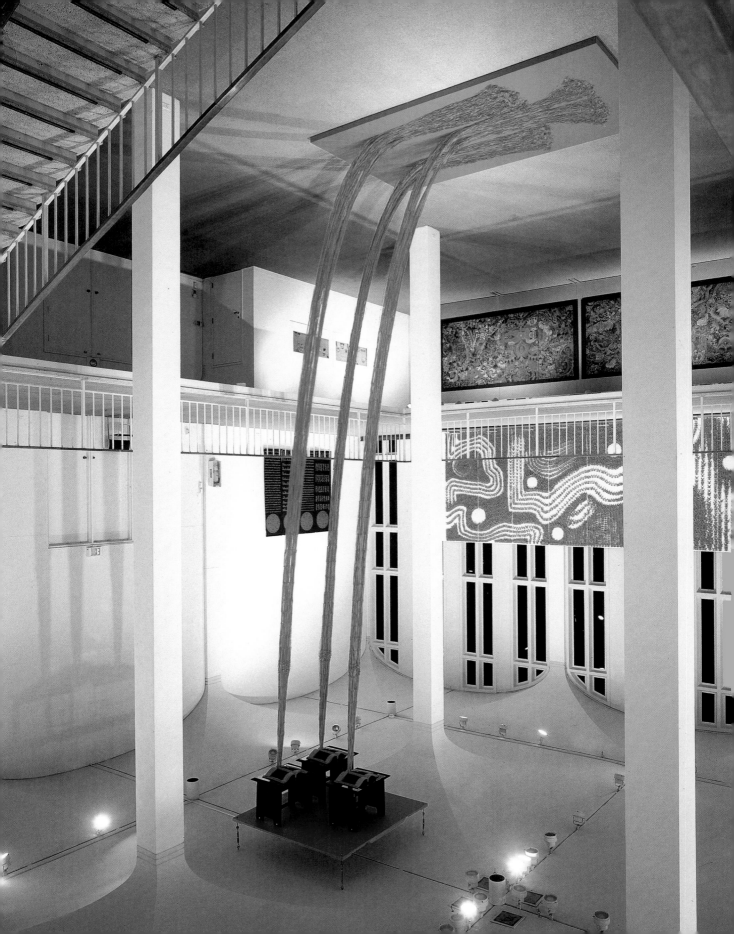

Proposal for **FROM HERE**, 2009
2 layers of hand-cut Dura-lar,
pencil, existing window overlooking
Columbus Circle
Collection of the artist

Fran Siegel

Fran Siegel received her BFA from the Tyler School of Art, Temple University, Philadelphia, and her MFA in painting from Yale University. She currently serves on the art faculty at California State University, Long Beach. Siegel's site-specific and site-referential installations have been seen at Muzeum Sztuki in Łódź, Poland; Nuova Icona, Venice; Center for Contemporary Art, Tel Aviv, Israel; and at several venues in Los Angeles—at the Torrance Art Museum, the Municipal Art Gallery–Barnsdall, and the Armory Center for the Arts. The artist represented the United States at the IX Bienal Internacional de Cuenca, Ecuador, in 2007 which was funded by the US State Department of Cultural Affairs. She has received an Individual Artist Fellowship from the City of Los Angeles Department of Cultural Affairs, and others from the Edward F. Albee Foundation, New York; the Fifth Floor Foundation, New York; and the Corporation of Yaddo, Saratoga Springs, New York.

Informed by location, my site-responsive drawings and installations interact with environmental light and architecture. For me, the process of cutting and removal reduces the image to its barest essential. Cutting opens up the form while integrating the drawing with its surroundings. Voids become pronounced over solids as influenced by Islamic architecture and the slashes of Lucio Fontana. The site-specific suspended drawing for the fifth-floor window of the Museum of Arts and Design is an extension of this work with location. Tracing light and human activity, I call attention to the classical symmetry of Columbus Circle, to daylight shifts, and surrounding neighborhood movement. The cuts within each of the two translucent layers maintain a different proportion in their relation to the view outside the window, emphasizing the viewers' shift in perspective as they move through the gallery.

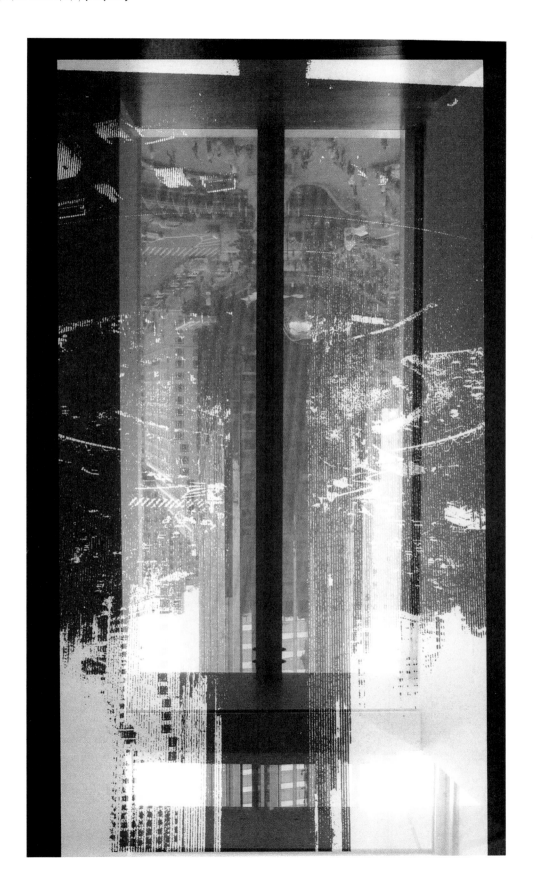

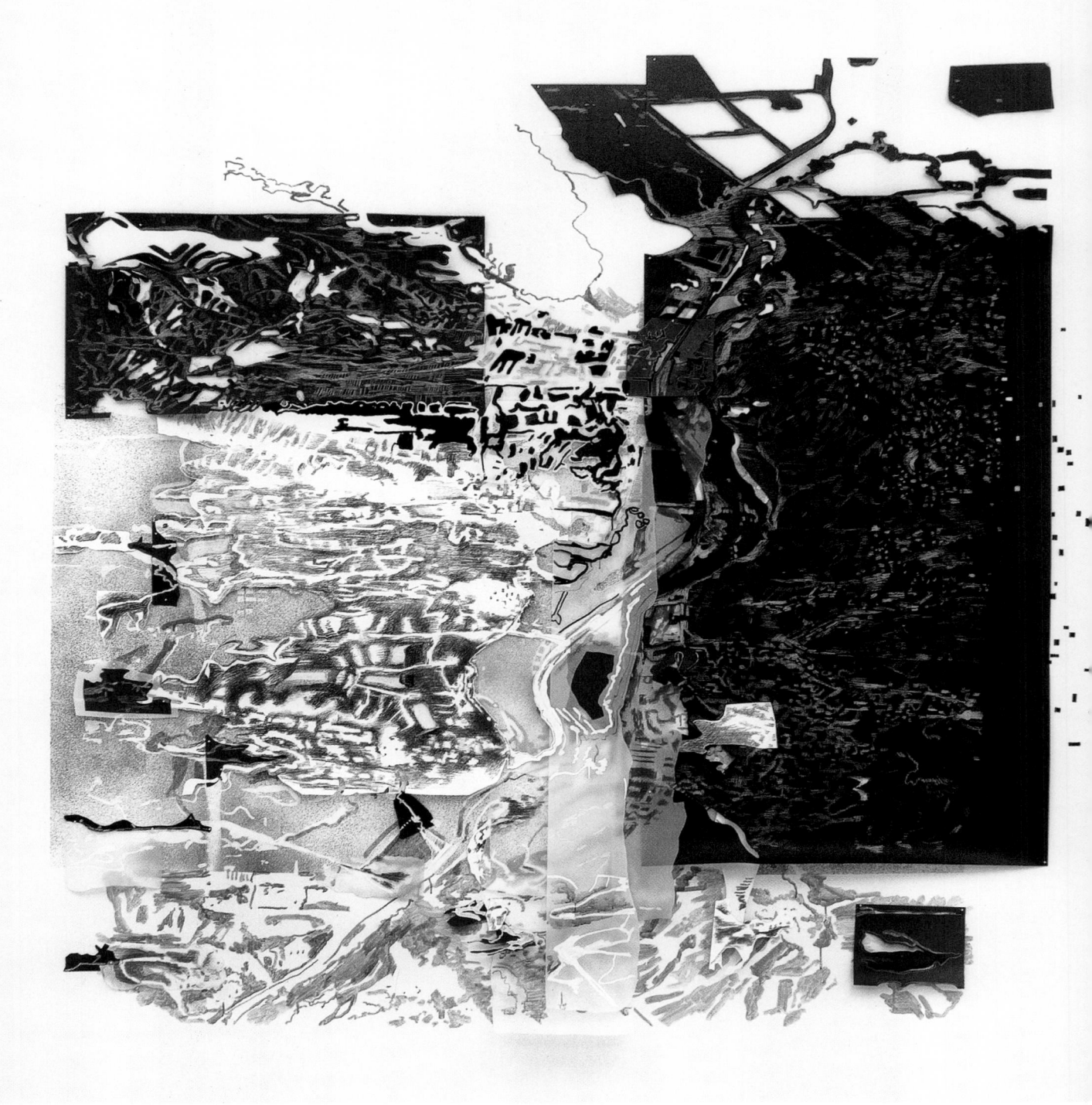

Overland 1, 2007
Colored pencil and pigment
on Dura-lar and cut papers,
painted wall
108 x 108 in. (274.3 x 274.3 cm)
Collection of the artist; courtesy
of Margaret Thatcher Projects,
New York

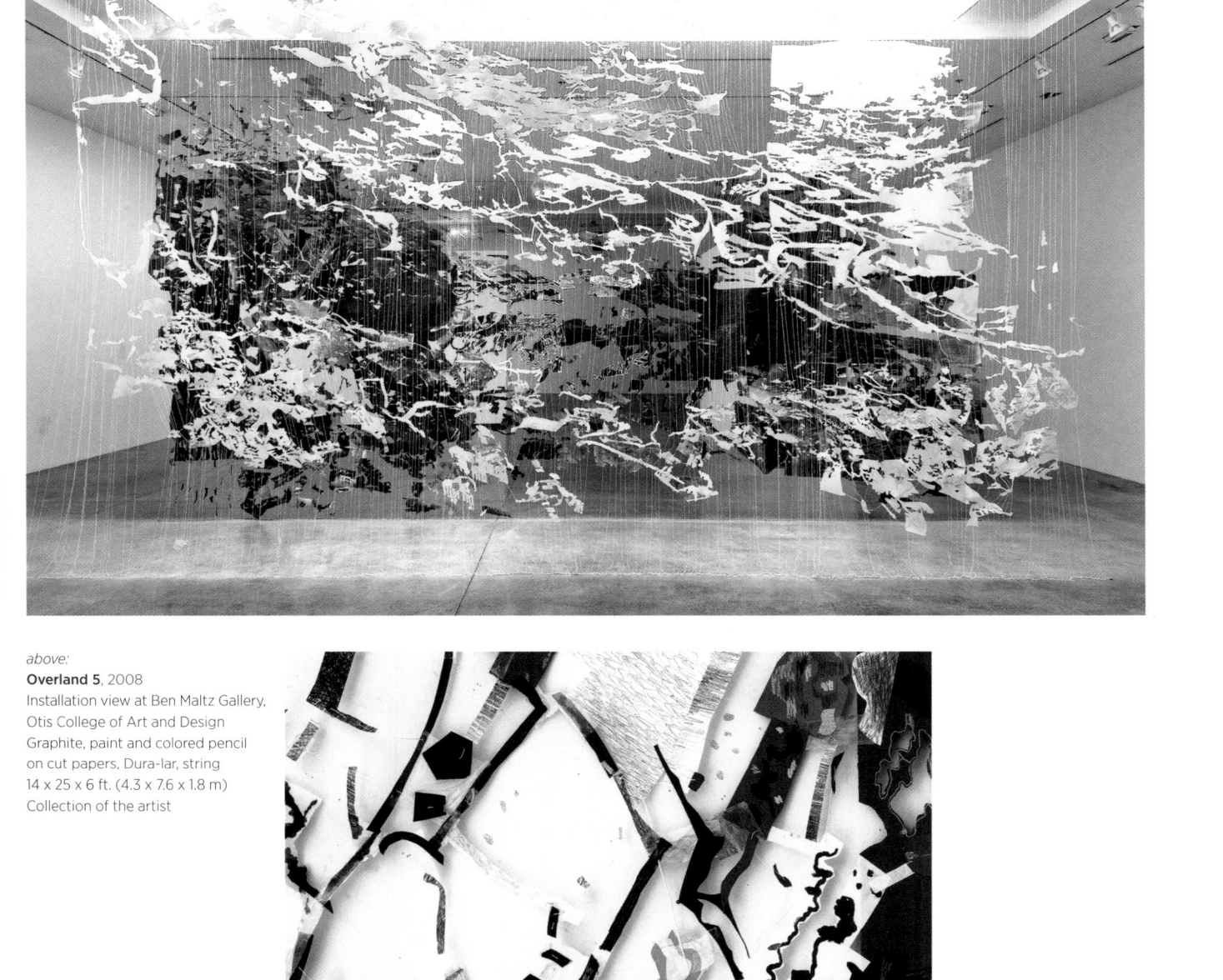

above:
Overland 5, 2008
Installation view at Ben Maltz Gallery,
Otis College of Art and Design
Graphite, paint and colored pencil
on cut papers, Dura-lar, string
14 x 25 x 6 ft. (4.3 x 7.6 x 1.8 m)
Collection of the artist

Overland 3, 2007 (detail)
Colored pencil, paint, ink, string on
cut papers
Overall: 94 x 86 in. (238.8 x 218.4 cm)
Collection of the artist; courtesy
of Margaret Thatcher Projects,
New York

Jane South

British-born Jane South currently lives and works in Brooklyn, New York. She studied at the Central School of Art (now Central/ St. Martins) in London, receiving a BA in theater set and costume design. Her MFA in painting and sculpture was earned at the University of North Carolina, Greensboro. Since 1998, her work has been seen in numerous institutions including the Whitney Museum of American Art at Altria, New York; White Columns, New York; MASS MoCA, North Adams, Massachusetts; the Aldrich Contemporary Art Museum, Ridgefield, Connecticut; and the Nassauischer Kunstverein, Wiesbaden, Germany. Among her fellowships, grants, and residencies are those from the Pollock-Krasner Foundation, the Rockefeller Foundation Bellagio Center, the MacDowell Colony, Yaddo, and the New York Foundation for the Arts. She has lectured, taught, and served as artist in residence in the United States, France, and Australia.

In Brooklyn, I live surrounded by the remnants of nineteenth-century industrial architecture, crumbling wharves, shipping cranes, and windowless warehouses, along with the burgeoning technological infrastructures of the twenty-first century, giant satellite dishes and fiber-optic cable terminals. My work references these structures and the ways I have seen my neighborhood evolve (for better and worse) over the years. New York City in particular is de- and re-constructed so much that it exists in a constant state of undress, exposing its history through dilapidated and/or shoddily/cheaply constructed layers—a reminder of the illusory and temporary nature of the urban landscape. Most of my work is made out of paper (the larger pieces also incorporating exposed wooden structures) which is hand-cut, folded, and constructed into three-dimensional elements. For me there is an honesty in the use of paper, a direct and fundamental art-making material that has a contrary relationship to the structures referenced. I would like these works to appear to waver between things: awkwardness/elegance, architecture/drawing, slight/monumental, direct/ mysterious, ancient/futuristic. I would also like them to exist as states navigated in the mind—the way one mentally maps the landscape of a novel—but also to be present in real, external space.

Untitled (Tower), 2009 (detail)
Hand-cut and folded paper, ink,
acrylic, wood
Overall: 15 x 6 x 5 ft.
(457.2 x 182.9 x 152.4 cm)
Courtesy of the artist and Spencer
Brownstone Gallery, New York

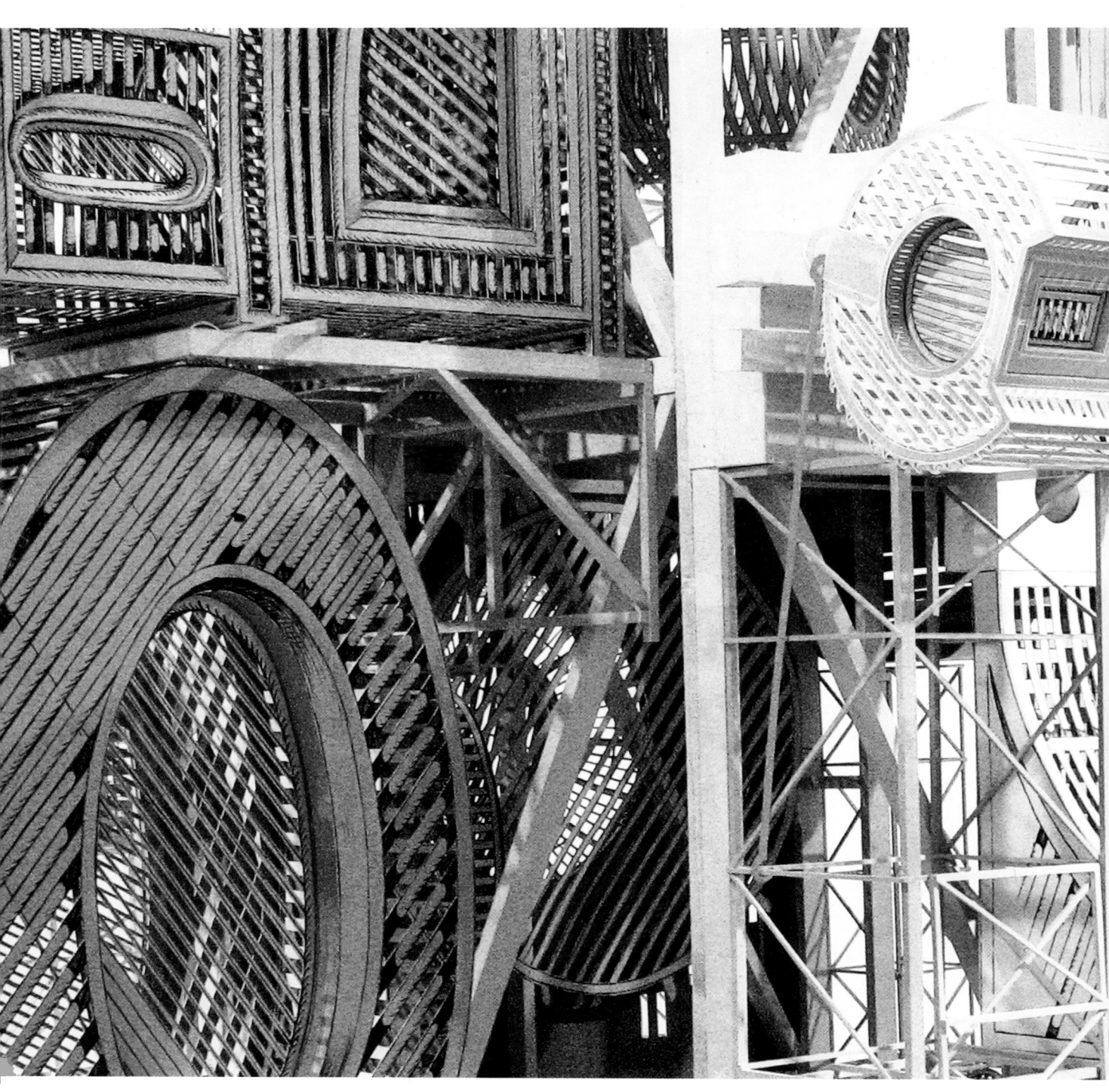

Untitled (Long Gray Construction),
2006
Hand-cut and folded paper, ink,
acrylic, balsa wood
67 x 116 x 14 in.
(170.2 x 294.6 x 35.6 cm)
Collection of the Weatherspoon
Art Museum, Greensboro, North
Carolina

Untitled (Tower), 2009 (detail)

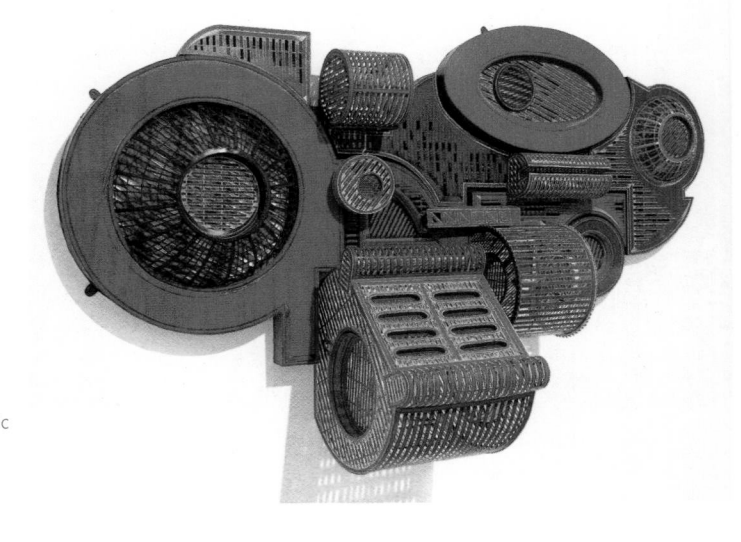

Untitled (Irregular Ellipse), 2008
Hand-cut and folded paper, ink, acrylic
9 x 3 x 1 ft. (274.3 x 91.4 x 30.5 cm)
Courtesy of the artist and Spencer
Brownstone Gallery, New York

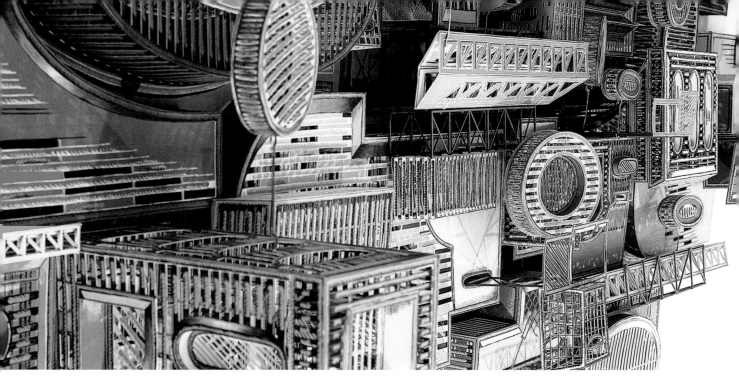

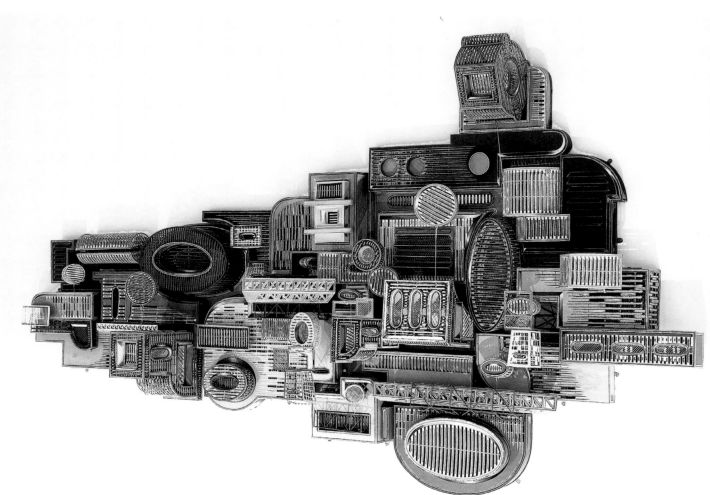

Black Tree, 2008
Black museum board
30 ¹¹⁄₁₆ x 13 ⅜ x 13 ⅜ in.
(78 x 34 x 34 cm)
Collection of the artist

Ferry Staverman

Ferry Staverman attended the technical school in Voorburg and Scheveningen in the Netherlands, where he learned to work with wood and metal. He went on to study at and graduate from the Royal Academy of Art (KABK), The Hague, concentrating on painting. Staverman worked with Sol Lewitt on two wall-drawings commissioned by the Gemeentemuseum in The Hague, and the Kröller-Müller Museum near Otterlo. Staverman has been exhibiting in the Netherlands since 1984; this is his first exhibition in New York. In addition to his studio work, Staverman is an educator at the Palace of Het Loo in Apeldoorn, the Netherlands, where he also lives.

In one form or another, I have always worked with paper. First as a surface for my drawings, watercolors, and gouaches. Sometimes these were folded drawings, and eventually they led to fully three-dimensional work. In 1995 I made a silhouette in a stack of cardboard; when glued together at one edge and opened, a human form appeared. And, although I found the technique too simple—it reminded me of paper foldout Christmas bells—the germ of an idea had been planted. Many of the early works took the form of female figures, but the shapes continued to evolve, and eventually the work began to resemble fountains, trees, or plants. When multiple forms were brought together, they evoked gardens and landscapes, probably drawing inspiration from the legendary gardens at Het Loo Palace. I love to create and develop new forms, but my sense of discipline and control means that each shape consumes a lot of time. While many works are white, I also explore color, which becomes more intense near the center of each form in these forms and landscapes.

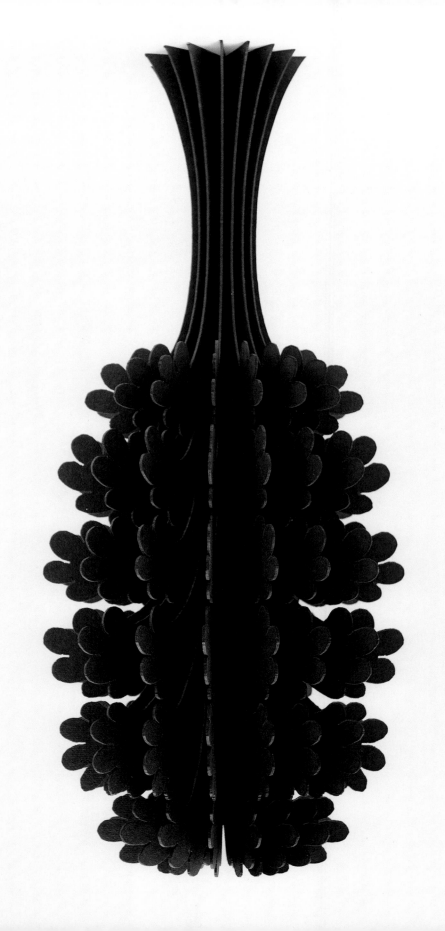

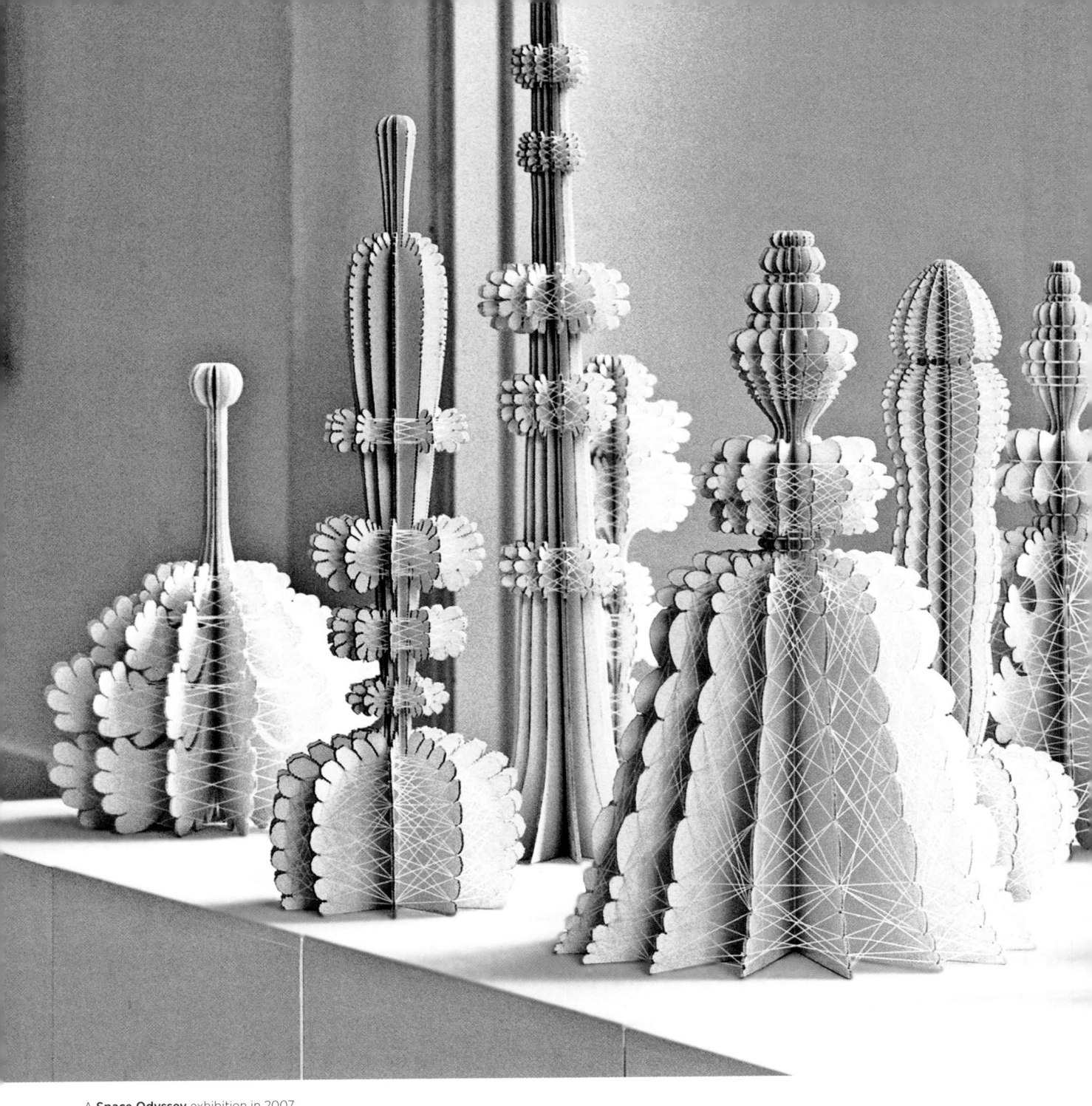

A **Space Odyssey** exhibition in 2007,
Weekend Art Gallery, Apeldoorn,
the Netherlands (objects from 2006
and 2007)
Cardboard, thread, paint
Dimensions variable
Collection of the artist; courtesy
of Bram van Gelderen, Bauke
Broersma, and Teun Renes

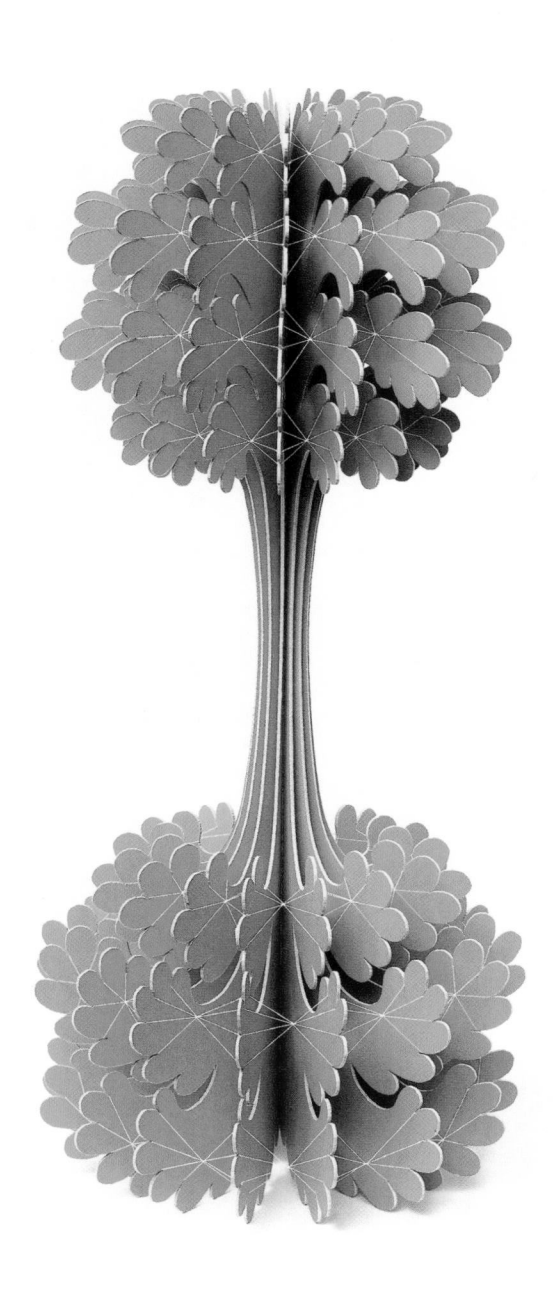

Red Fountain 2, 2007
Cardboard, thread, paint
31 ½ x 14 ³/₁₆ x 14 ³/₁₆ in.
(80 x 36 x 36 cm)
Collection of the artist

**PEACEABLE KINGDOM
(MYSTIC LIGHT)**, 2009
60 x 60 in. (152.4 x 152.4 cm)
Acrylic on laser-cut paper mounted
on Plexiglas over acrylic on panel
Collection of the artist

Lane Twitchell

Lane Twitchell received his BFA from the University of Utah, Salt Lake City, and his MFA from the School of Visual Arts in New York. Since 1992 he has participated in over forty group exhibitions at P.S.1 Contemporary Art Center/MoMA, Long Island City, New York; the Aldrich Contemporary Art Museum, Ridgefield, Connecticut; and the Corcoran Gallery of Art, Washington, DC, among others. His solo exhibitions have been seen in New York, Washington, DC, and Salt Lake City. Twitchell has also received commissions from the Chicago Public Art Program and New York's Percent for Art Program. He has been awarded two fellowships—in drawing and craft—by the New York Foundation for the Arts. Twitchell's work is found in the permanent collections of the Baltimore Museum of Art in Maryland; the Corcoran Gallery of Art; the Museum of Modern Art, New York; and the Neuberger Berman Art Collection, New York, among others.

The Peaceable Kingdom painting series, begun in 2008, explores the American zeitgeist, both contemporary and historical. Referencing the well-known paintings of this title by the nineteenth-century artist Edward Hicks, they comment on the religious roots of American culture. The symmetrical and static composition evokes traditional religious art. The animals depicted radiate from the dome atop the Zoo Center of the Bronx Zoo. The architectural elements highlight a faint Christian cross; the animals burst forth over this symbol as emblems of escape. In this series, I am advocating for an alternative to traditional organized religion and reminding an American audience that our history is not necessarily one of "In [one monotheistic] God We Trust," but the nation was founded instead on rational humanist principles designed to assure "liberty and equality for all."

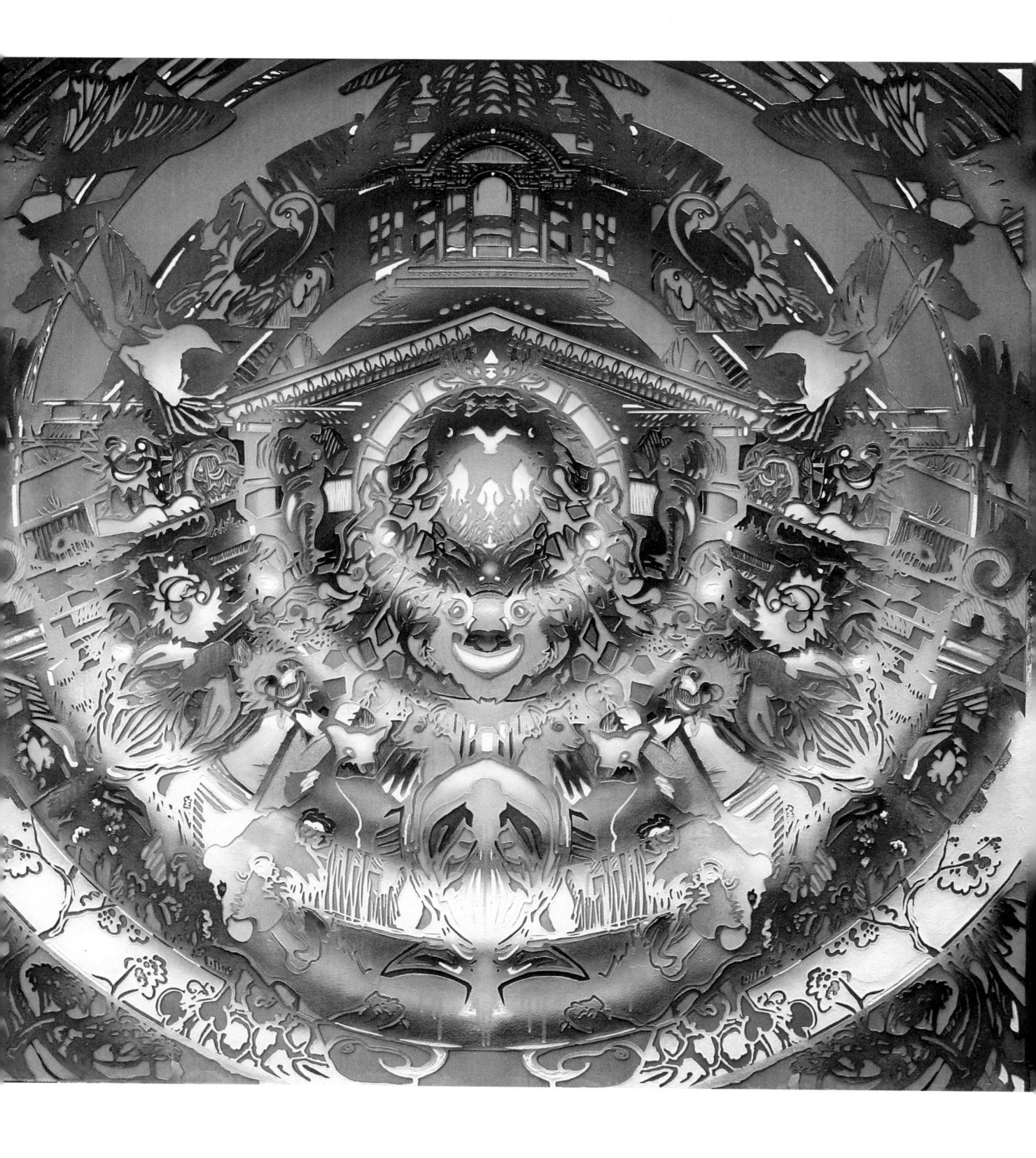

**Peaceable Kingdom
(Morning Light)**, 2008
60 x 60 in. (152.4 x 152.4 cm)
Acrylic on laser-cut paper mounted
on Plexiglas over acrylic on panel
Collection of goetzpartners

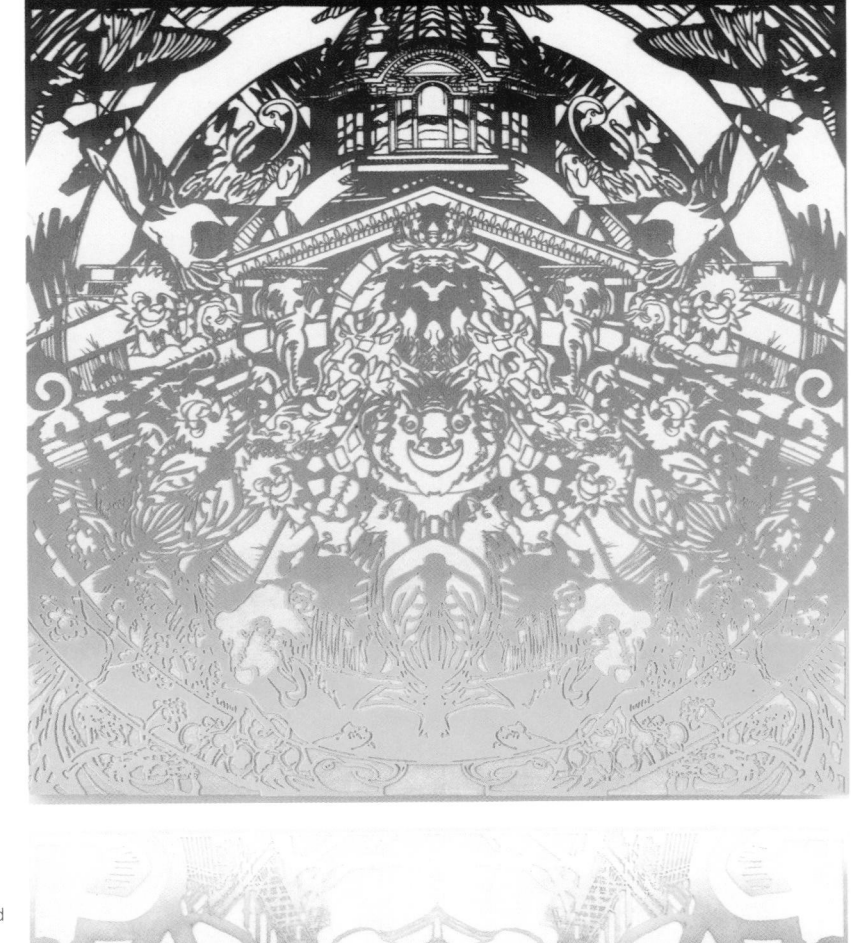

Cheer Up (New York Blues),
2007–8
48 x 48 in. (121.9 x 121.9 cm)
Enamel on laser-cut paper mounted
on Plexiglas over acrylic on panel
Collection of the artist

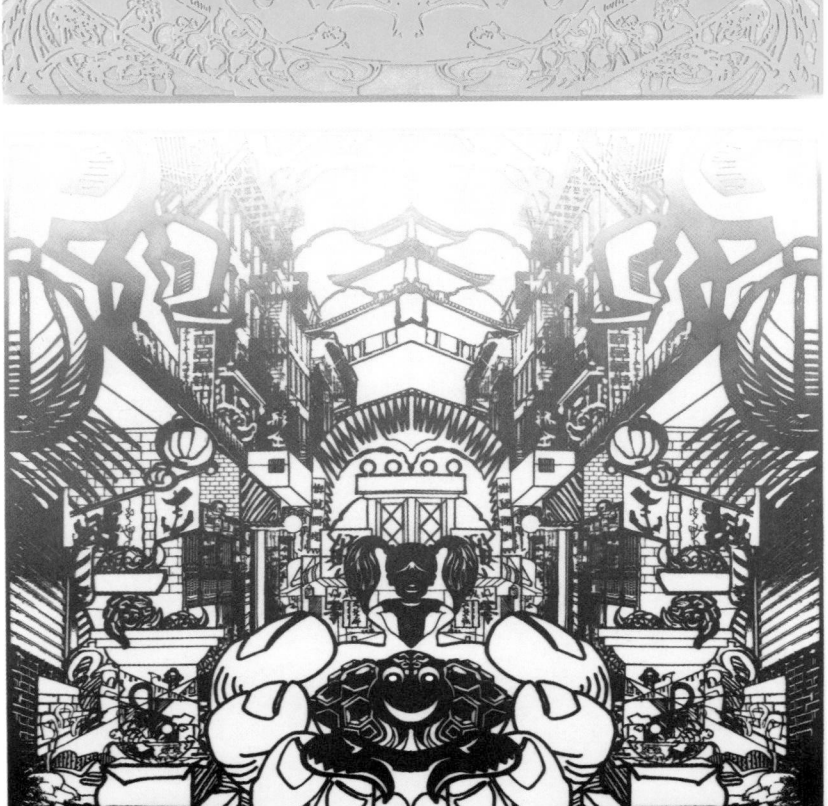

Suburban Showdown (Santa Cruz),
2008
36 x 36 in. (91.4 x 91.4 cm)
Urethane on hand-cut olifin
mounted on acrylic, pencil on panel
Courtesy of Artist Pension Trust

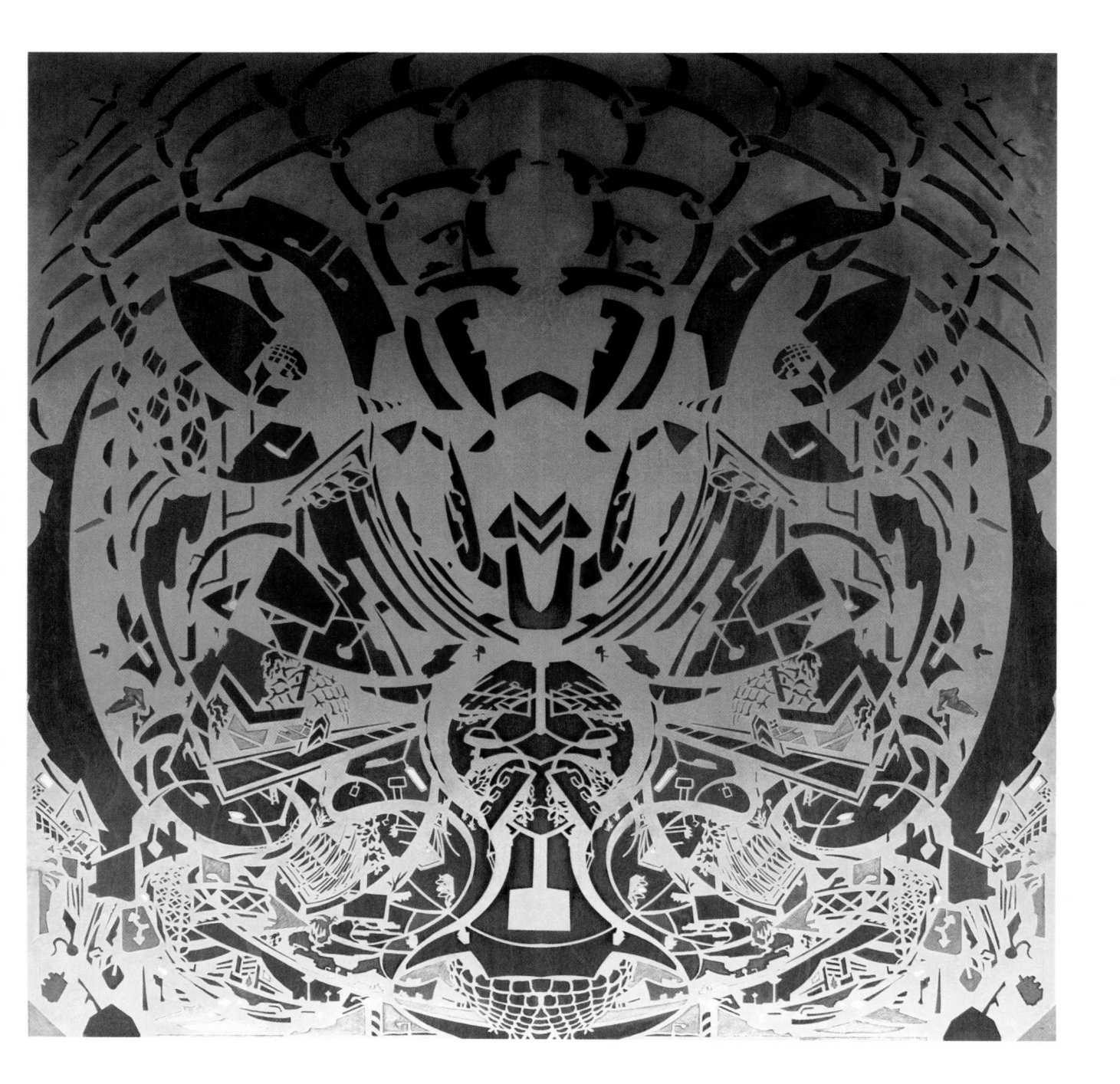

Shaul Tzemach

Shaul Tzemach received both his BA and MFA degrees from Bezalel Academy of Arts and Design in Jerusalem. He began exhibiting his work in 2000 and has continued to show at museums and galleries in Israel. This is his first New York showing. Tzemach received a prize from the America/Israel Cultural Foundation in 2005 and in 2006 the Young Artist Prize from Israel's Ministry of Education and Culture. In 2008 he earned an award from the Fund for Video Art and Experimental Cinema in Israel, from the Center of Contemporary Art, Tel Aviv, for his three dimensional experimental animation film that explored the concept of transformation.

In my art, I try to create ways to engage the viewer and draw him or her into the interior space of the work. This, in my outlook, parallels the interior of the viewer's soul, and questions preconceived notions of space. My point of departure is the contemplation of the phenomenon of nature. Today, nature is constructed of endless geometric forms repeated on many scales. This work expresses one of the most interesting concepts for me—superimposition, the existence of two distinct things occupying the same space and time. This idea seems important to me because it transfers the emphasis from the object to the relationships between objects, expressing the spirit of our times—the "web," the growth of communication networks, and the upsurge in information.

The concept of superimposition constitutes a bridge or a prism for recognition of the simultaneity of the world and existence itself. The motivation that lies in the base of this work is to reach a perception of chaos and complexity. The work attracts the viewer to observe it by going forward and backward in order to decipher its content. That movement in space is accompanied by movement in time, while observing the sources of the images which are revealed. It converges the principle of the eternal return, which is manifested in the circularity, symmetry, and the presence of a center, with the principle of the unique and the irreversible, which is manifested in the random, coincidental, asymmetry, and the presence of few centers. There is a fusion of ancient, traditional, and mythical elements in the form of circles, tree, whirlpools, animals from the snow fractal, together with contemporary, secular, and scientific elements in different aspects of the same and other forms. The circles are actually the shape of atom particles viewed in an electronic microscope, of molecule bonds, neuron network, the fractal, and the cube inside the cube (which corresponds to the fourth dimension and beyond).

above; detail right:
CONCRETION/CONGLOMERATE,
2005–7
Cut paper
27 9/16 x 39 3/8 in. (70 x 100 cm)
Collection of the artist

right; detail opposite:

The Legend of Species and Phenomena, 2004–5
Cut paper
19 ¾ x 27 ⁹⁄₁₆ in. (50 x 70 cm)
Collection of the artist

Double Wheel Fugue, 2008–9
Cut paper on silicon strings, electronic system
42 ⅛ x 30 ⁵⁄₁₆ in. (107 x 77 cm)
Collection of the artist

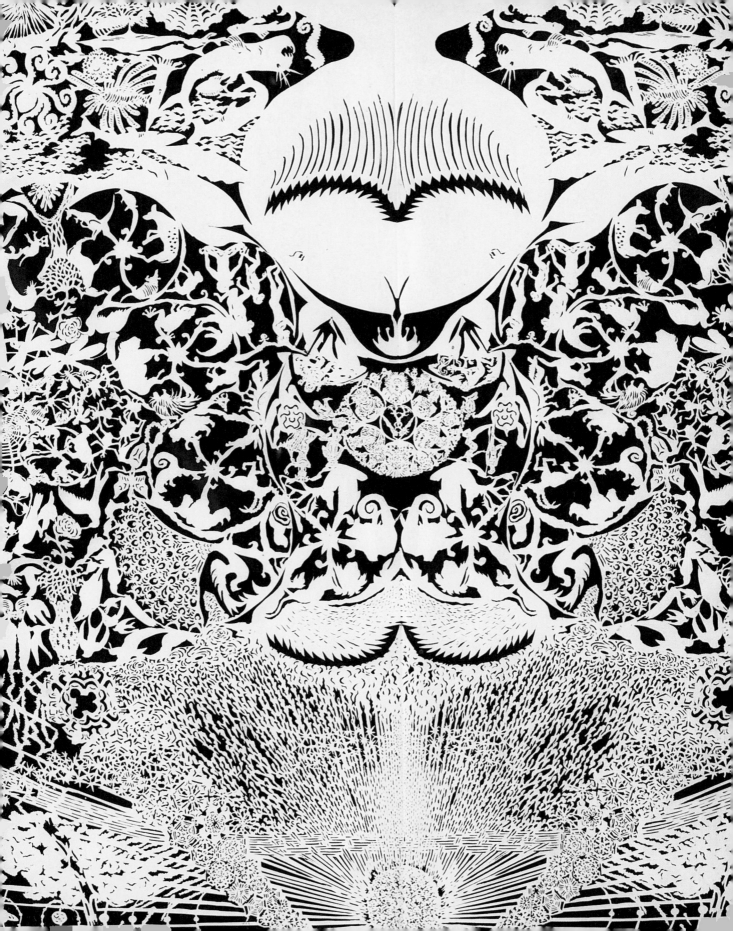

Kako Ueda

Kako Ueda was born in Japan. She moved to the United States at age fifteen and today lives and works in Brooklyn, New York. She earned a BFA from Tufts University. She also studied photography at the School of the Museum of Fine Arts, Boston, and received an MFA from Pratt Institute in Brooklyn, New York. Ueda's work has been exhibited at the Decordova Museum and Sculpture Park in Lincoln, Massachusetts; Museum of Contemporary Art Kiasma in Helsinki, Finland; Brooklyn Botanic Garden, New York; Smack Mellon Studios in Brooklyn, New York; Cathedral of St. John the Divine, New York; and at several New York galleries. Ueda recently received fellowships from Smack Mellon Studio Program, the New York Foundation for the Arts, and the Urban Artist Initiative/NYC.

Paper has been my primary medium of choice for a long time. It is an everyday material yet has potential to manifest itself in surprisingly diverse ways. I became attracted to the medium because of its history as well as the process of cutting to make images. Cut-paper pieces have the look of a hybrid, an object that bridges drawing and sculpture. My cut-paper pieces incorporate references to world myths, fairy tales, art and medical history, science, and body politics. I am interested in organic life—insects, animals, vegetation, and human bodies—how they are part of nature but are constantly influenced and modified by culture. Early in my work, I focused on the notion of body as environment/ecosystem based on the philosophy of ancient Chinese medicine. Another recurrent theme is the ancient Greek idea of macrocosm and microcosm. Basically this is seeing the same patterns in all levels of reality: the body as environment, the environment as body.[1]

opposite; detail top:
RECIPROCAL PAIN, 2009
Hand-cut paper, acrylic, wire
94 x 59 in. (238.8 x 149.9 cm)
Courtesy of the artist and George
Adams Gallery, New York

1. Kako Ueda to David McFadden, email correspondence, April 2009.

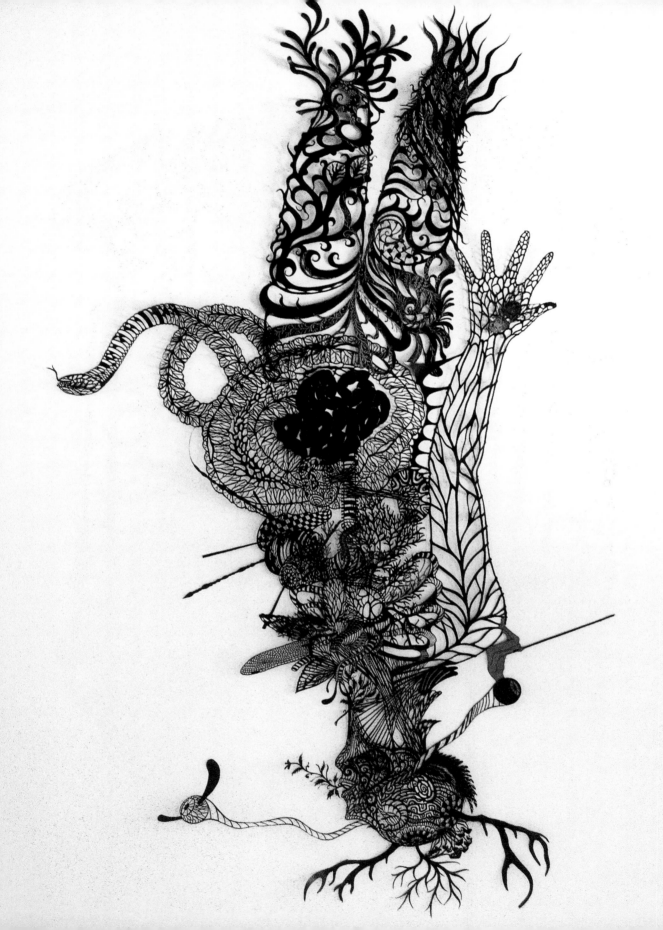

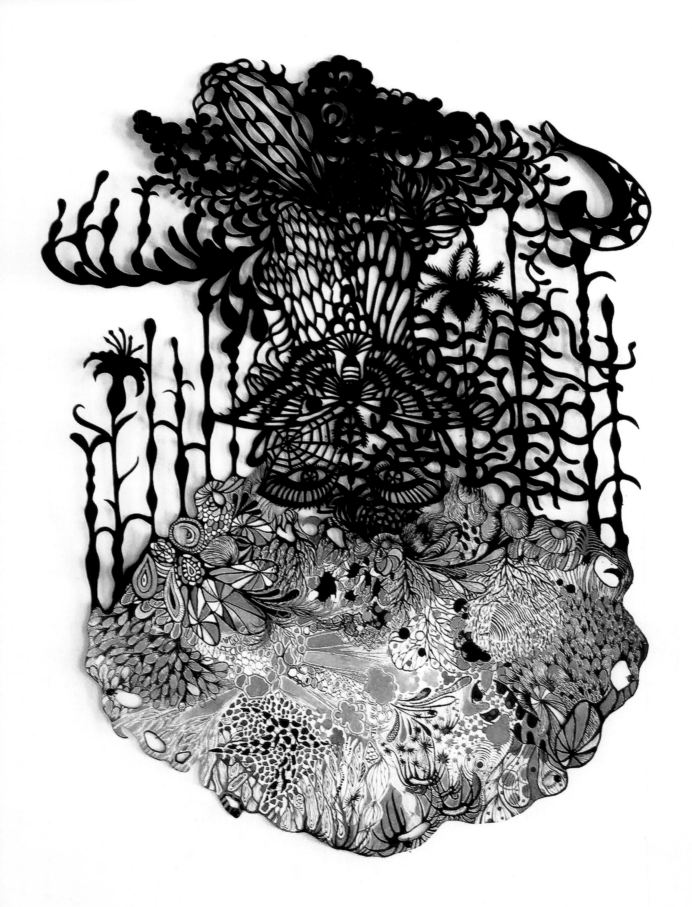

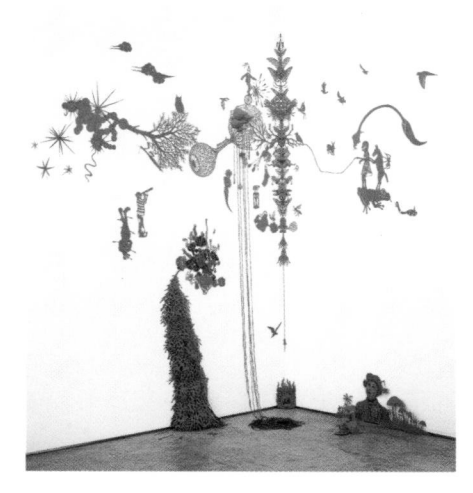

above; detail left:
Totem, 2008
Hand-cut paper, collage, string
110 x 142 x 30 in.
(279.4 x 360.7 x 76.2 cm)
Courtesy of George Adams Gallery,
New York

opposite:
Gaze, 2005
Watercolor on hand-cut black paper
20 x 14 in. (50.8 x 35.6 cm)
Courtesy of George Adams Gallery,
New York

Tower 1, 2009 (detail)
Cut paper, glue
Overall: 72 x 24 x 3 in.
(182.9 x 61 x 7.6 cm)
Courtesy of the artist and DCKT
Contemporary, New York

Michael Velliquette

Michael Velliquette received his BFA from the Florida State University, Tallahassee, and his MA and MFA from the University of Wisconsin–Madison. He began exhibiting his work in 2002 and was given his first solo exhibition in 2003. He has had residencies at Artpace, San Antonio, Texas; the Vermont Studio Center, Johnson; and the John Michael Kohler Arts Center, Sheboygan, Wisconsin, among others. Velliquette has been the Marie Christine Kohler Fellow at the University of Wisconsin–Madison, and has received grants from Artpace; the Foundation for Contemporary Arts; and the Dallas Museum of Art. He is currently a lecturer in the department of visual art at the University of Wisconsin–Madison and is represented by DCKT Contemporary, New York.

My process evolved from my background in mixed-media sculpture and installation (where cardstock and other colored papers were often one component among many). At the time, my work was about transforming conventional craft or building materials into spectacle objects. But as the paper works evolved I began to look for ways to move beyond the inherent flatness to achieve the same sense of submersion that had been such an important part of my previous installation work. I spent time looking at other art forms like mosaic, relief sculpture, collage, and other paper-crafting traditions, and I have gone on to incorporate aspects of these forms into my work. The results have been ever-increasing levels of detail and dimensionality. For me, these works have become an exploration of the relationship between emotions and the visual cues that we perceive in design. They are vaguely mythological, sometimes Muppet-like, both fierce and friendly. In the abstract, I would say that they are concerned with the dynamics of familiarity and otherness. But these works also speak somewhat about spiritually driven object-making and devotional ornamentation out of the co-mingling of abstract figuration and transcendental themes.

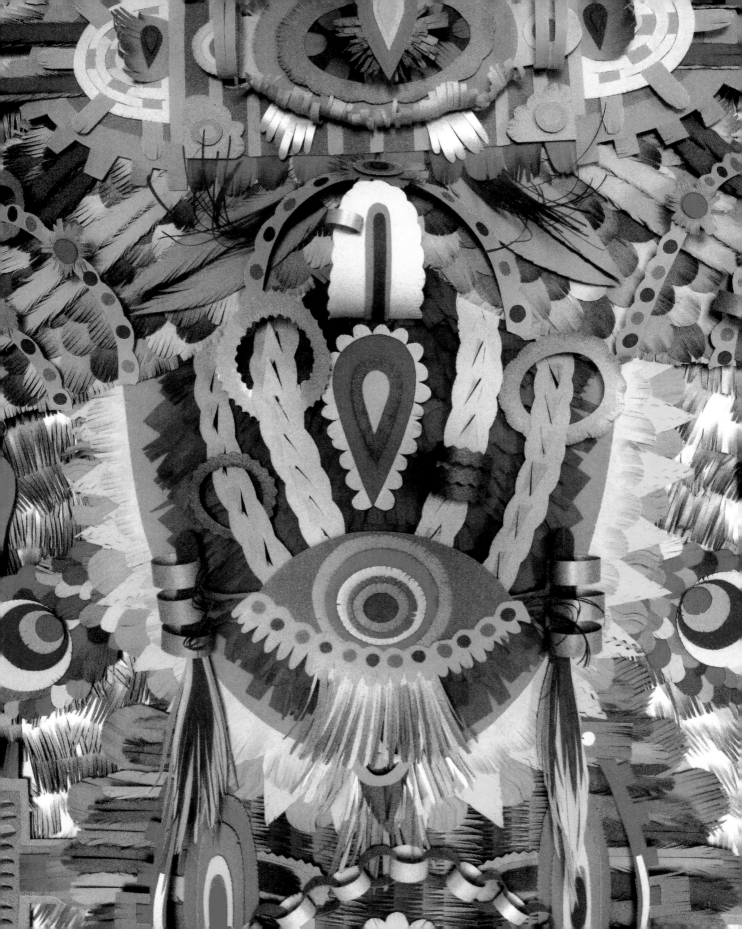

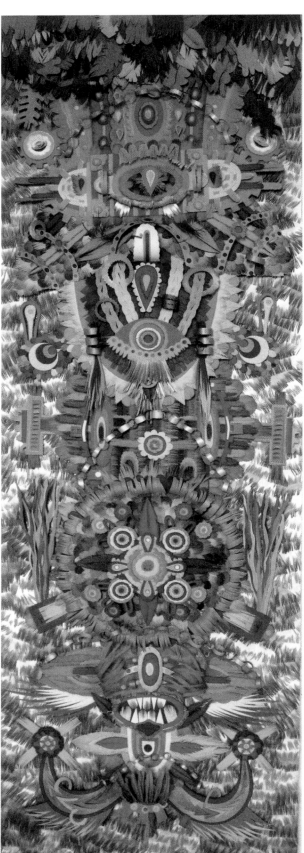

Tower 1, 2009 (detail)

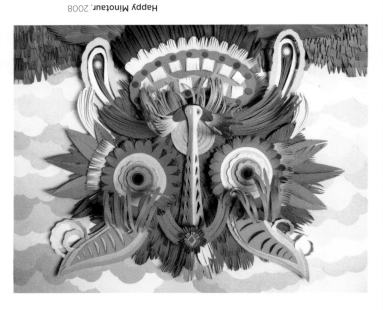

opposite, top:

Clubbo, 2008 (2 views)
Graphite on cut medium/density
fiberboard
13 x 8 x 5 in. (33 x 20.3 x 12.7 cm)
Courtesy of the artist and DCKT
Contemporary, New York

Happy Minotaur, 2008
Cut paper, glue
16 x 20 x 2 in. (40.6 x 50.8 x 5.1 cm)
Courtesy of the artist and DCKT
Contemporary, New York

The You in the I, 2004
Mixed media installation, ArtPace,
San Antonio, TX
Dimensions variable
Courtesy of the artist and DCKT
Contemporary, New York

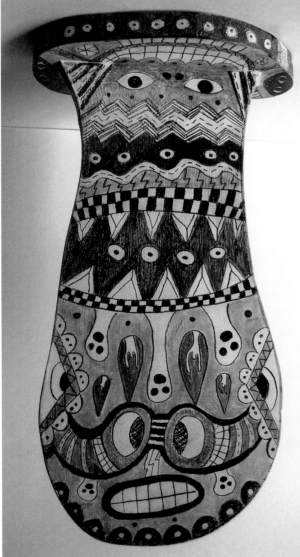

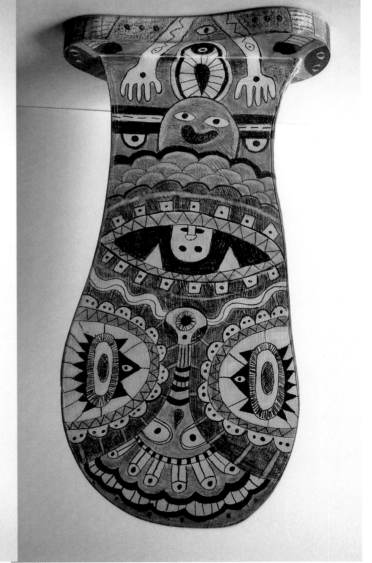

Kara Walker

Kara Walker received degrees in painting and printmaking from the Atlanta College of Art (BFA) in Georgia and the Rhode Island School of Design (MFA), Providence. She first exhibited in group exhibitions in Atlanta in 1991, the year of her graduation. In 1995 she produced her first three solo exhibitions, and since then has had more than forty solo exhibitions at such international institutions as the Metropolitan Museum of Art and the Whitney Museum of American Art in New York; Tate Liverpool in England; and the Tel Aviv Museum of Art in Israel. She has also shown in the Netherlands, Italy, Mexico, Germany, Switzerland, Sweden, and elsewhere. Walker's work was presented at the 2002 International Bienal de São Paolo, Brazil; the 2007 Biennale di Venezia, Italy; and the Carnegie International at the Carnegie Museum of Art in Pittsburgh. Walker has received numerous grants, awards, and fellowships, most notably the John D. and Catherine T. MacArthur Foundation award. Her work is found in museum collections worldwide.

I was really searching for a format to sort of encapsulate, to simplify complicated things. . . . And some of it spoke to me as: "it's a medium . . . historically, it's a craft . . . and it's very middle class." It spoke to me in the same way the minstrel show does: ". . . it's middle-class white people rendering themselves black, making themselves somewhat invisible, or taking on an alternate identity because of the anonymity," and because the shadow also speaks about so much of our psyche. You can play out different roles when you are rendered black, or halfway invisible.[1]

I don't know how much I believe in redemptive stories, even though people want them and strive for them. They're satisfied with stories of triumph over evil, but then triumph is a dead end. Triumph never sits still. Life goes on. People forget and make mistakes. Heroes are not completely pure, and villains aren't purely evil. I'm interested in the continuity of conflict, the creation of racist narratives, or nationalist narratives, or whatever narratives people use to construct a group identity and to keep themselves whole— such activity has a darker side to it, since it allows people to lash out at whoever's not in the group. That's a contact thread that flummoxes me.[2]

opposite:
DESCRIPTION/ATROCITY/ WITNESS/*YAWN*/WARNING WARNING/REPEAT: THE RIGHT OF WAY, 2008
Cut paper
5 ⅜ x 7 ½ x 4 in. (13.7 x 19.1 x 10.2 cm)
Courtesy of the artist and Sikkema Jenkins & Co., New York

1. Quoted from "The Art of Kara Walker," Walker Art Center, Minneapolis, http://learn.walkerart.org/karawalker/Main/TechniquesAndMedia (accessed June 2009).

2. Quoted from "Kara Walker: My Complement, My Enemy, My Oppressor, My Love," p. 8, Whitney Museum of Art, New York, http://www.whitney.org/www/exhibition/kara_walker/pdfs/kwgalleryguide.pdf.

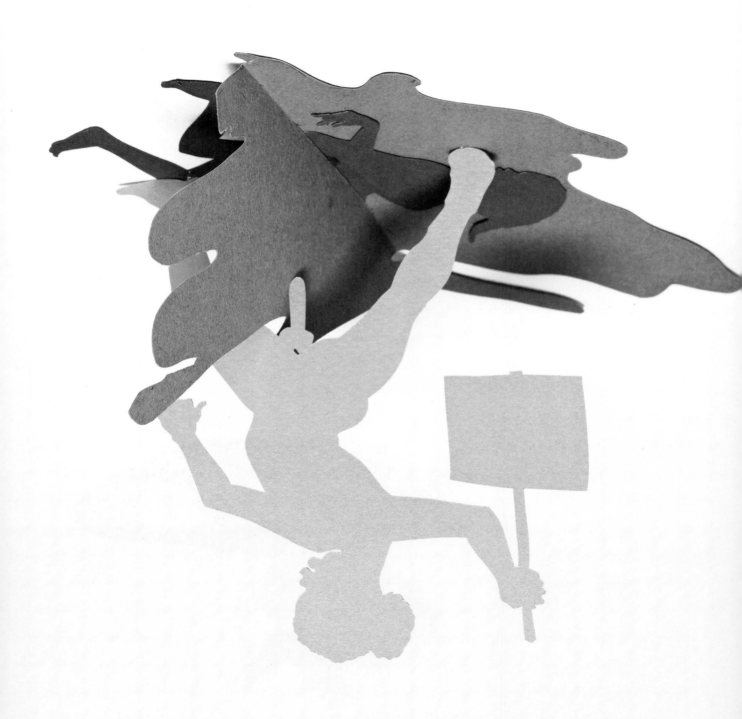

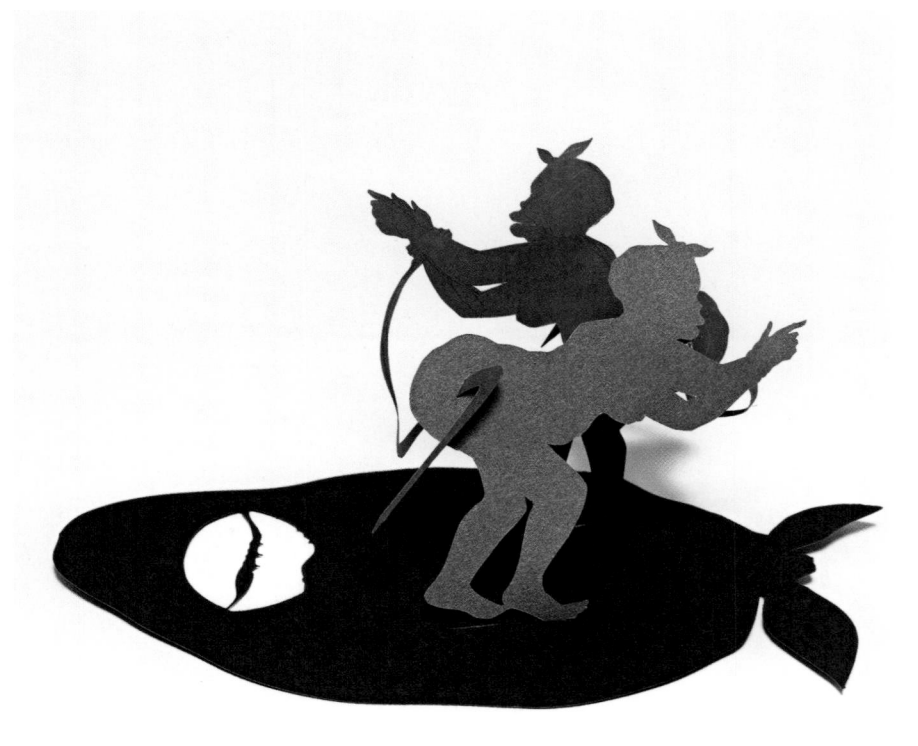

left:

**DESCRIPTION/ATROCITY/
WITNESS/*YAWN*/WARNING
WARNING/REPEAT: INTIMATIONS**,
2008
Cut paper
5 x 10 x 6 ⅛ in. (12.7 x 25.4 x 15.6 cm)
Courtesy of the artist and Sikkema
Jenkins & Co., New York

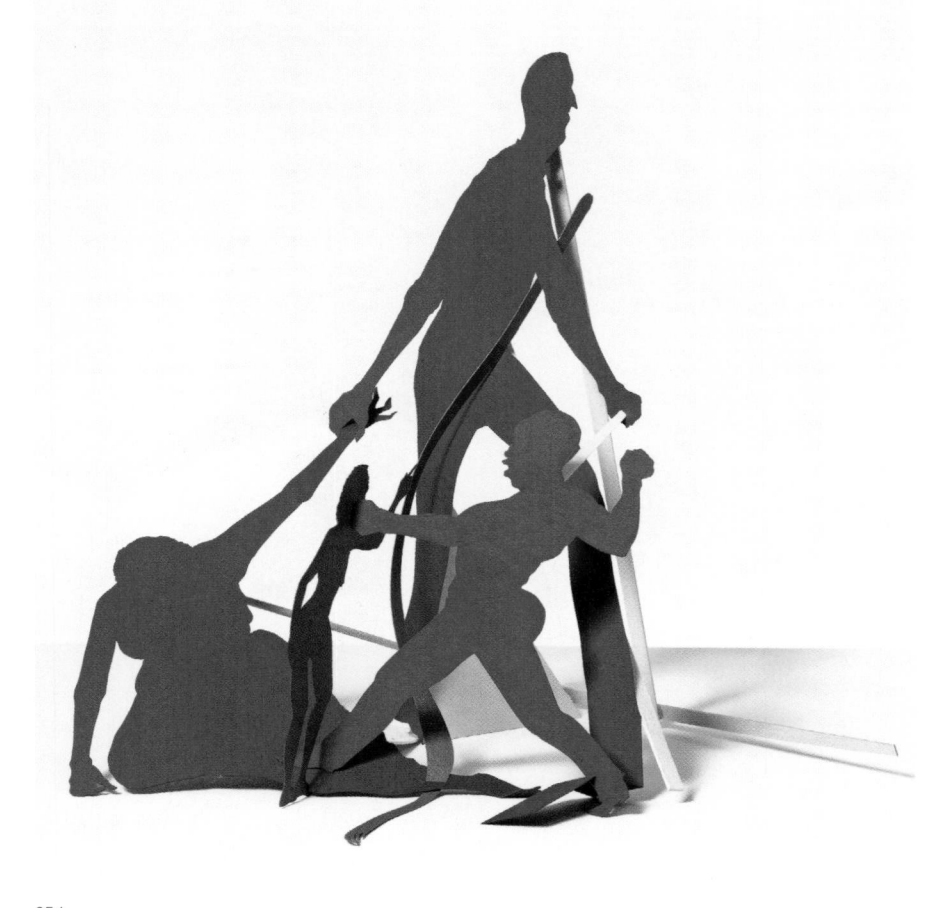

left:

**DESCRIPTION/ATROCITY/WITNESS/
YAWN/WARNING WARNING/
REPEAT: LEGACY OF A DOORMAT,
BALLAD OF THE LOVER**, 2008
Cut paper, wood, adhesive
10 ½ x 9 ½ x 7 in. (26.7 x 24.1 x 17.8 cm)
Courtesy of the artist and Sikkema
Jenkins & Co., New York

opposite bottom:
**Freedom Fighters for the Society
of Forgotten Knowledge, Northern
Domestic Scene**, 2005
Cut paper and adhesive on wall
10 x 40 ft. (3.1 x 12.2 m)
Courtesy of the artist and Sikkema
Jenkins & Co., New York

**Cotton Hoards in Southern Swamp.
Harper's Pictorial History of the
Civil War (Annotated)**, 2005
Offset lithography and silkscreen
39 x 53 in. (99.1 x 134.6 cm)
Courtesy of the artist and Sikkema
Jenkins & Co., New York

COTTON HOARDS IN SOUTHERN SWAMP

Doug Beube
War History Remapped, 2002
Altered atlas, collage
15 x 12 x 1 in. (38.1 x 55.9 x 2.5 cm)
Collection of the artist